WATCH MINI BIBLE

VOLUME 1

TECTUM
PUBLISHERS

WATCH MINI

BIBLE

VOLUME 1

© 2008 Tectum Publishers
 Godefriduskaai 22
 2000 Antwerp
 Belgium
 info@tectum.be
 + 32 3 226 66 73
 www.tectum.be

ISBN: 978-90-76886-77-0
WD: 2008/9021/16
(60)

DESIGN : Gunter Segers

PRINTED IN CHINA

PREFACE

Mechanical watches are more popular than ever and people often ask me if I have any idea why this is. I believe it is due to a combination of factors, which also differ from one country to another.

Of course, it is linked to prosperity. Indeed, we often talk about expensive products that are in many cases quite superfluous; after all, the time appears on a mobile phone, a car dashboard, a computer screen and a microwave oven to name only a few examples. Those who choose to wear a mechanical watch do so mainly to make a statement; it is an expression of style and reveals a sense of beauty and class.

I describe it as a Renaissance of craft. After years of rapid consumption, when the lifespan of appliances was constantly getting shorter and people felt obliged to go ever more quickly in search of a 'new and improved version', the need for calm has arisen. The need for something you can cherish, feel proud of, to which you can form an attachment and that retains its value.

Mechanical watches are without equal in fulfilling these needs. They are timeless, they accentuate your personality and they stay with you for many years, sometimes even for generations.

The book that you hold in your hands is not an almanac and does not pretend to give a complete overview of the market. What it does do is provide a unique view of the magical world of high class watch making today, a fast moving world but one that always honours its past.

I hope you enjoy the book.

Gerben Bijpost
Editor in chief Watch Magazine NL

PRICE INDICATION

ⓡ	till 5.000 €
ⓡⓡ	5.000 € – 25.000 €
ⓡⓡⓡ	25.000 € – 75.000 €
ⓡⓡⓡⓡ	from 75.000 €
∿	HERITAGE

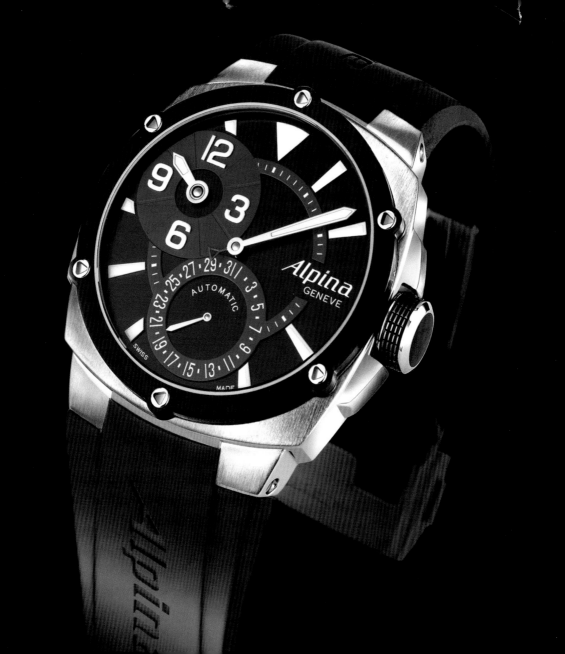

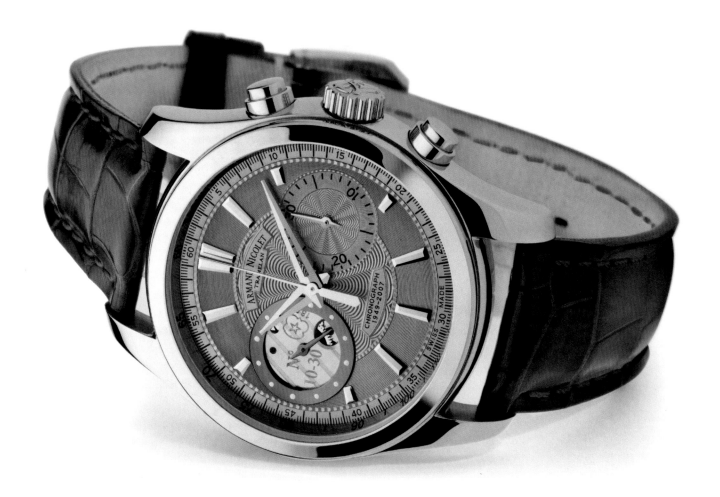

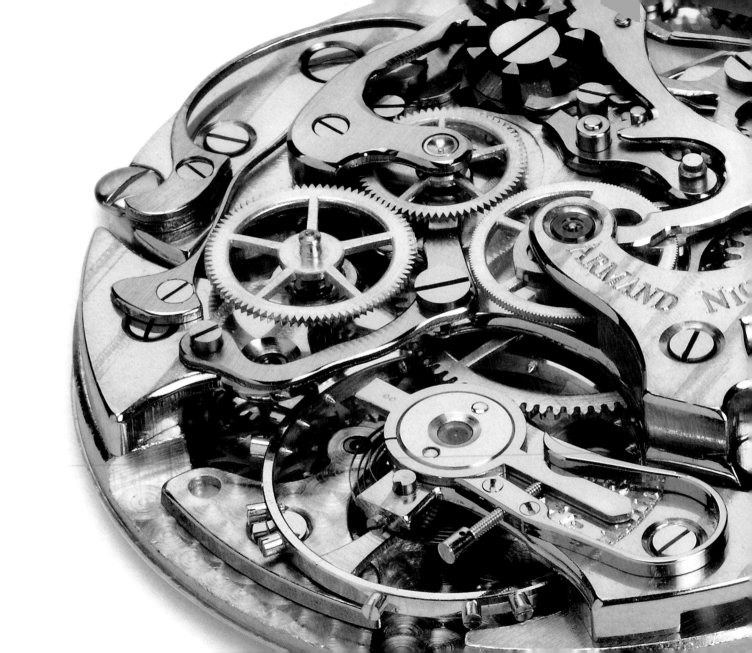

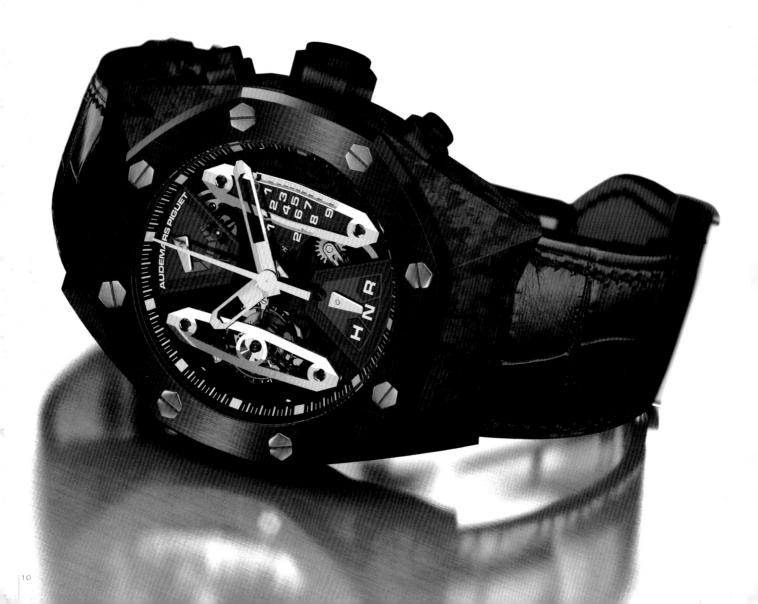

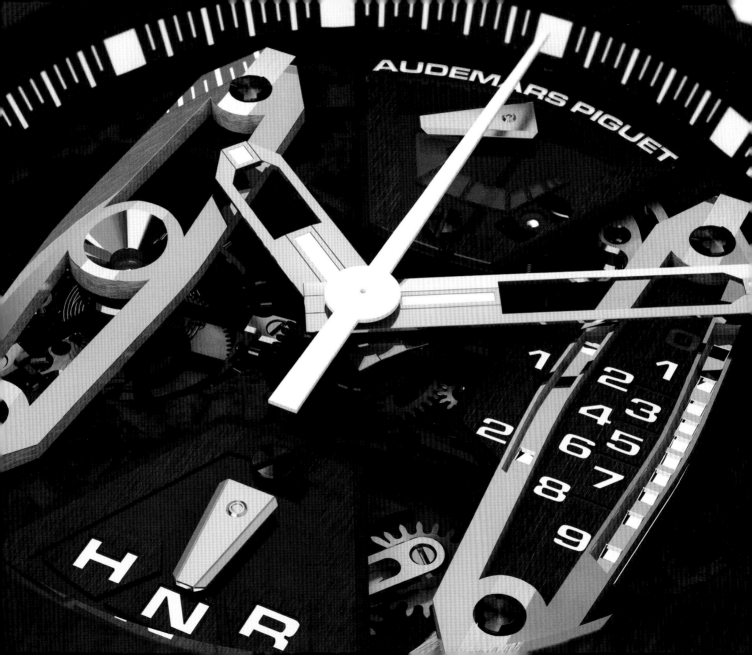

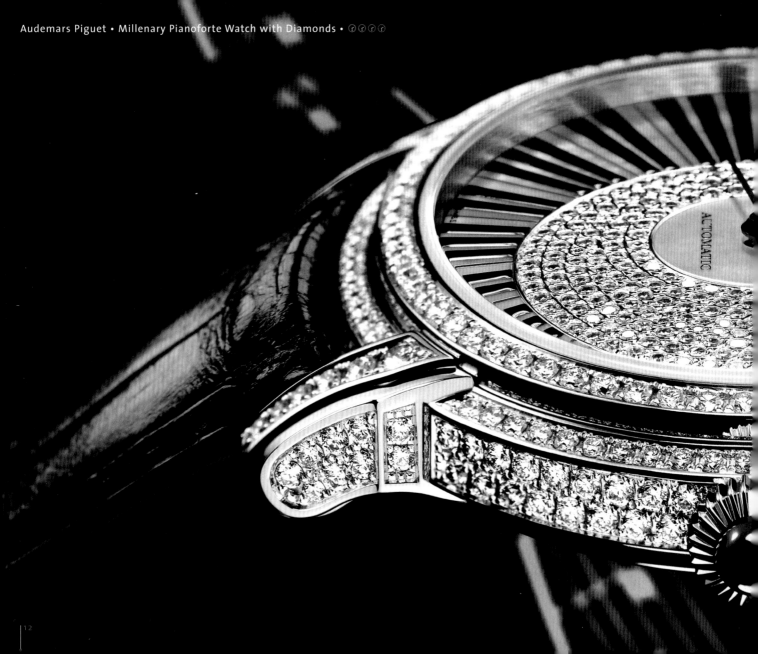

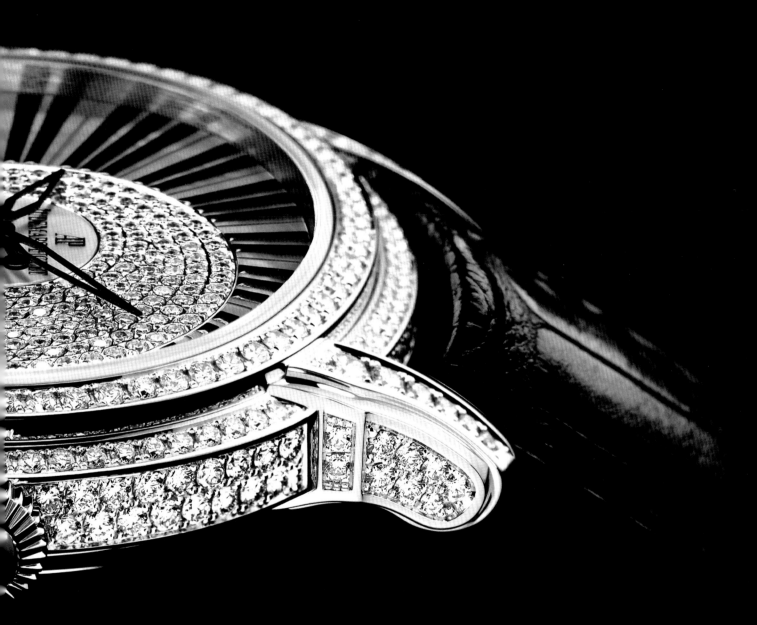

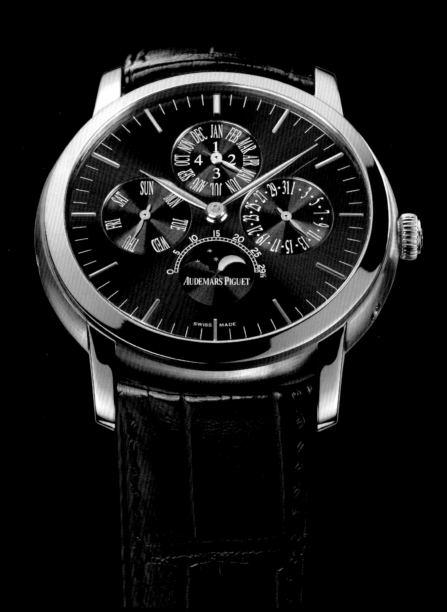

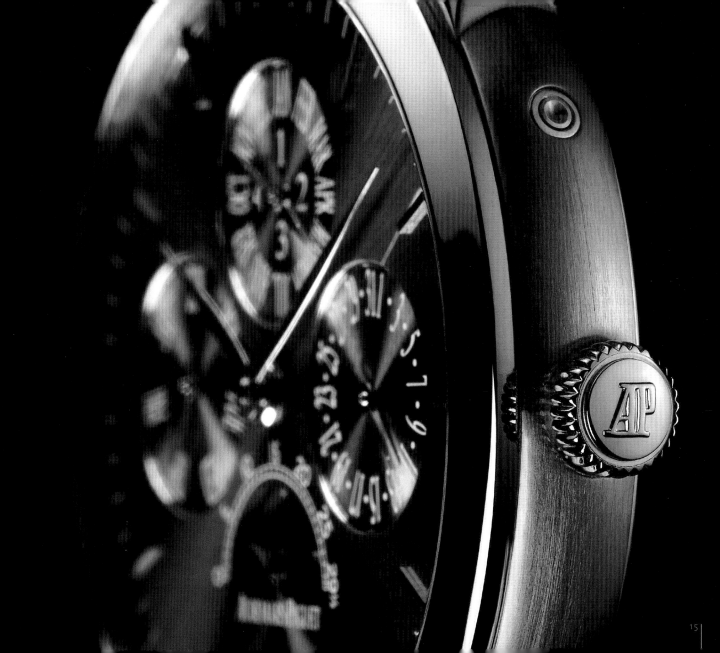

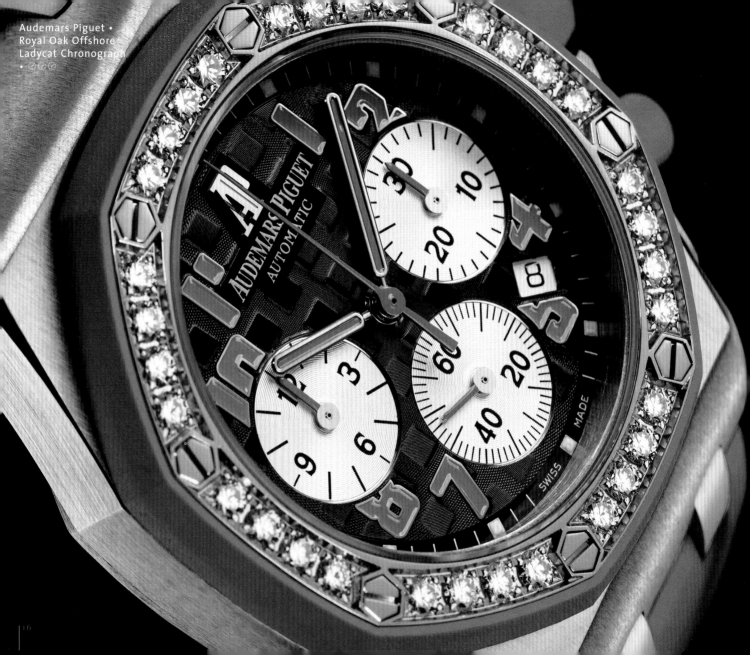

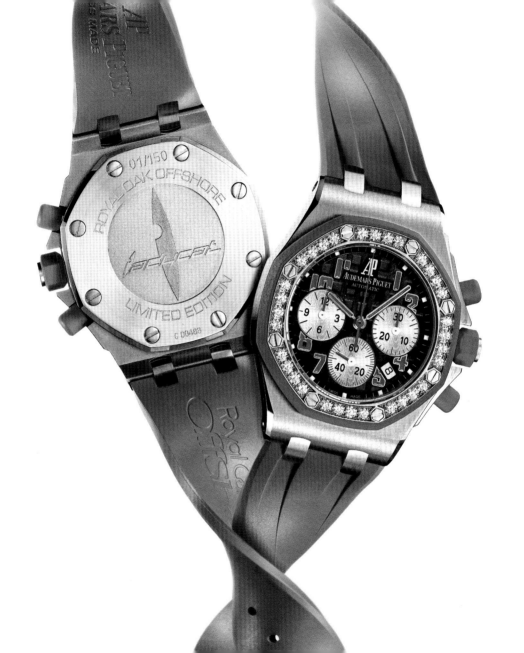

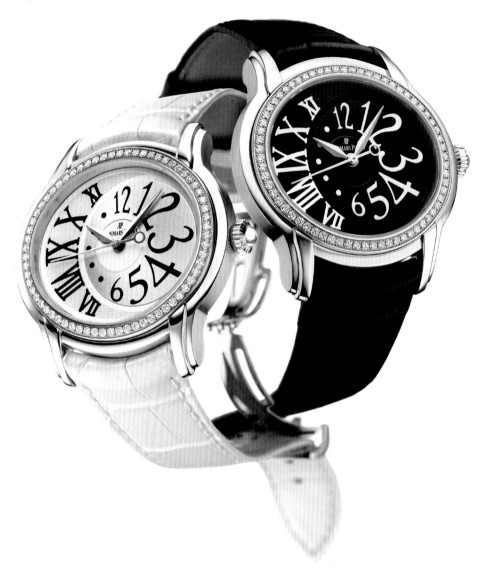

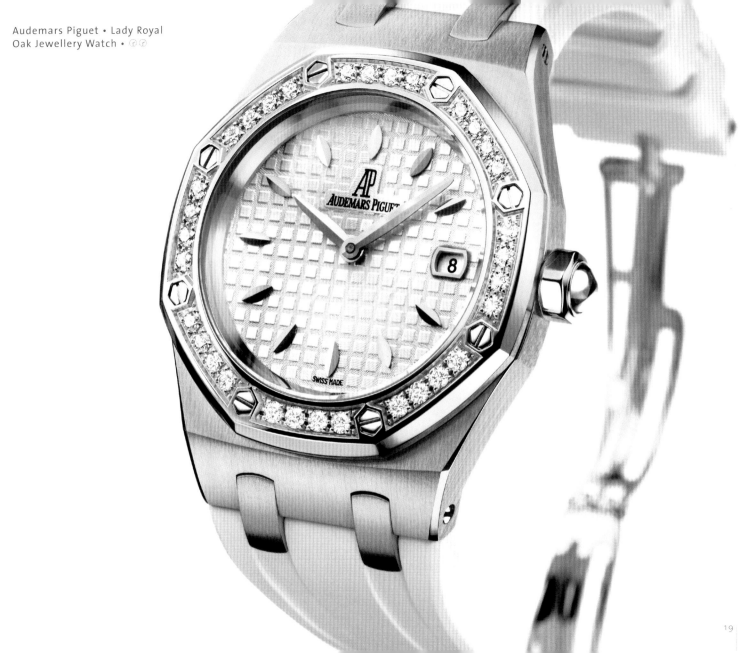

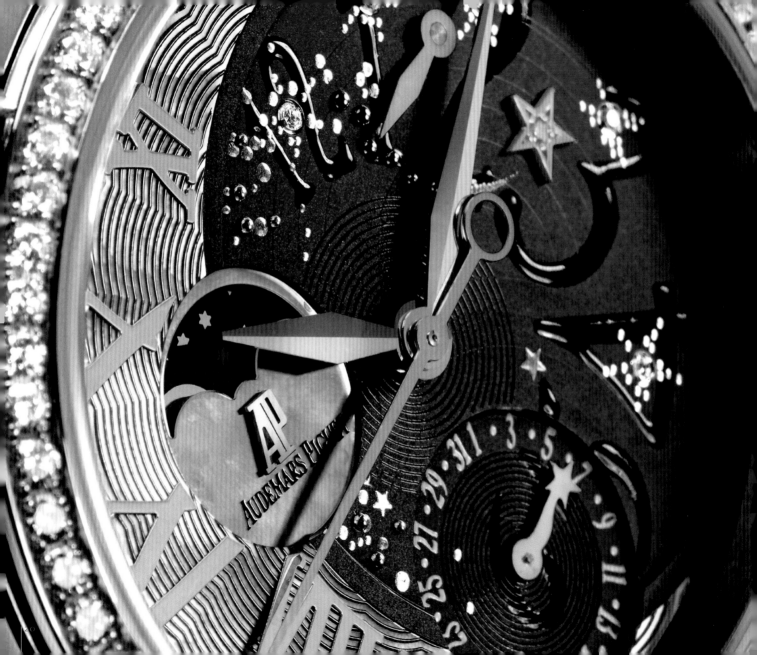

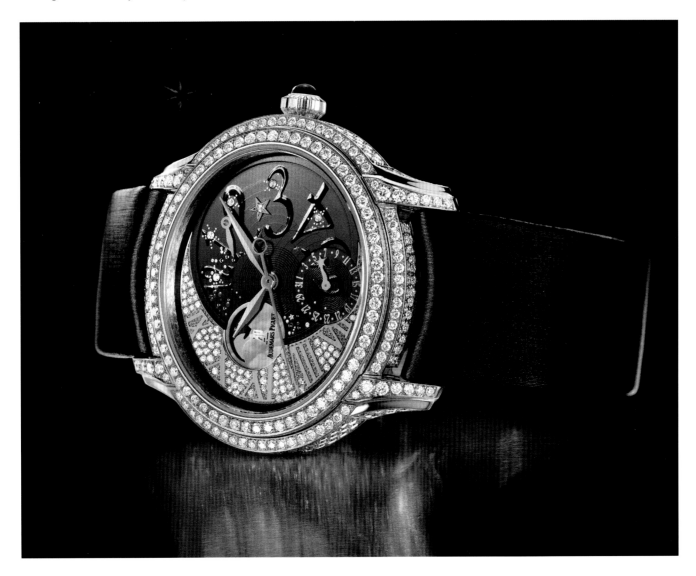

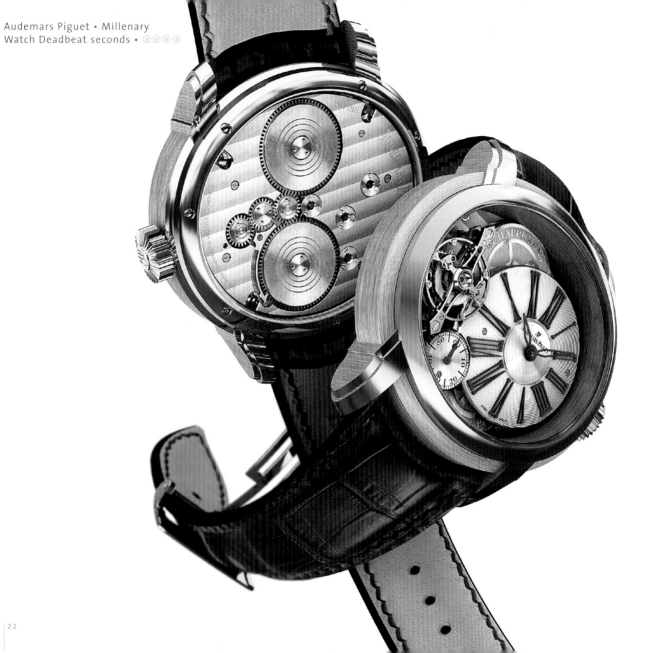

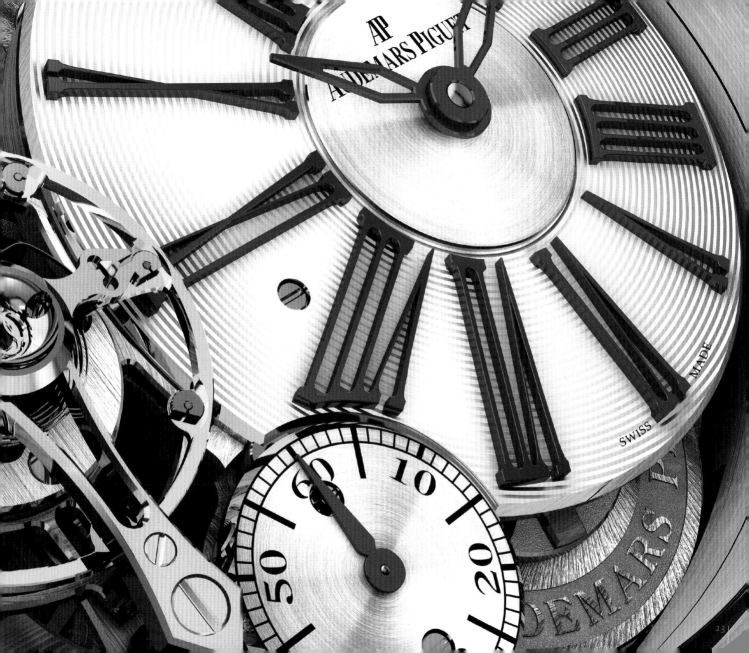

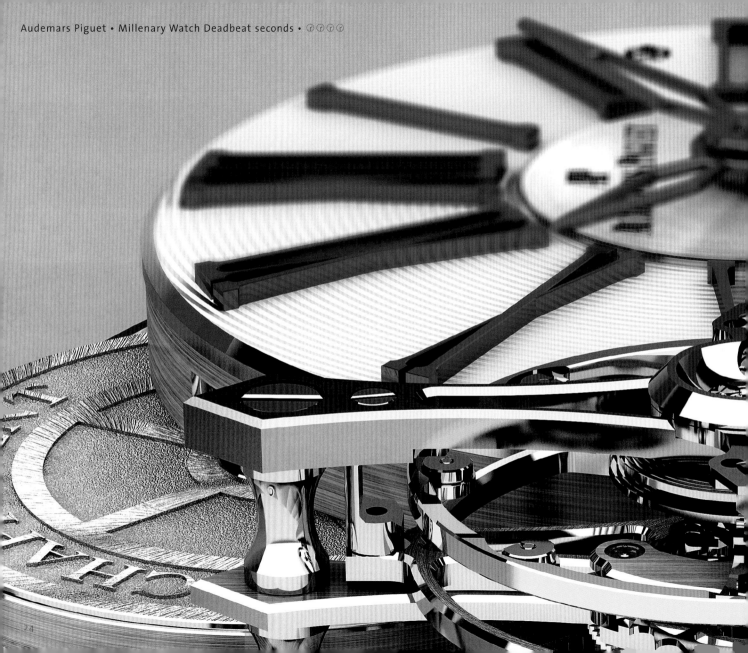

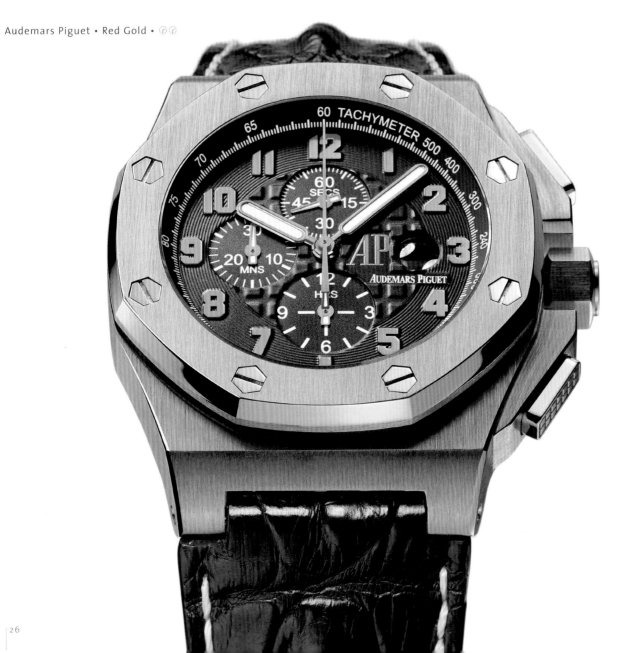

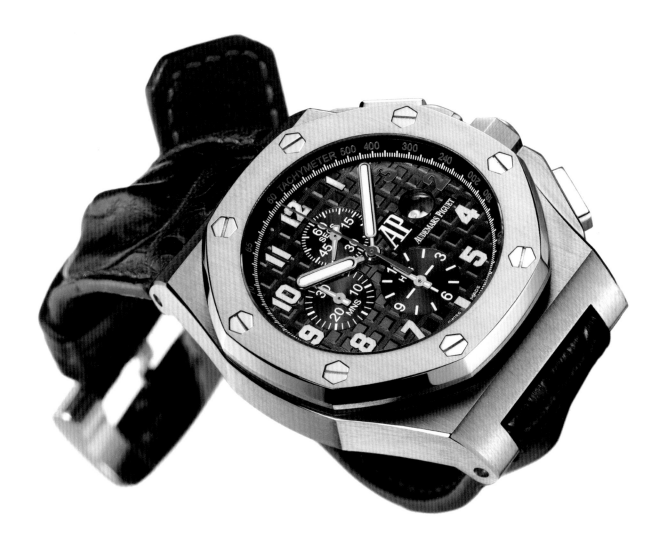

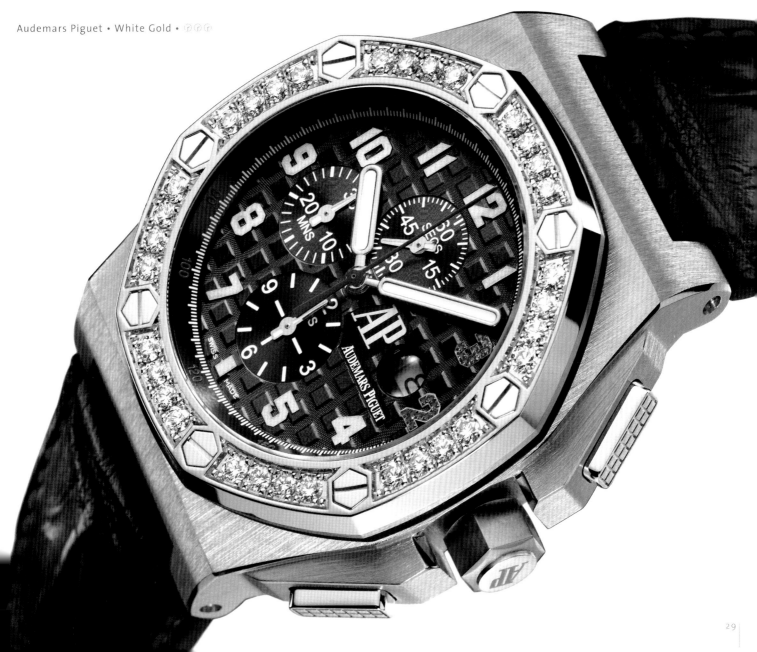

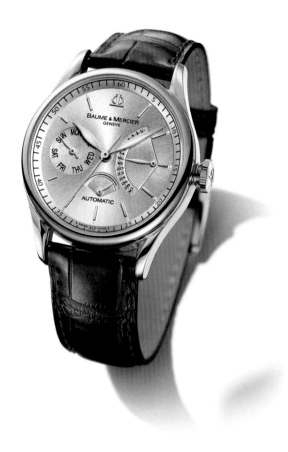
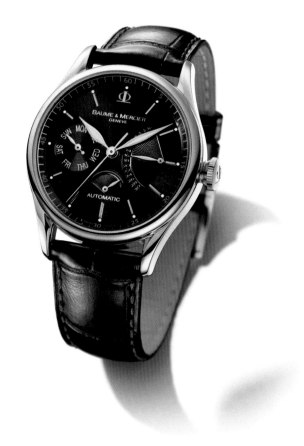

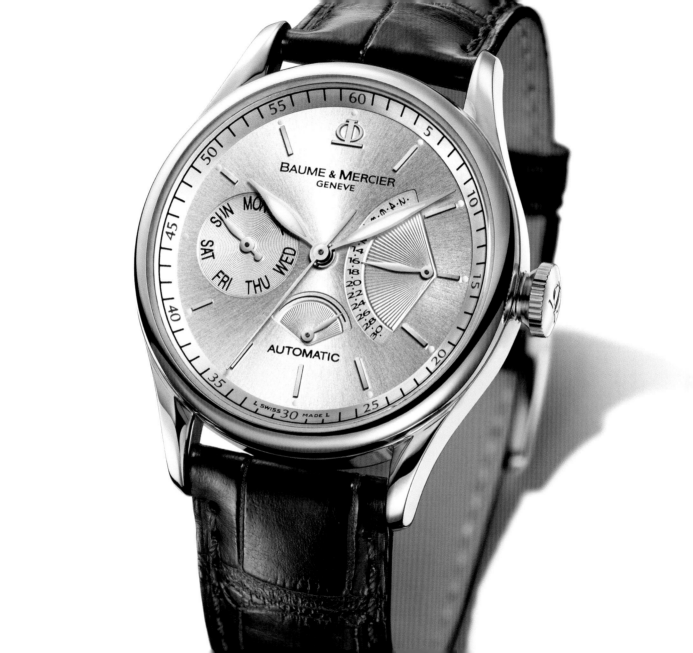

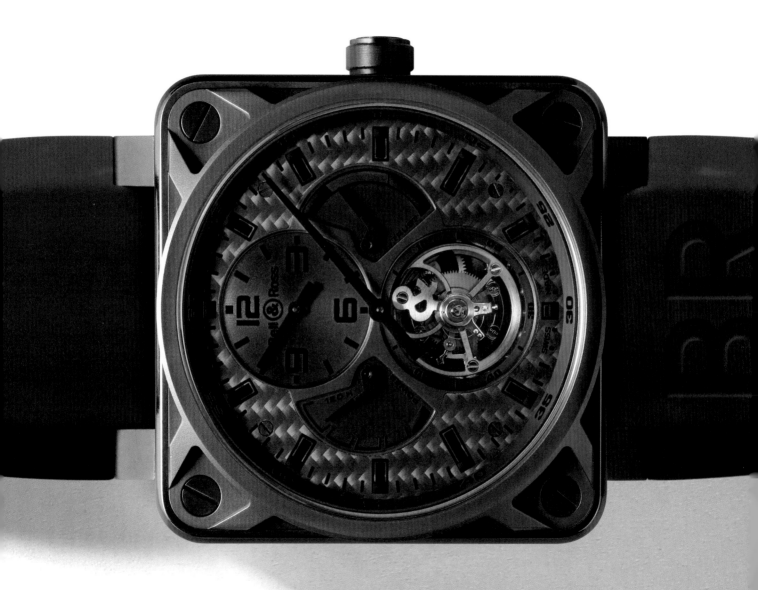

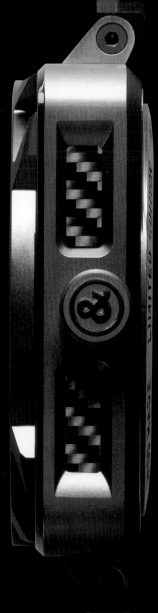

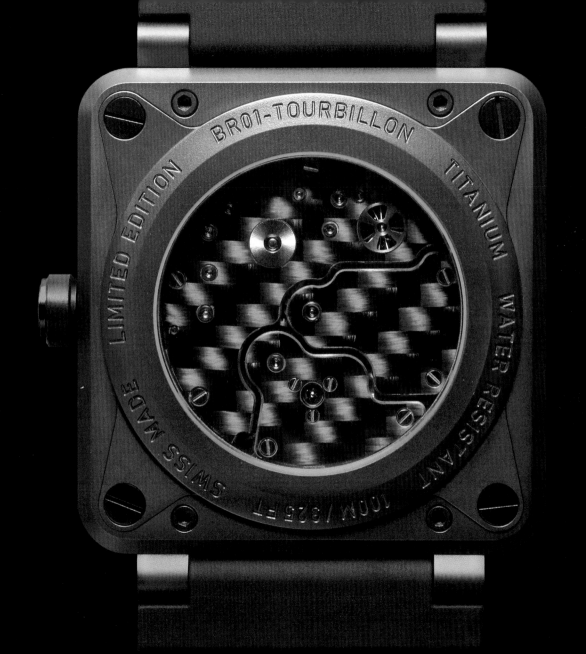

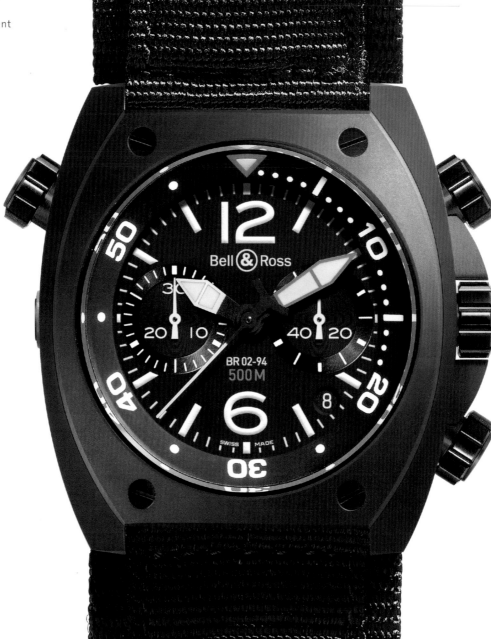

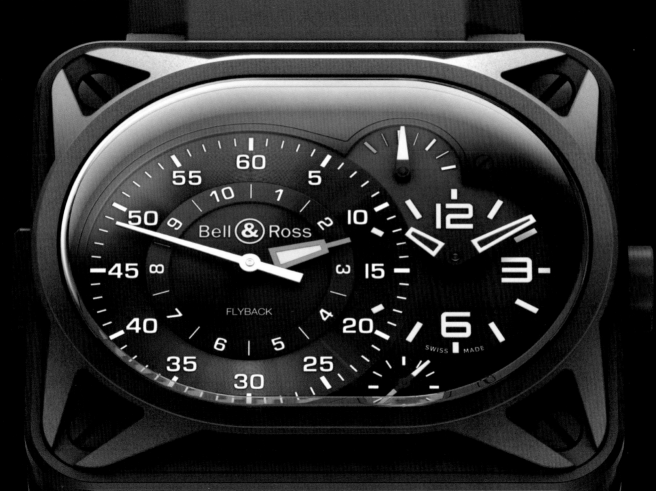

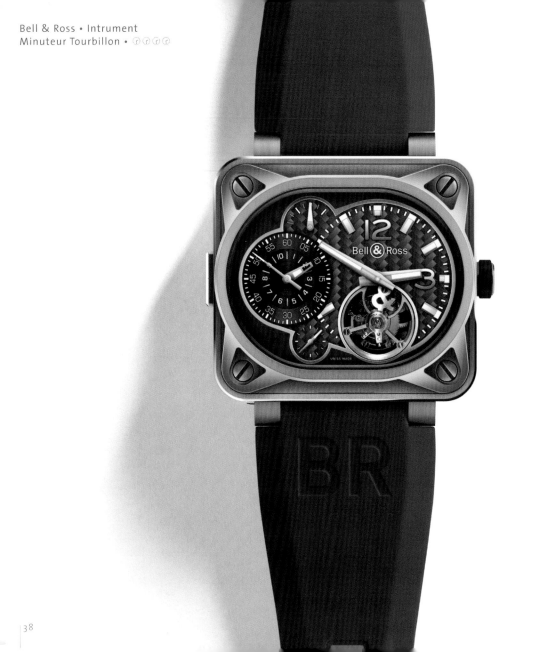

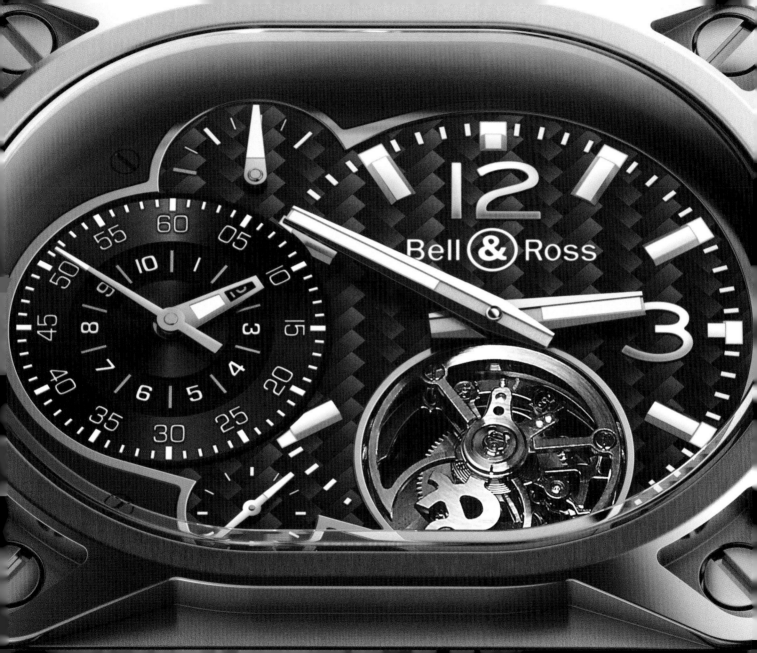

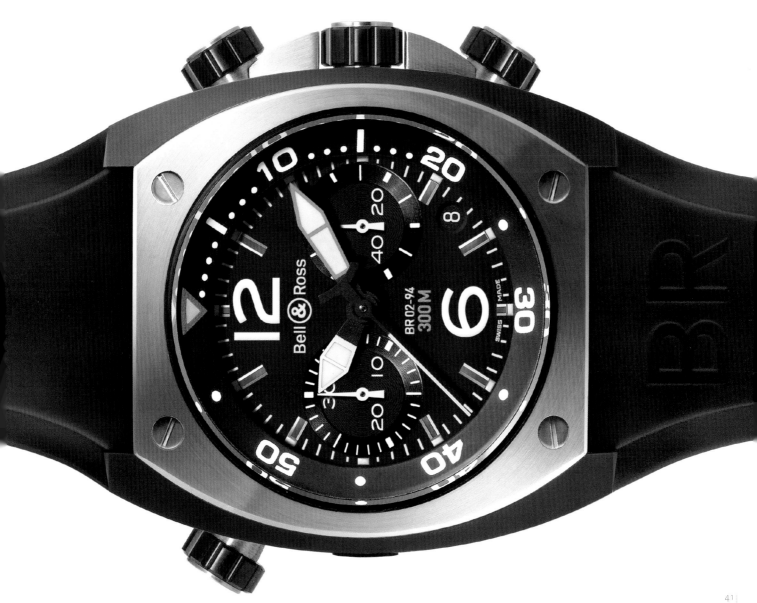

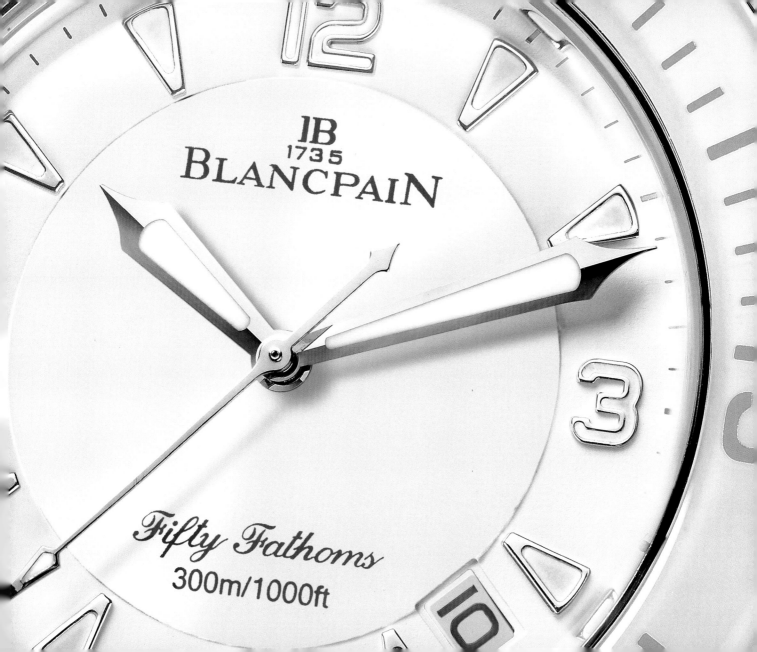

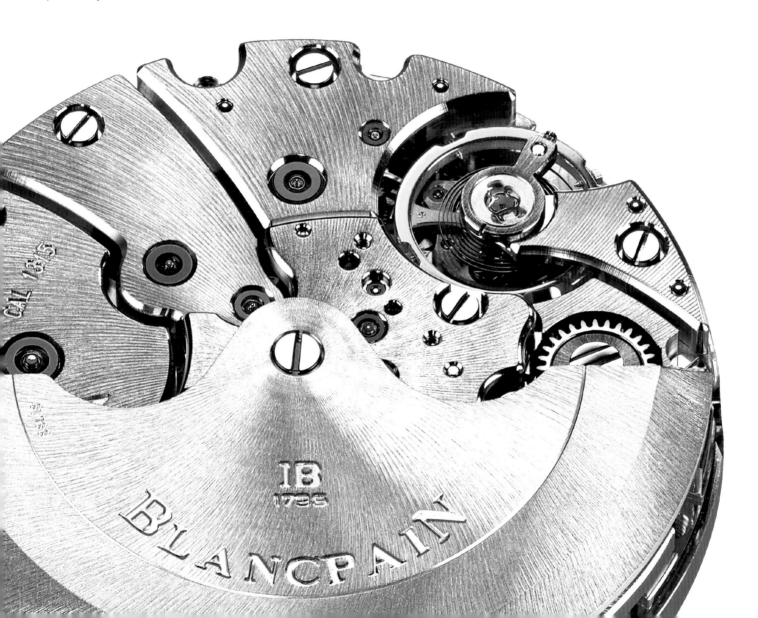

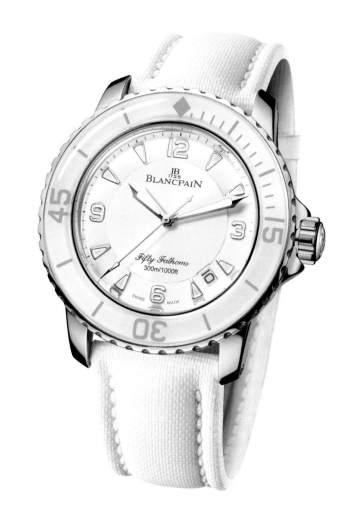

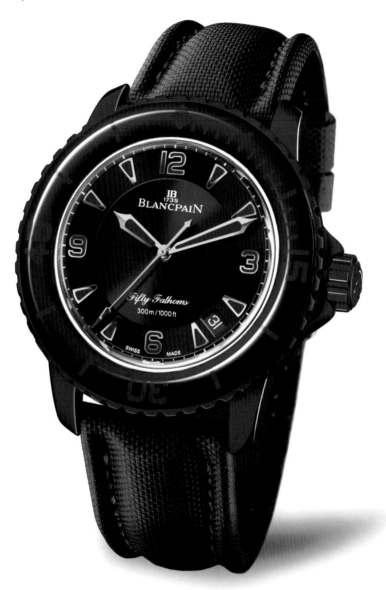

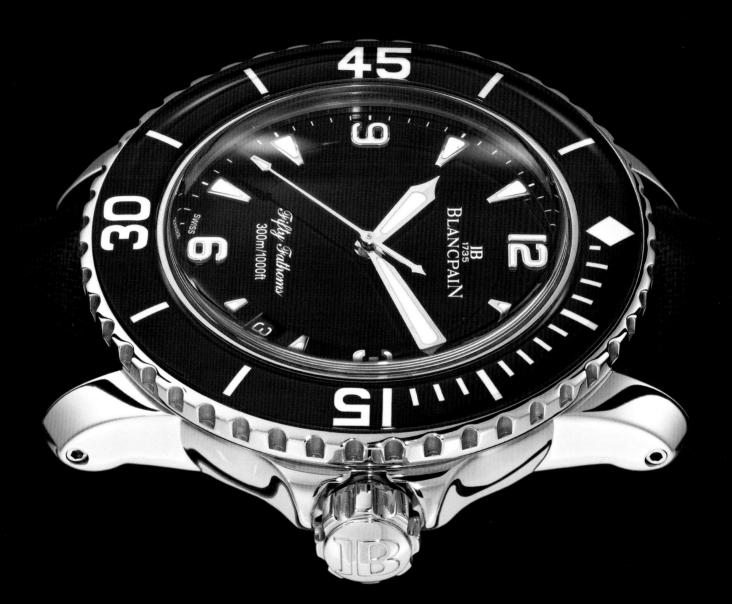

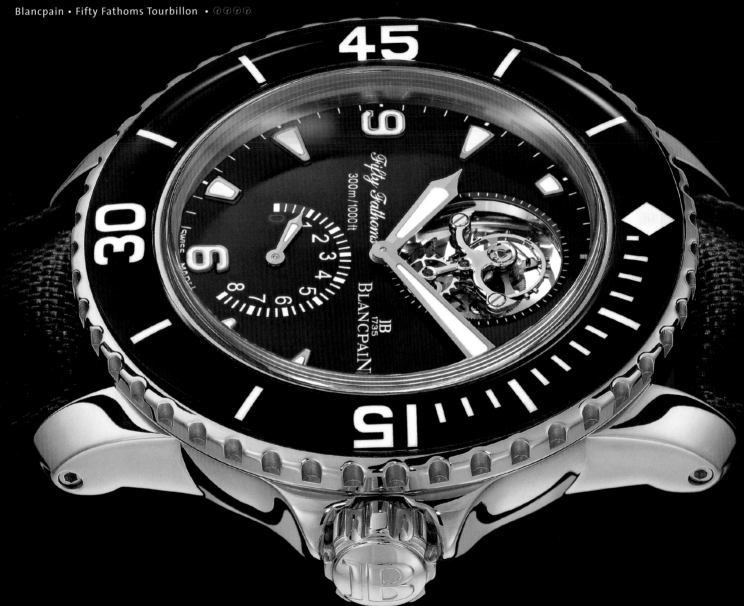

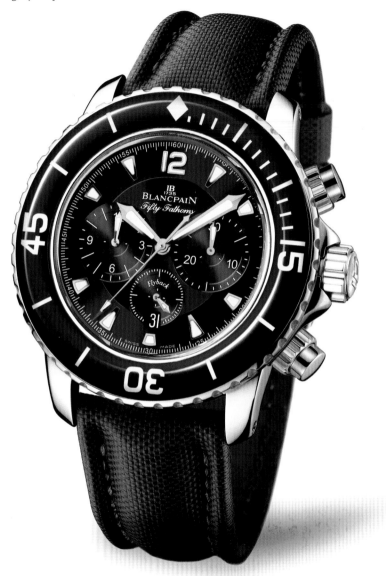

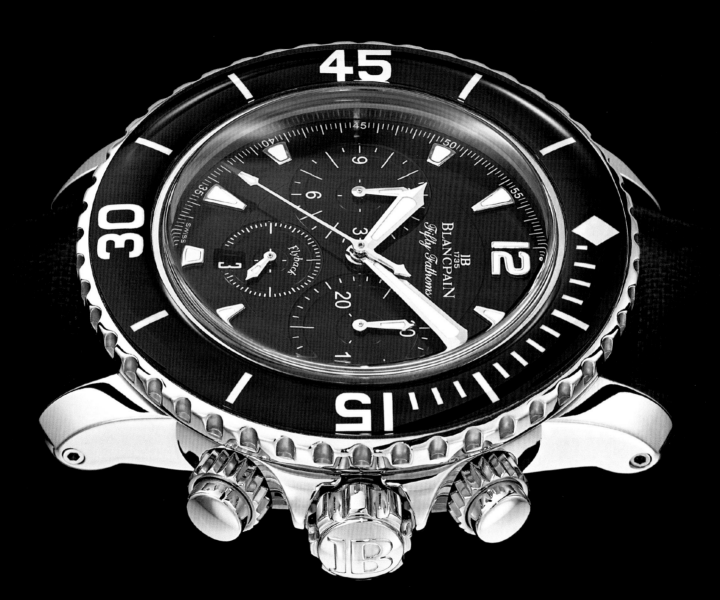

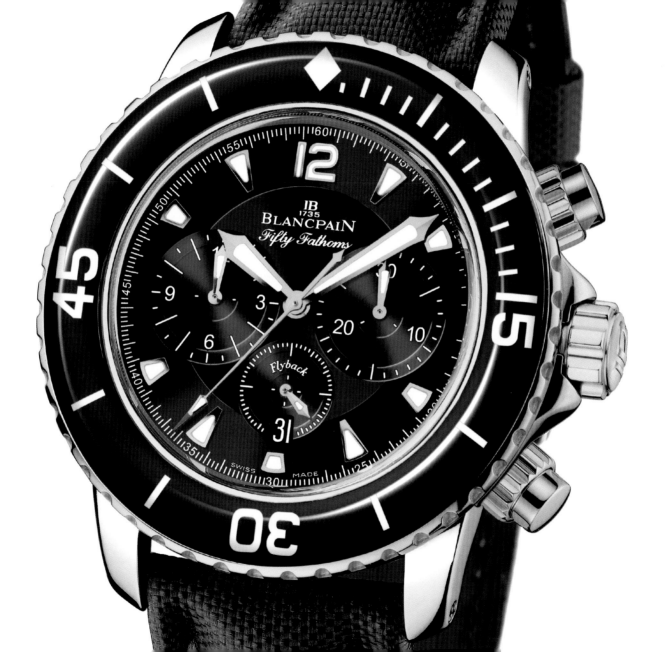

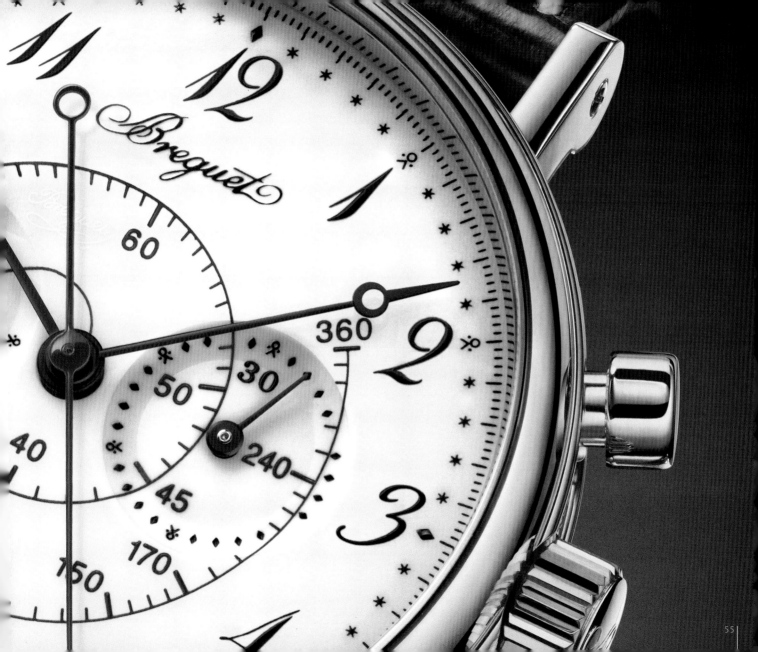

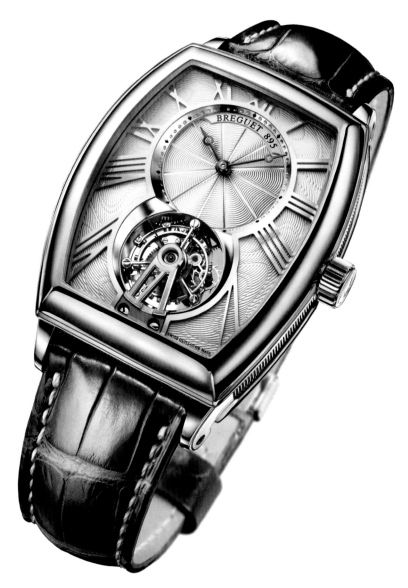

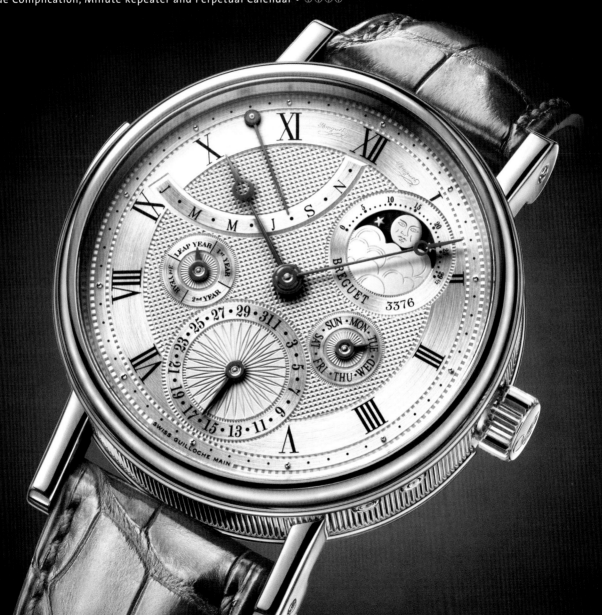

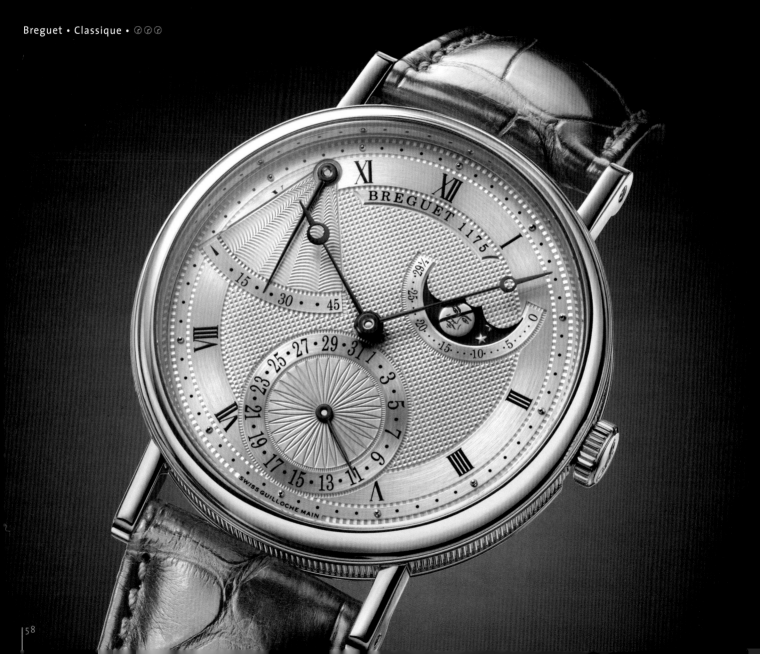

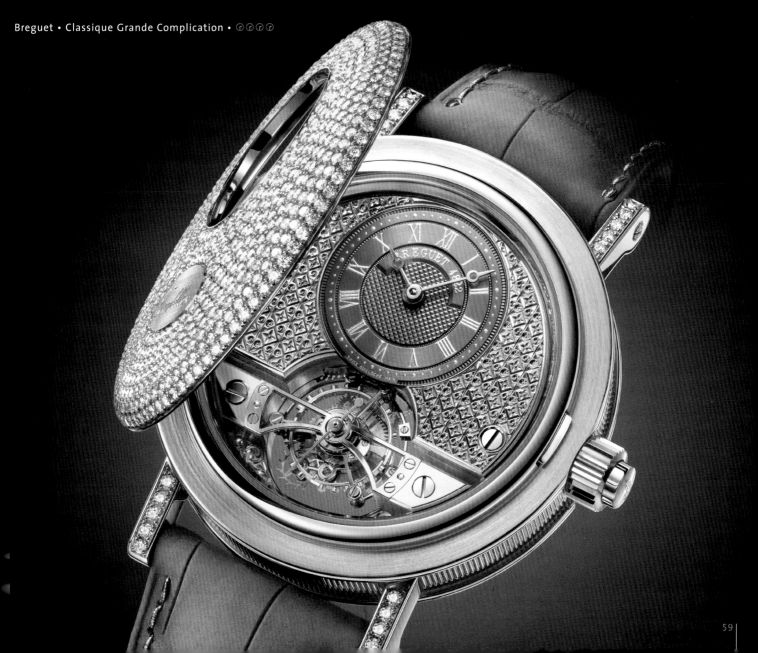

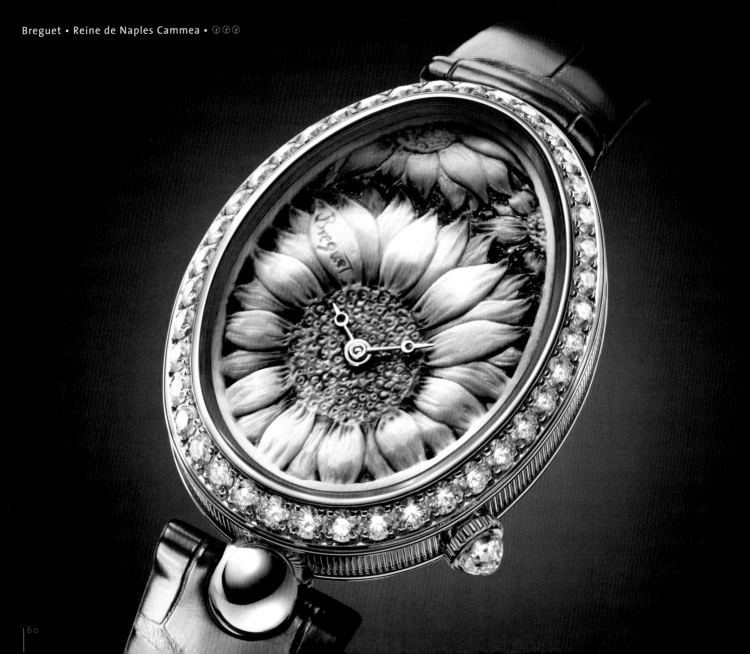

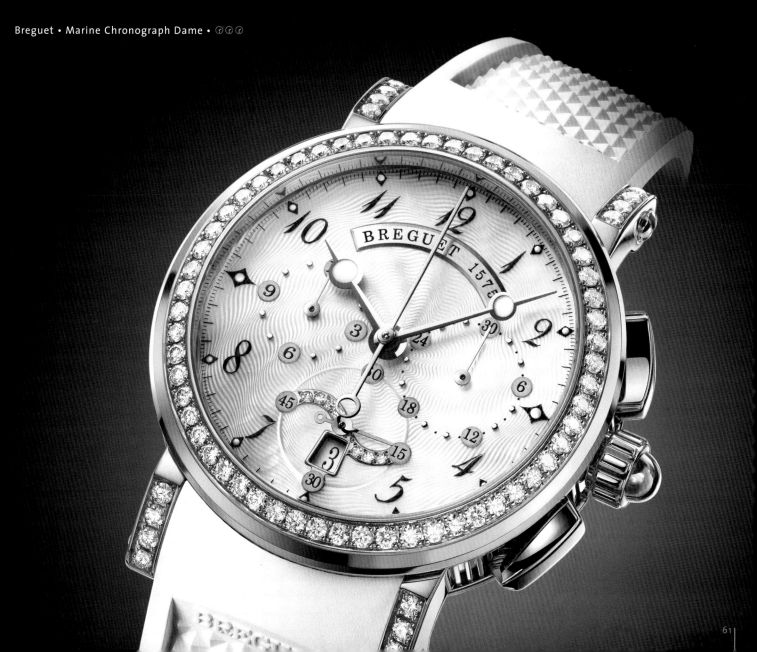

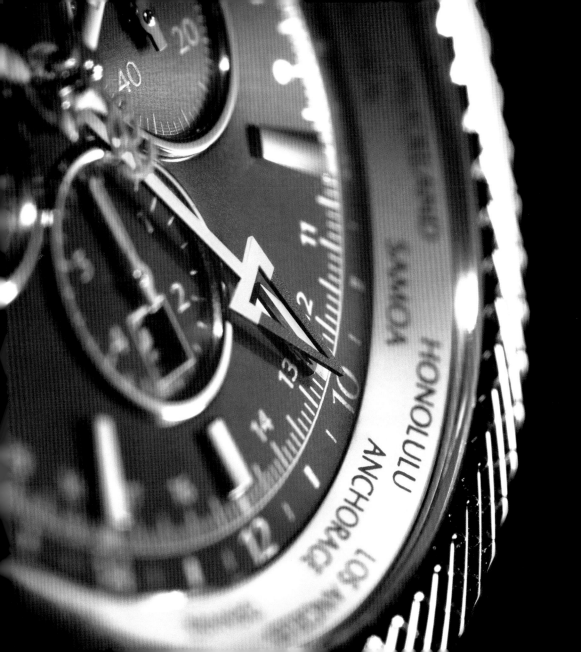

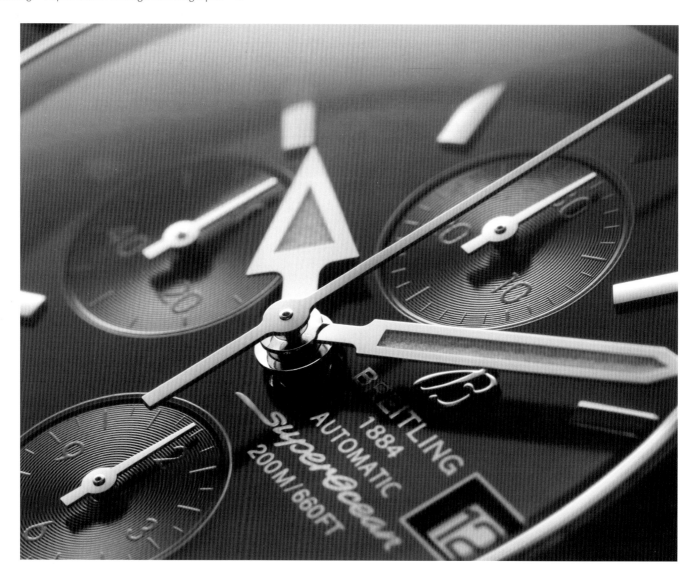

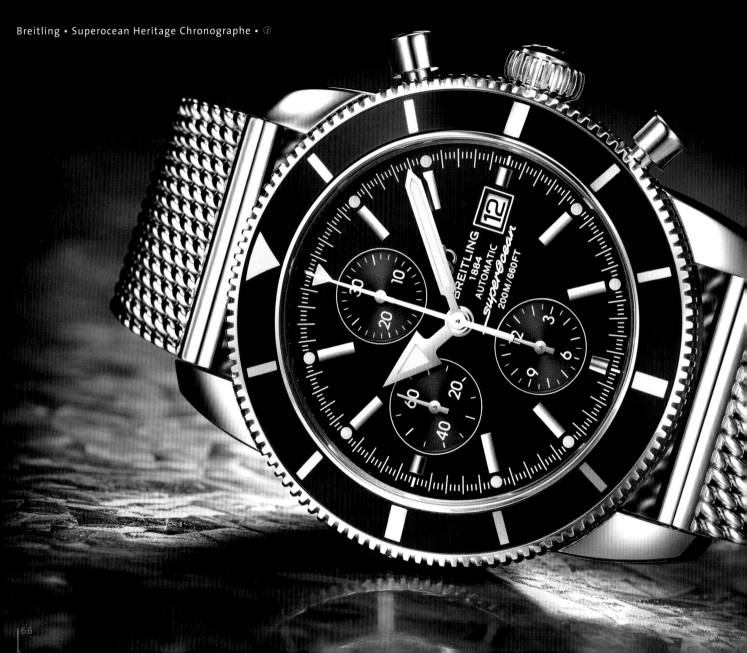

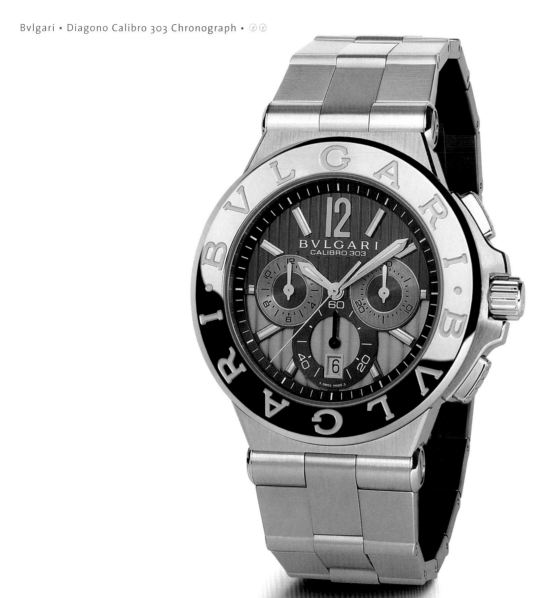

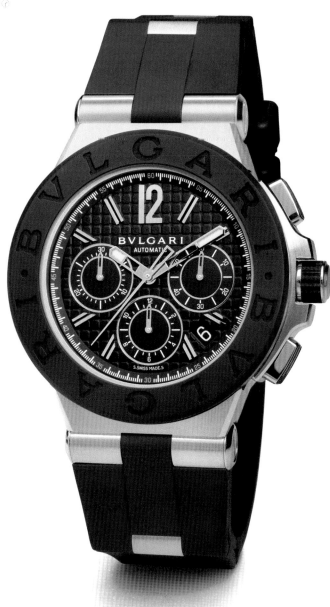

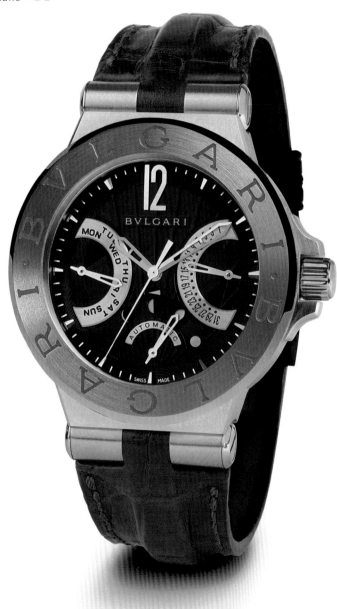

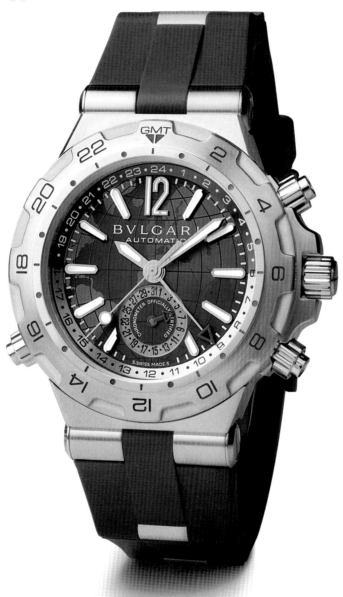

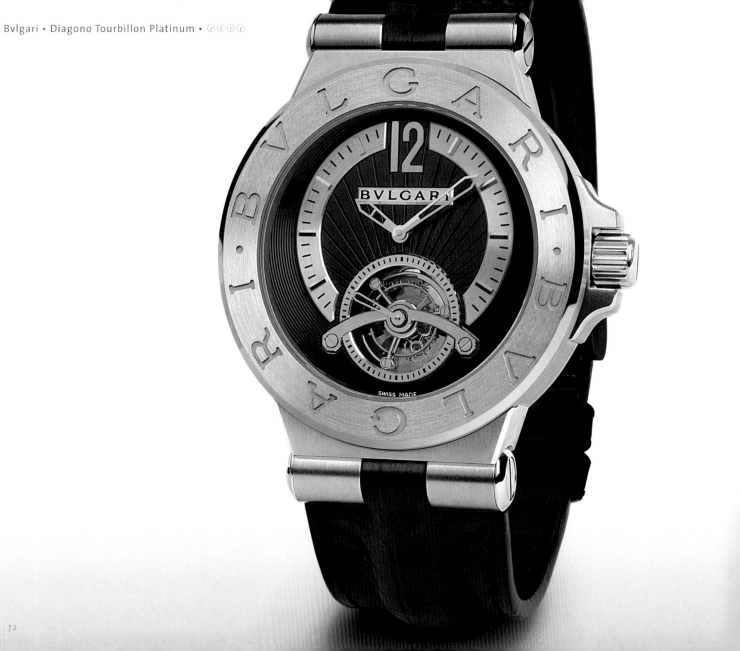

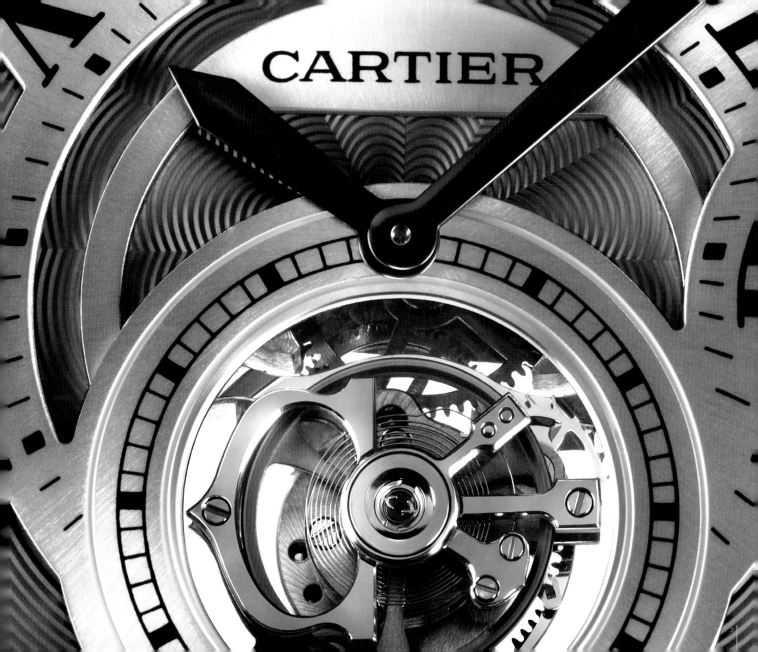

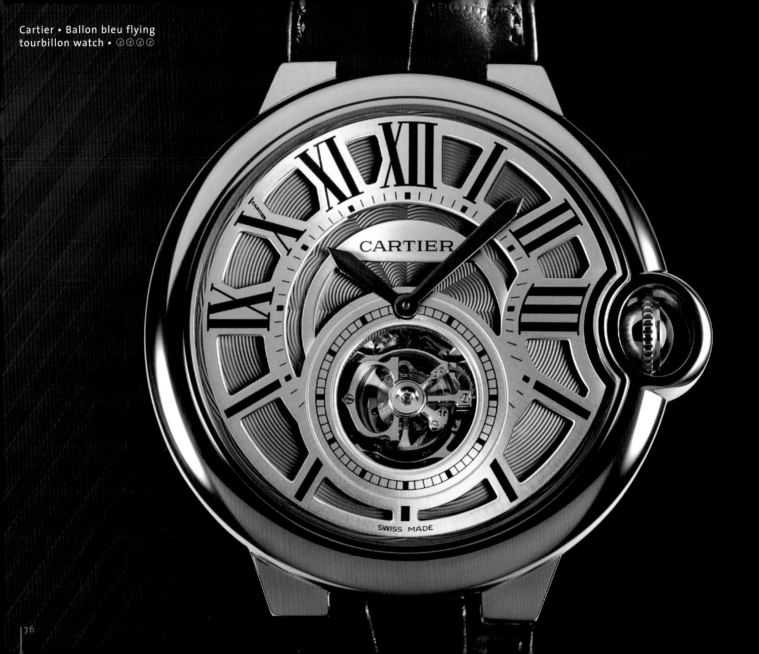

Cartier • Ballon bleu, large model, pink gold • ⓟ ⓡ

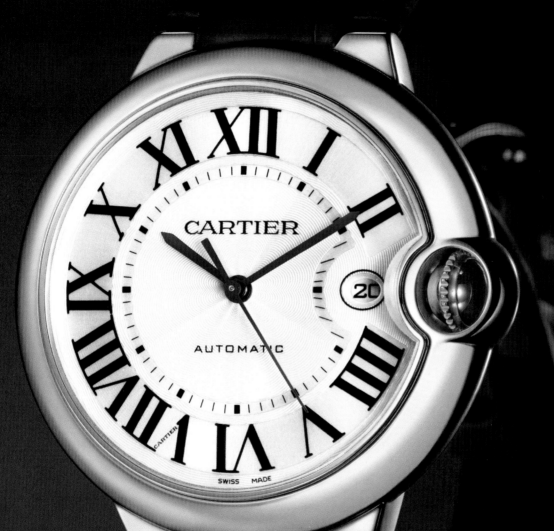

Cartier • Noeud watch, from the Cartier Libre collection • ⓕ ⓕ ⓕ

80

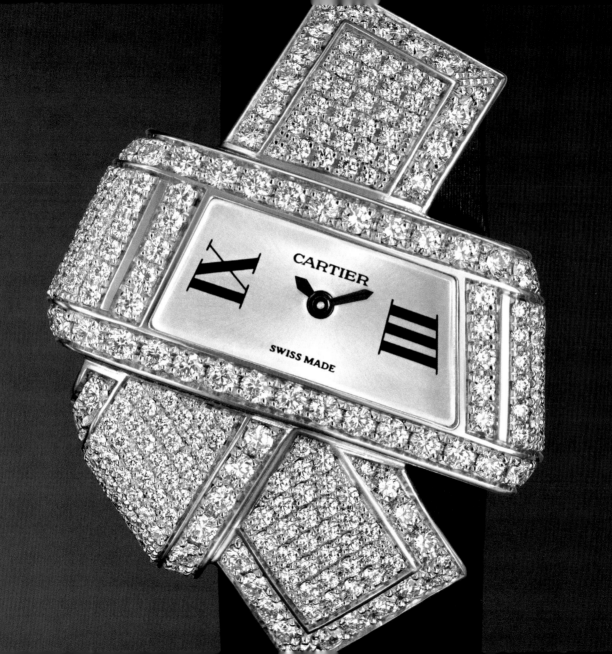

CARTIER

AUTOMATIC

L SWISS MADE L

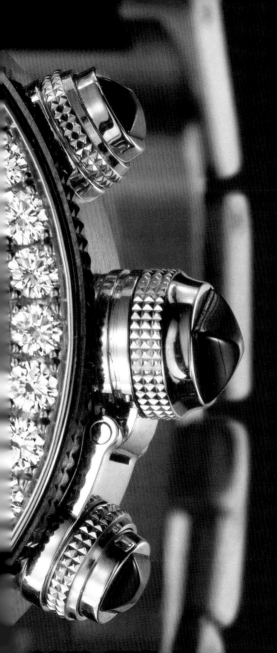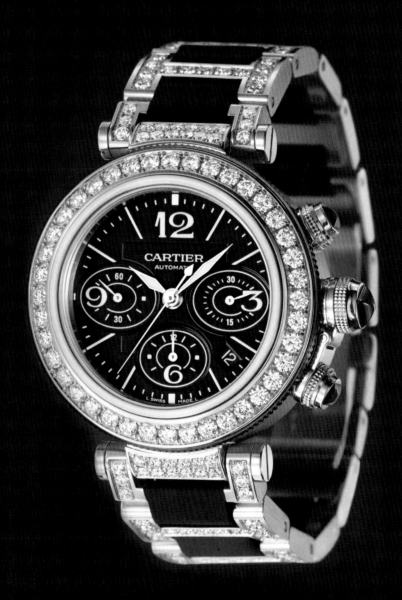

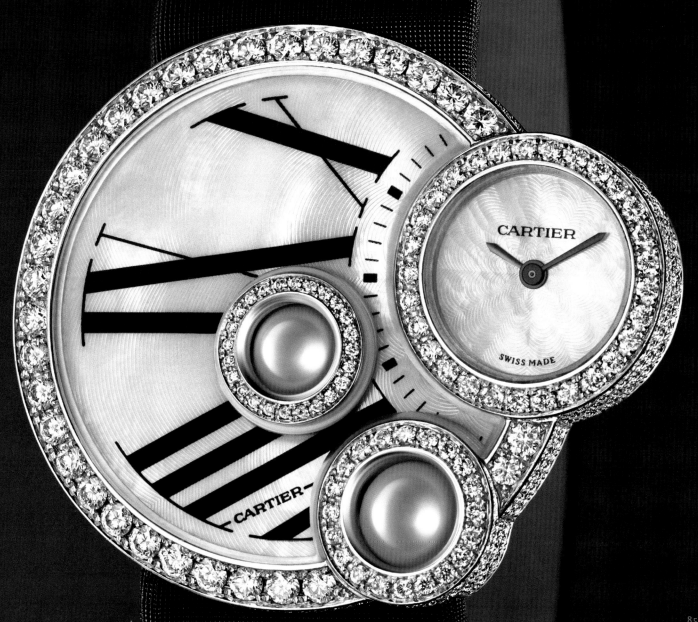

Cartier • Santos, pink gold and matt black • ⓕⓕ

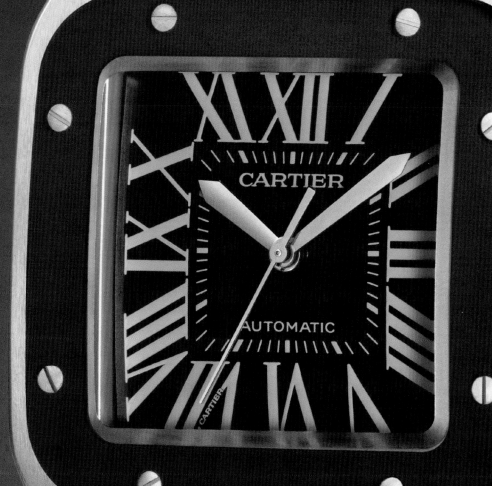

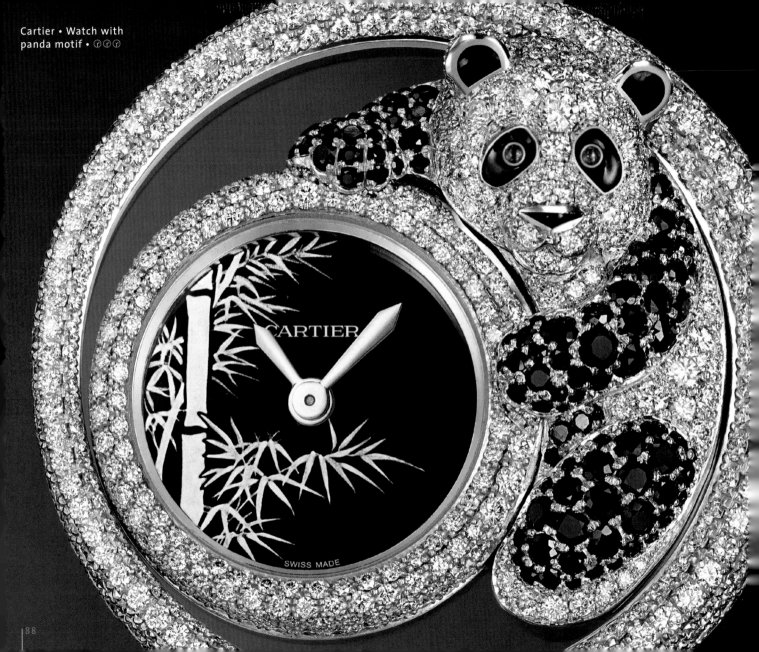

CARTIER

SWISS MADE

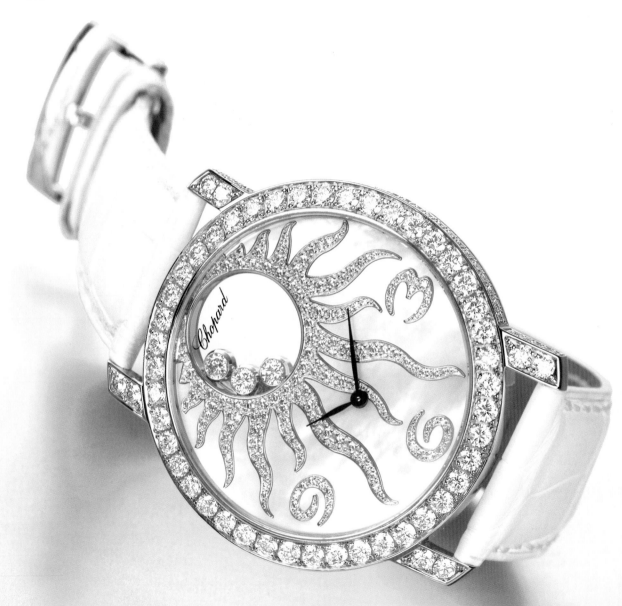

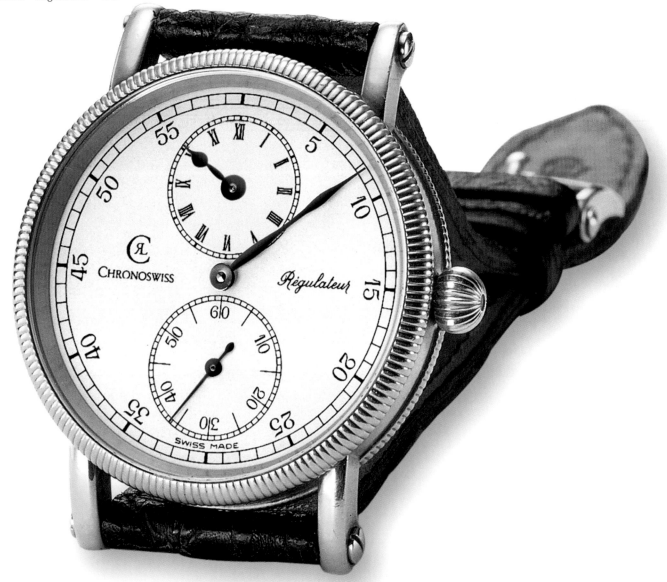

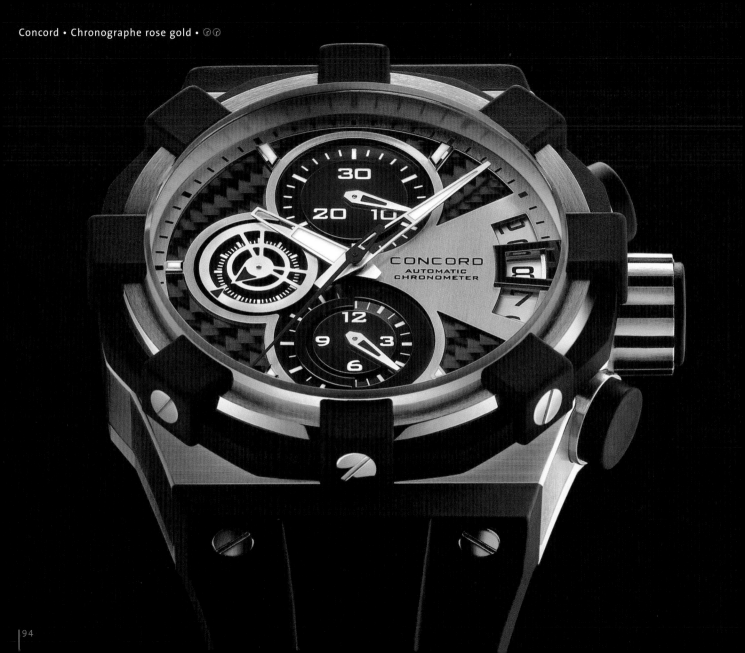

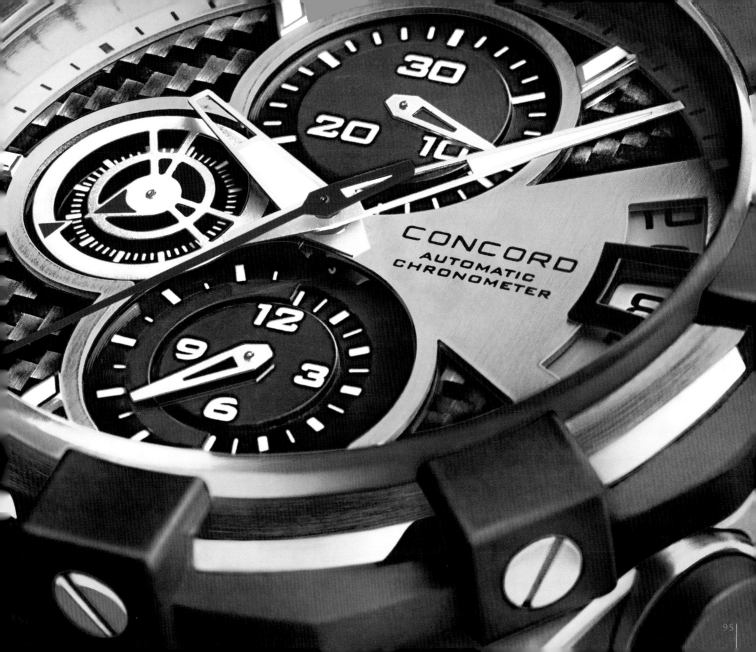

CONCORD
AUTOMATIC
CHRONOMETER

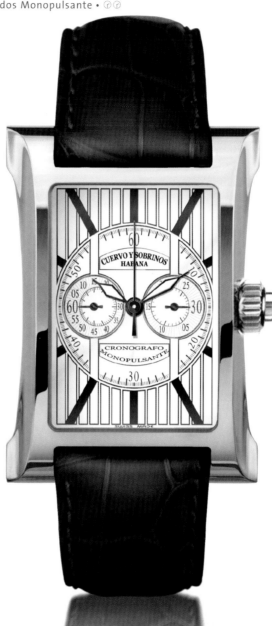

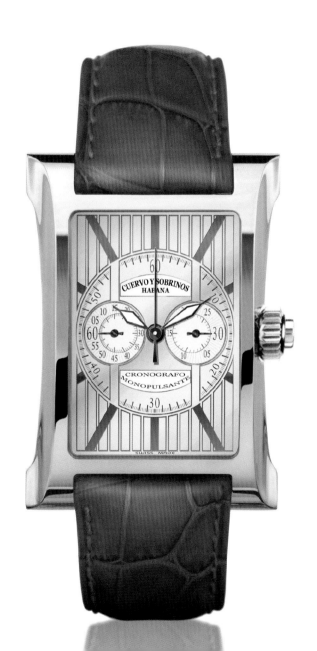

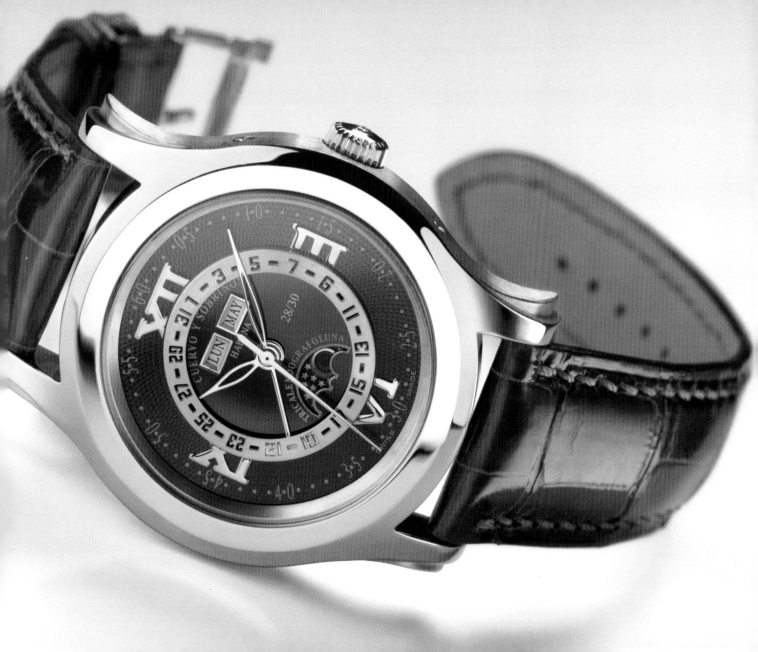

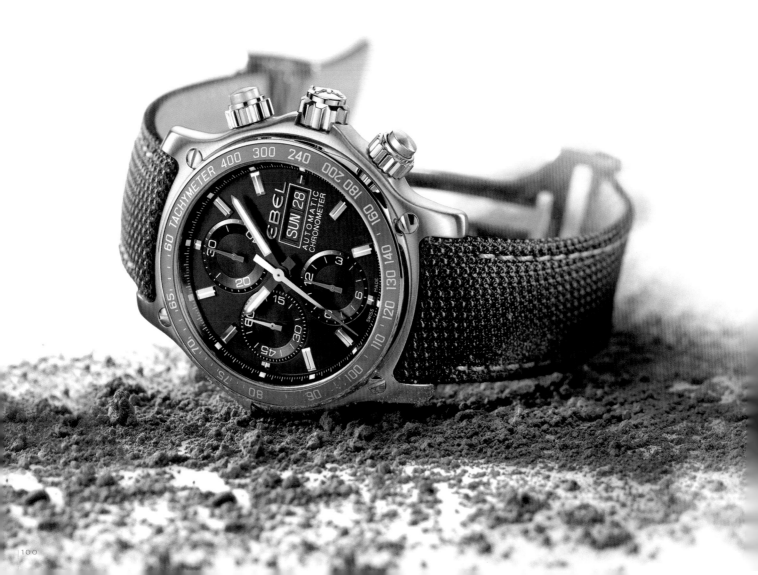

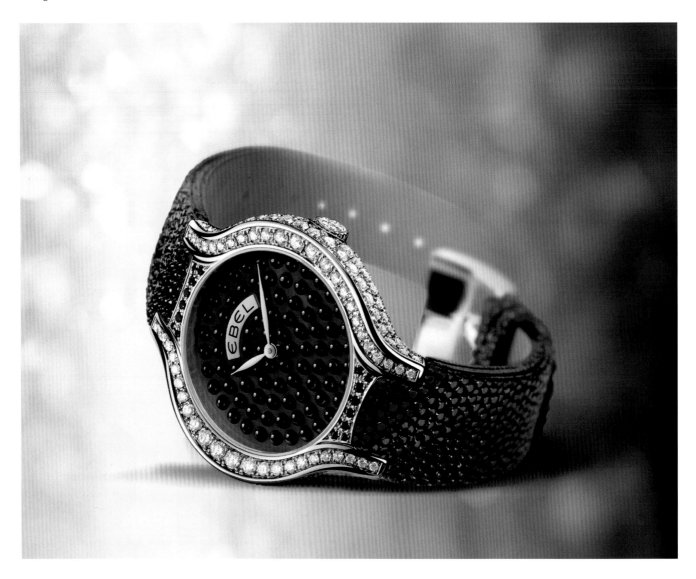

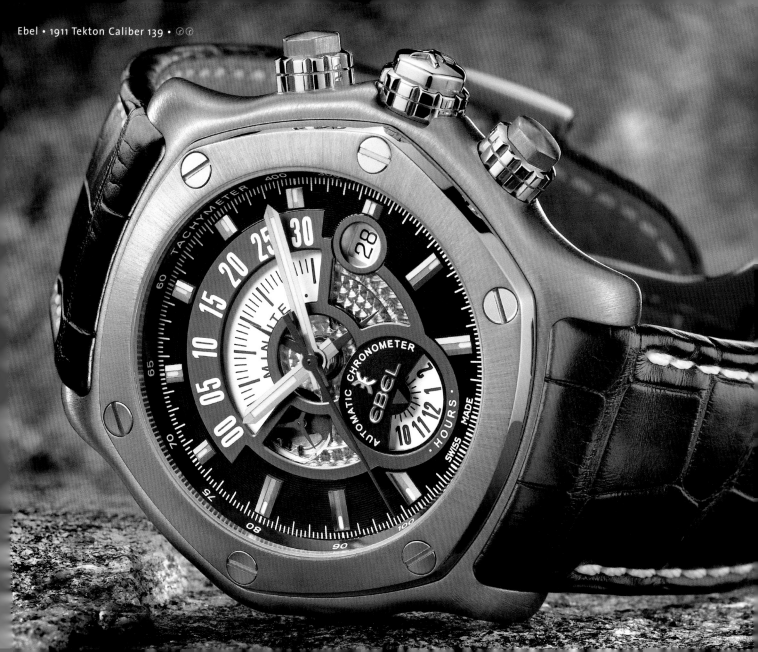

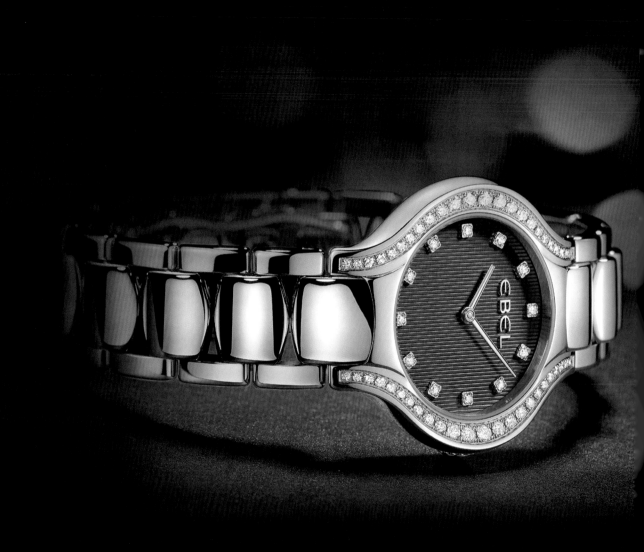

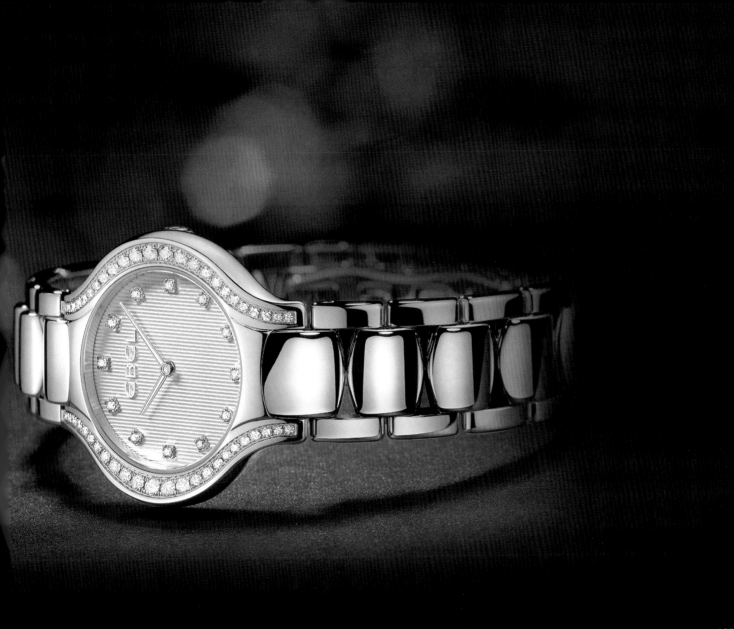

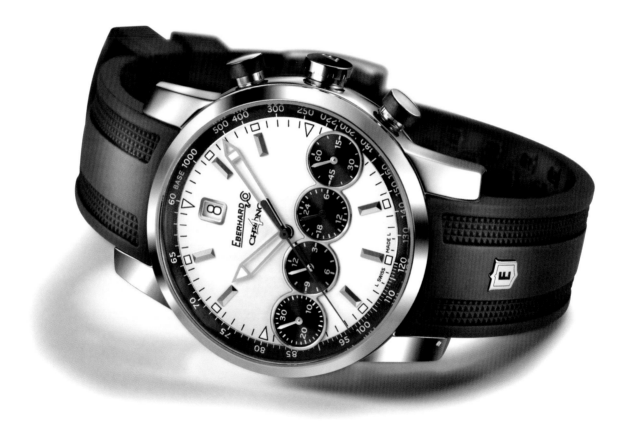

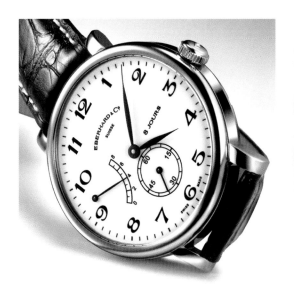

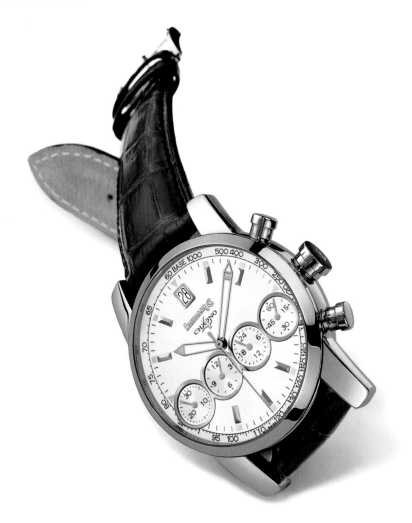

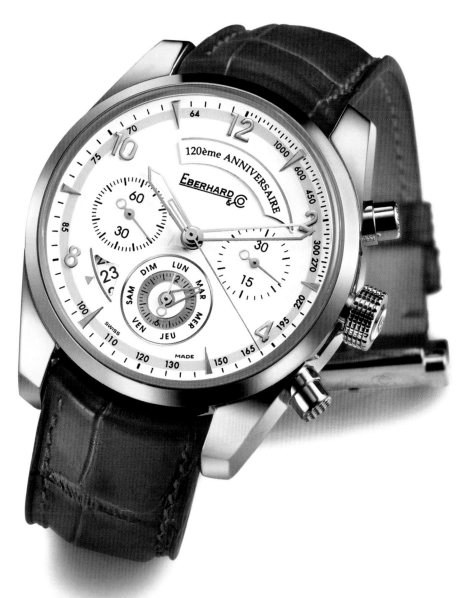

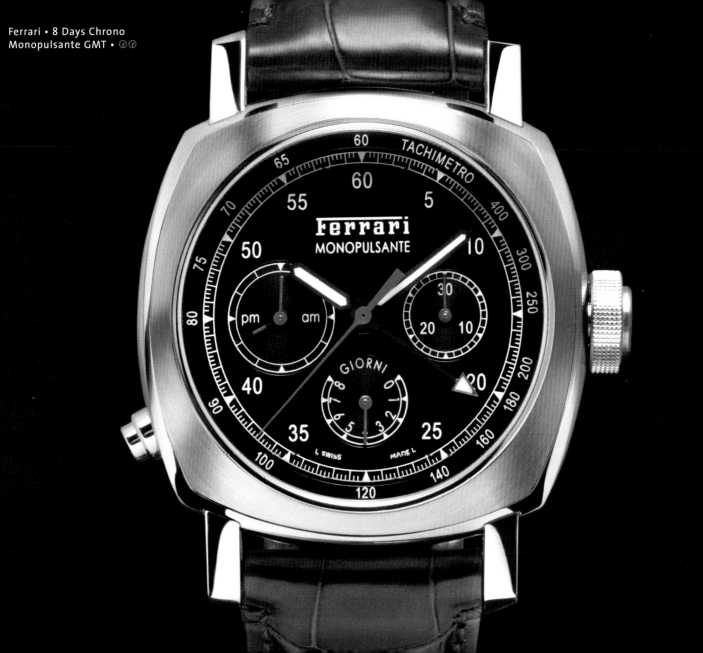

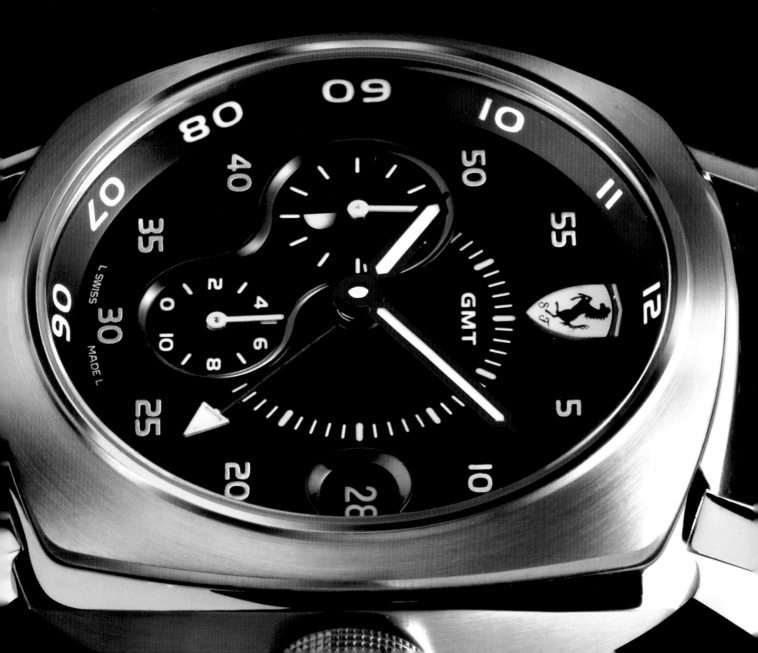

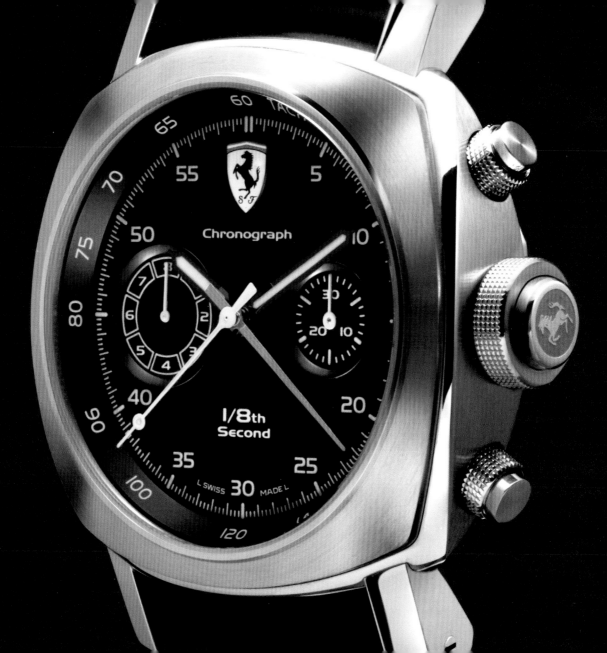

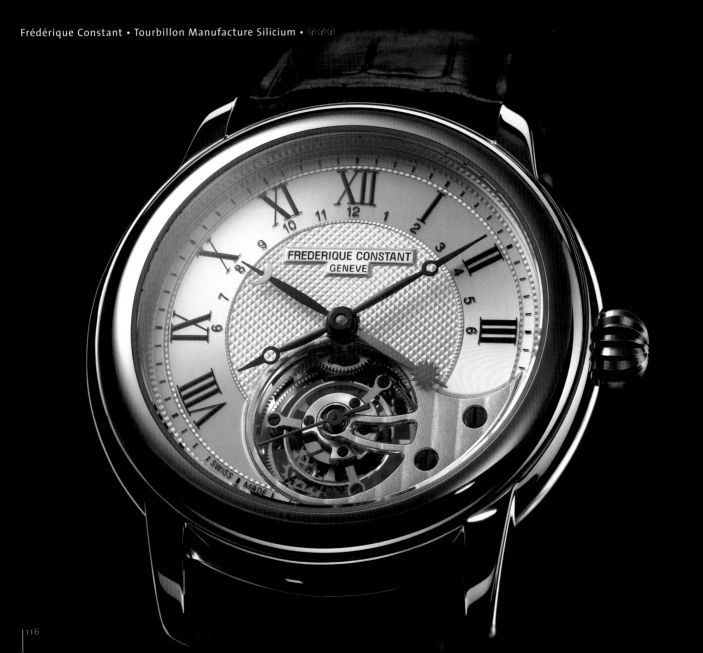

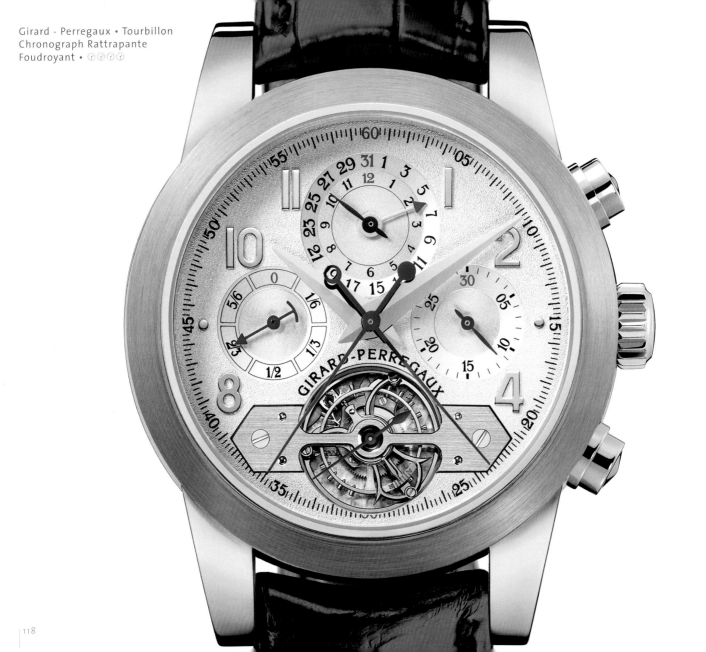

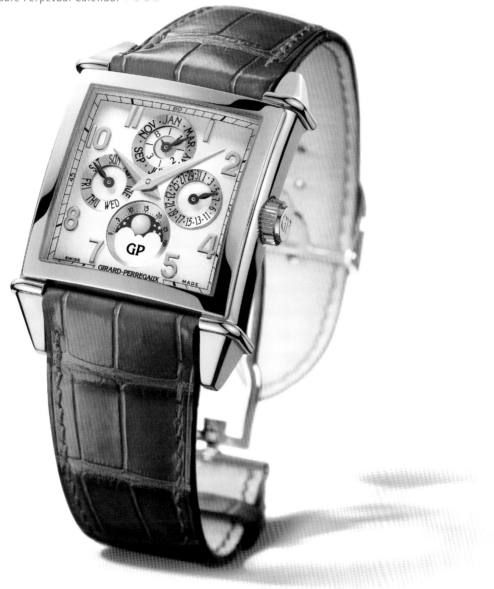

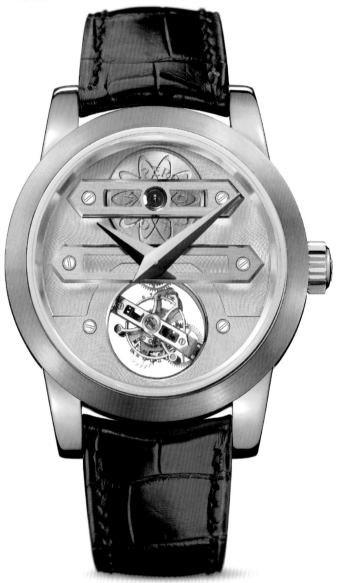

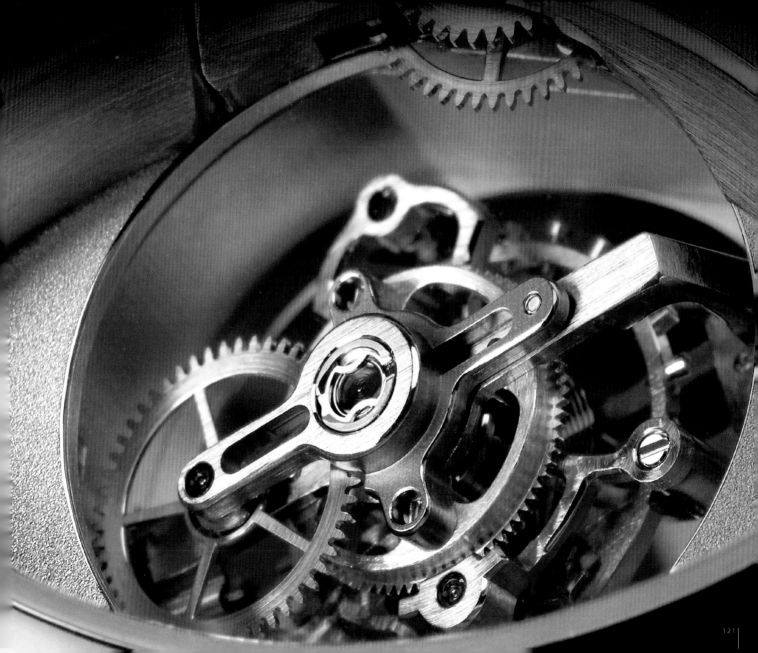

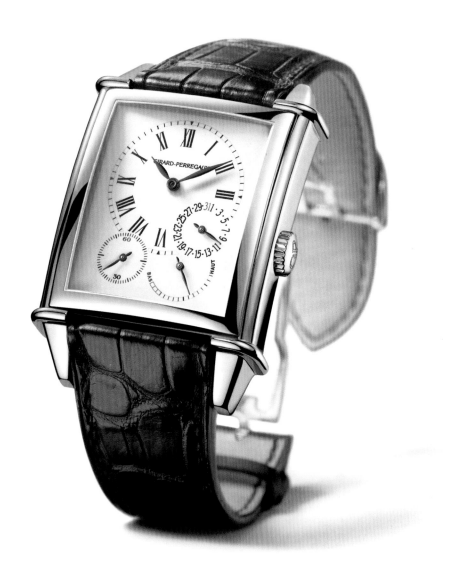

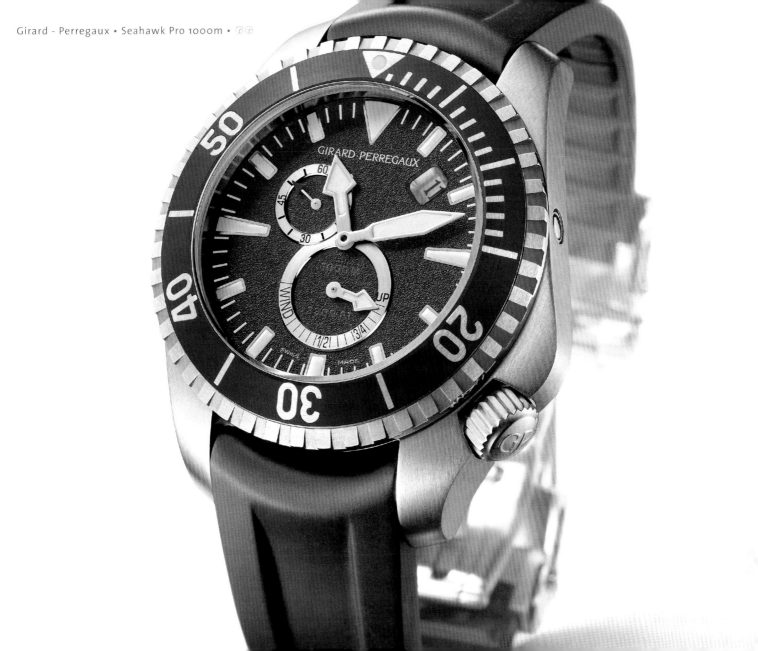

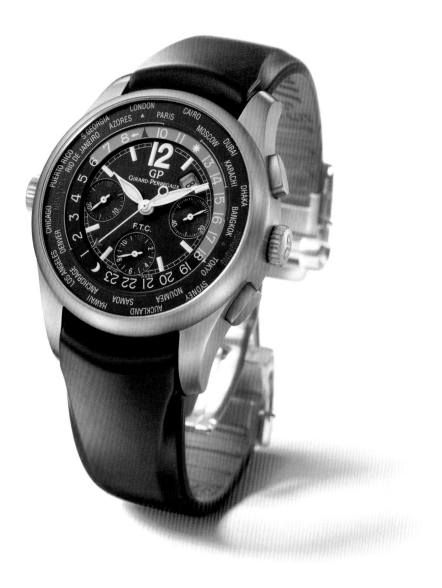

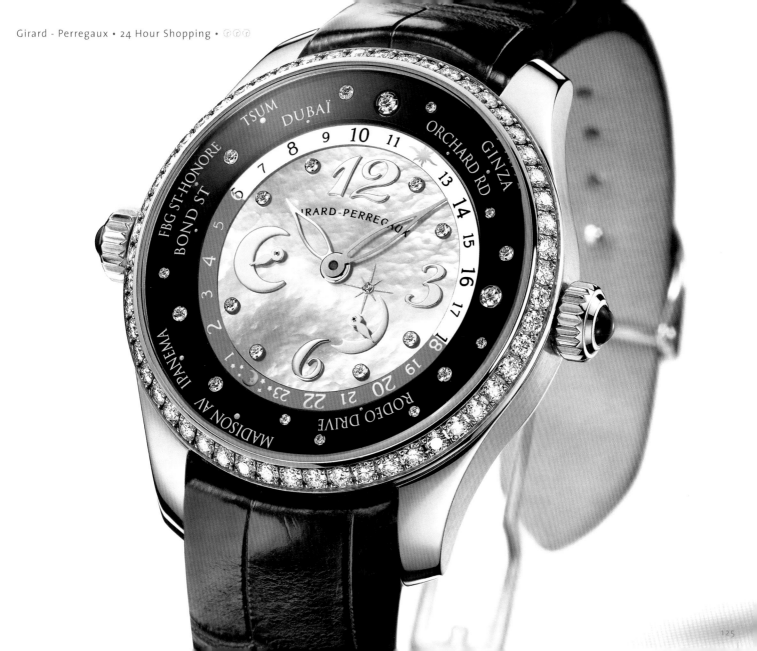

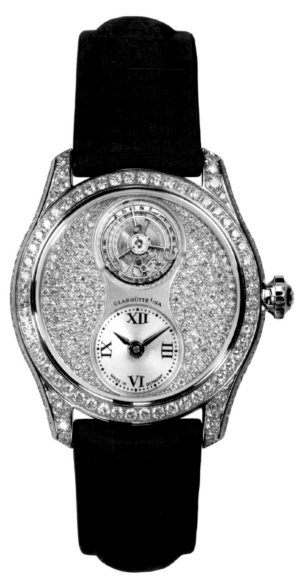

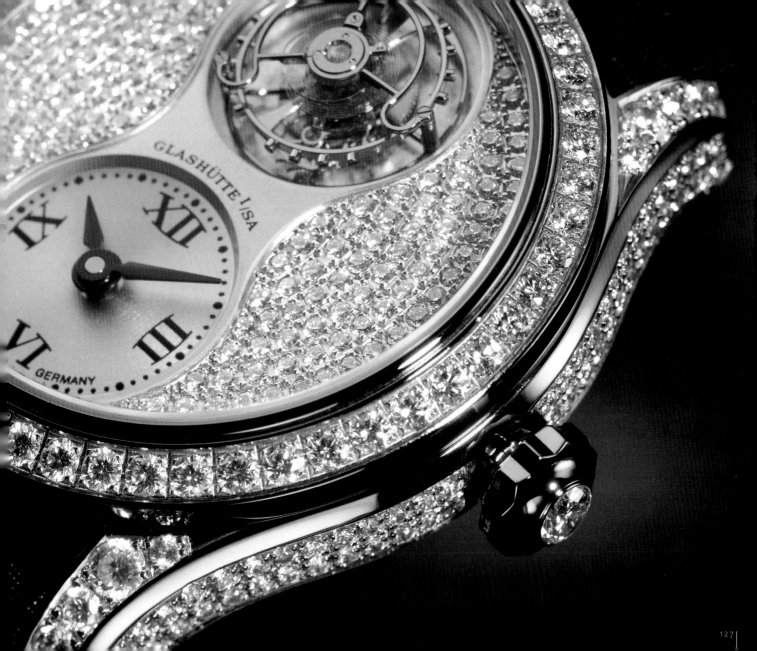

GLASHÜTTE I/SA

XII

IX

VI

III

GERMANY

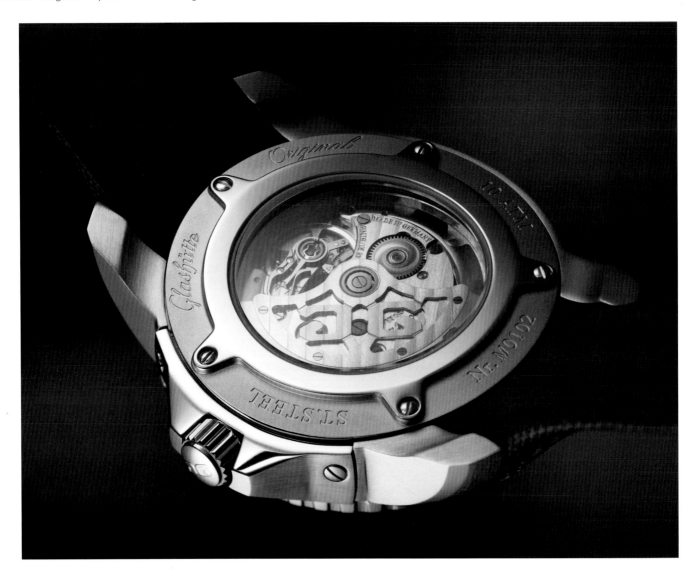

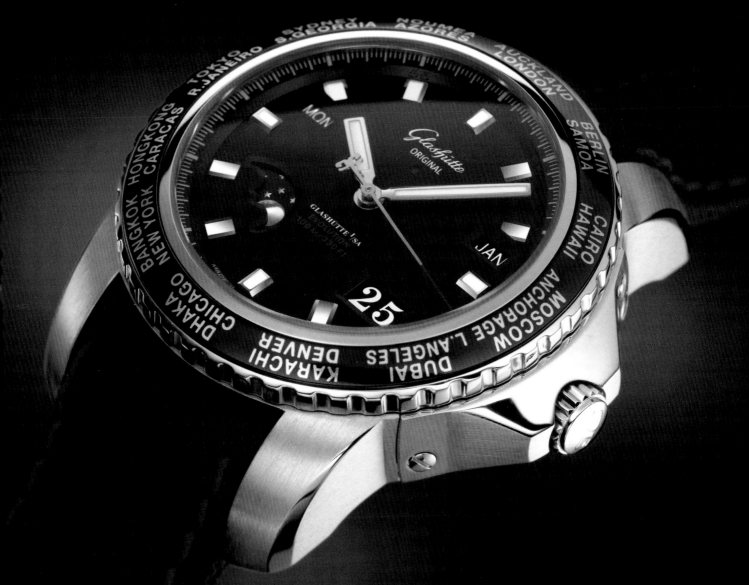

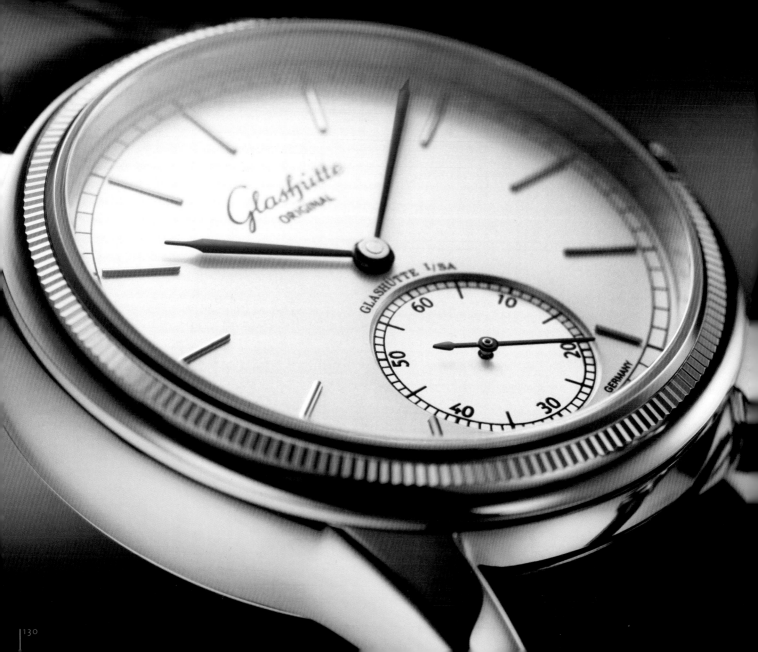

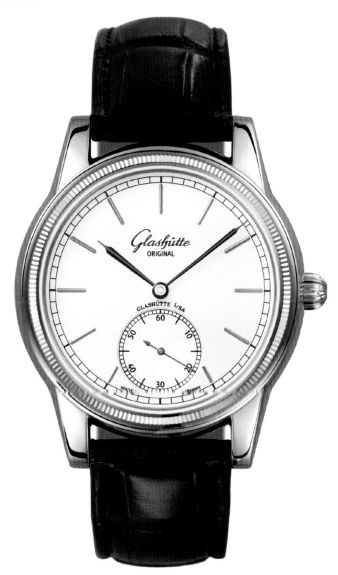

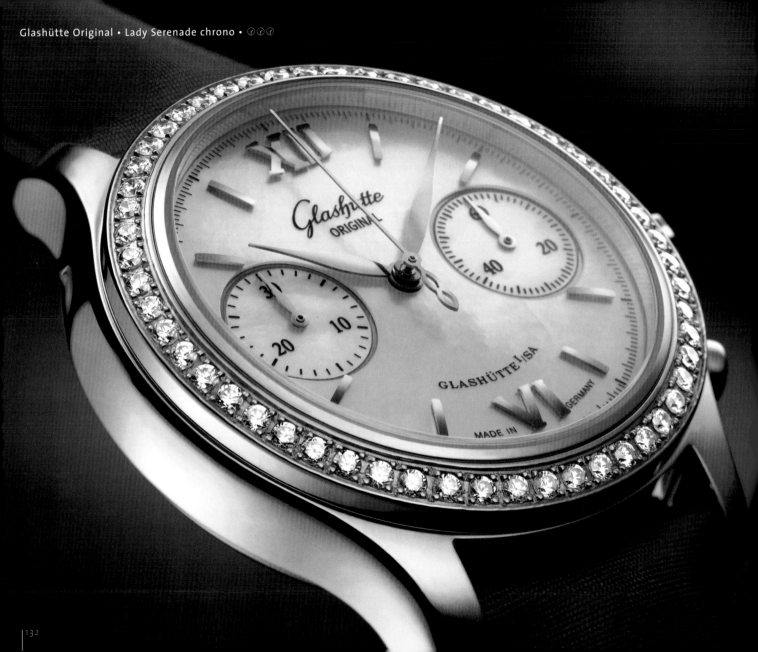

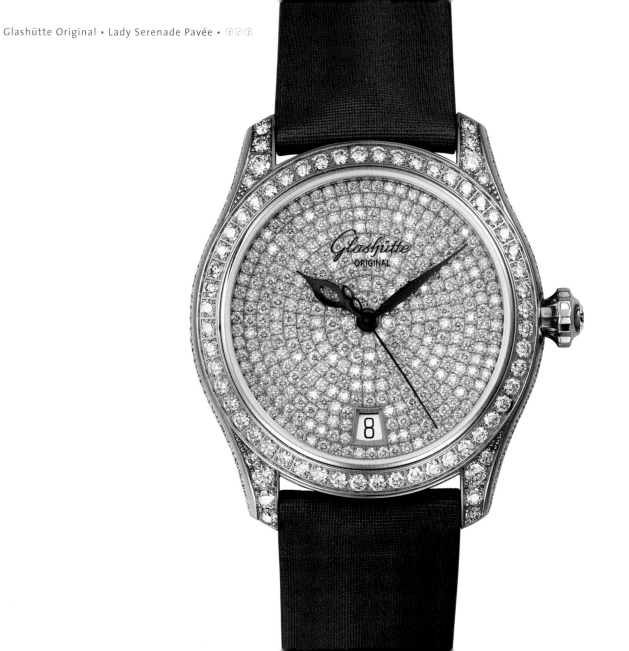

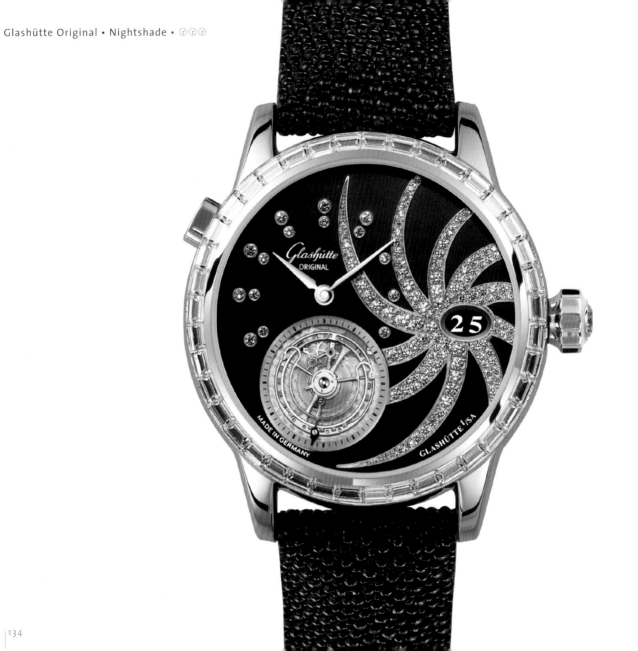

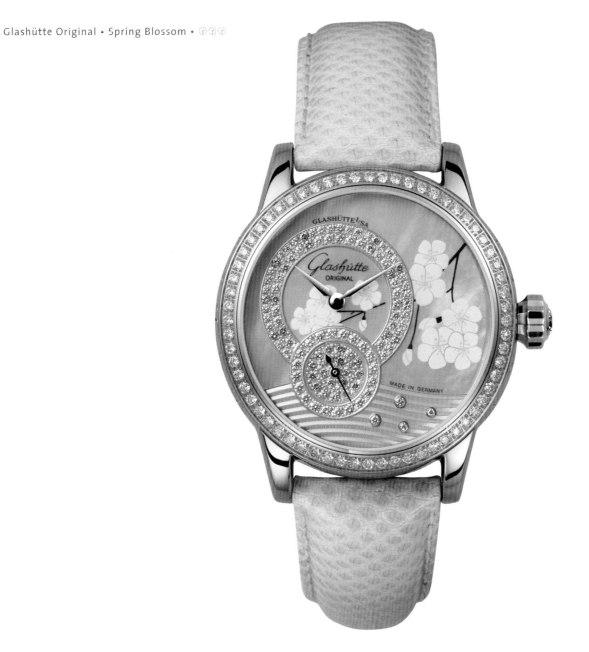

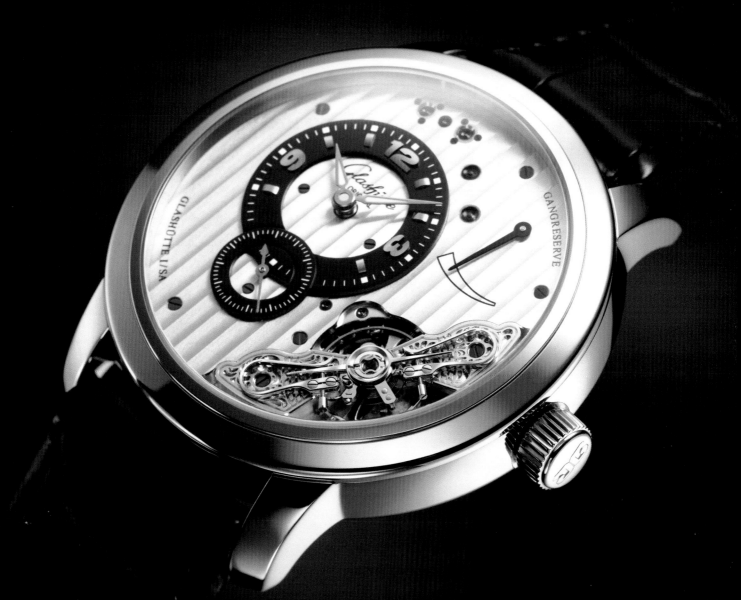

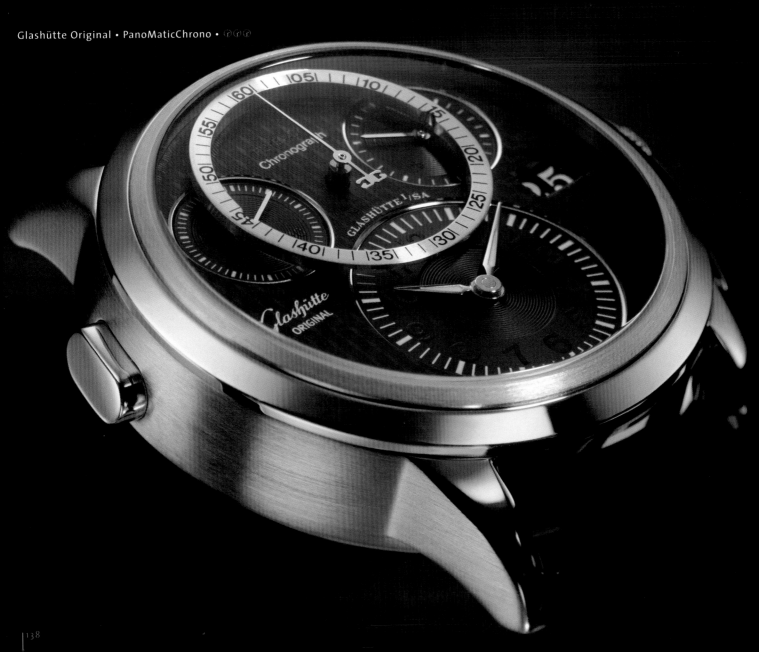

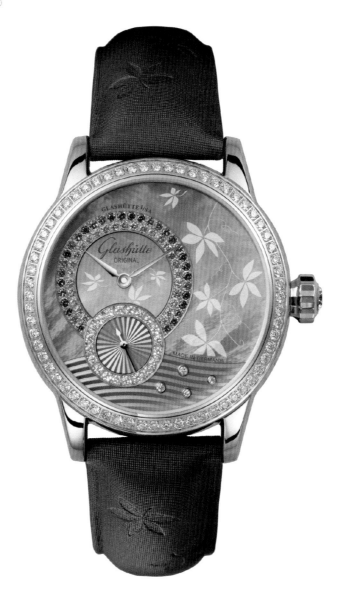

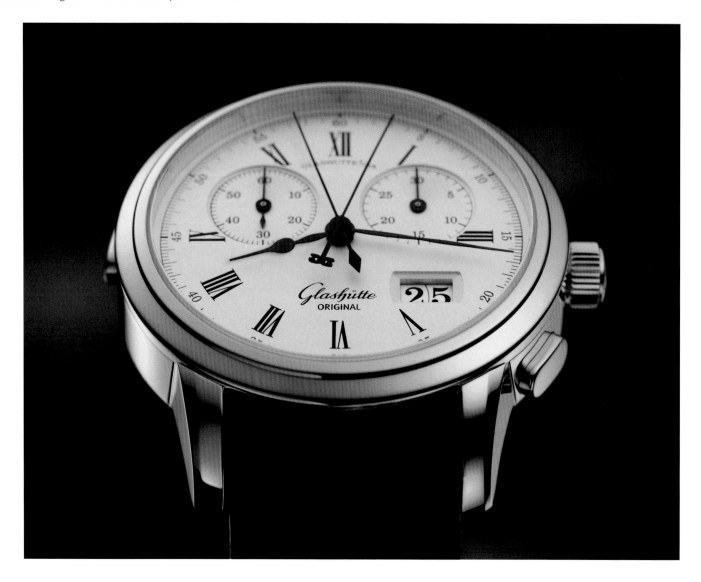

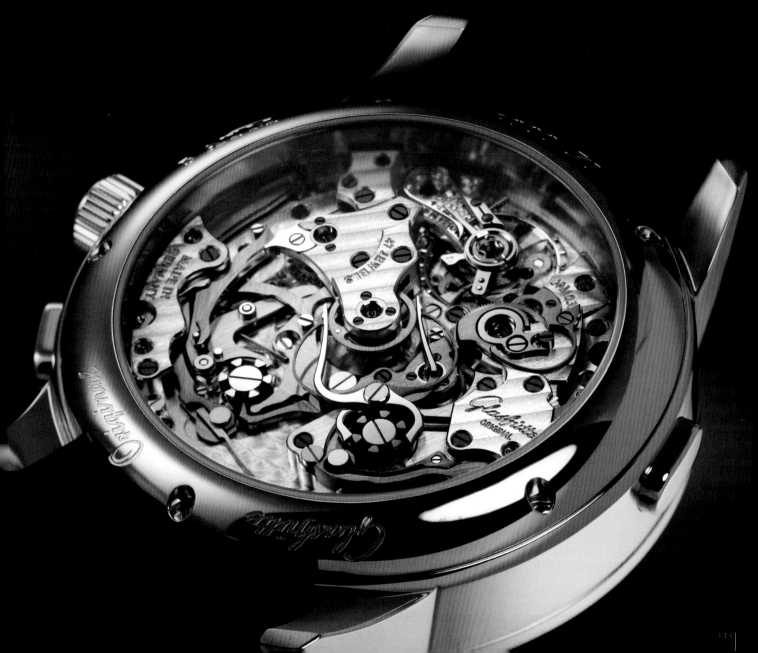

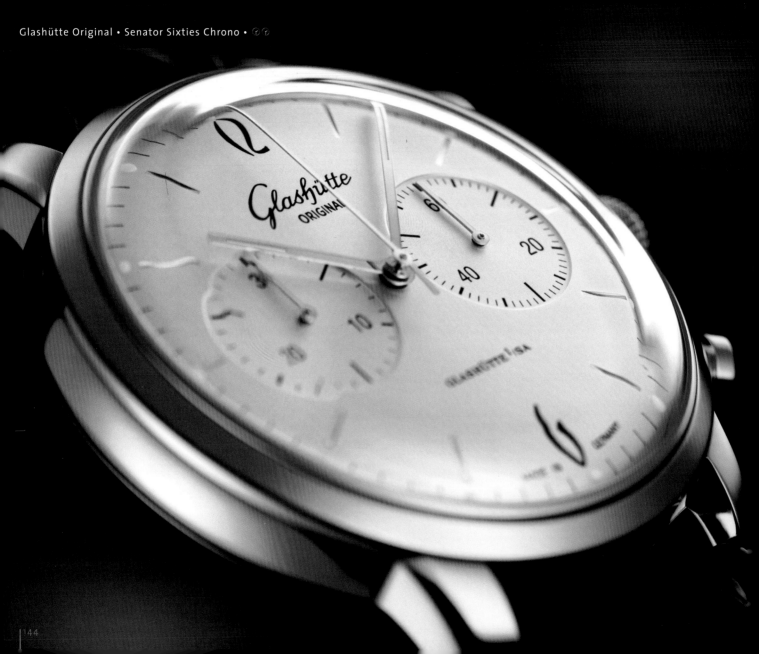

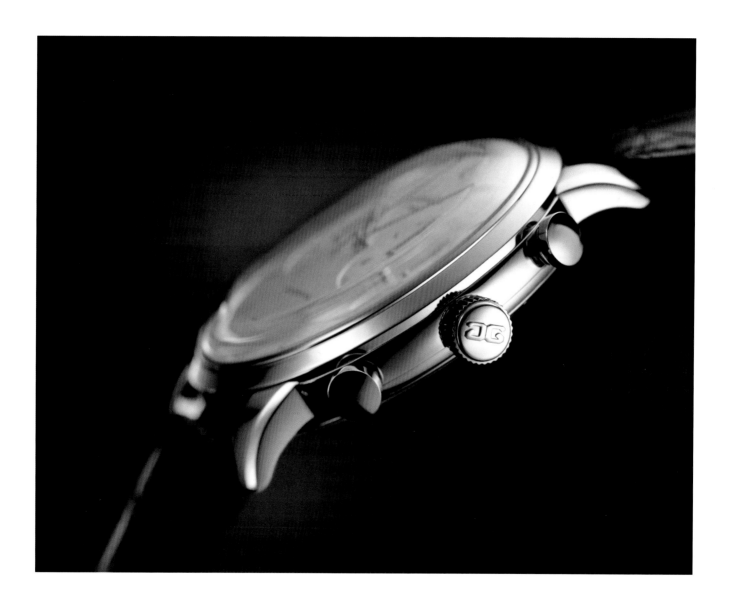

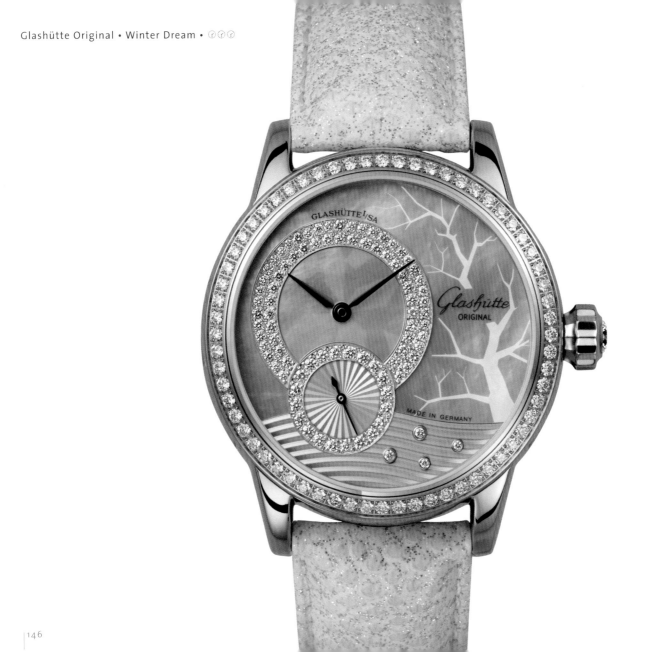

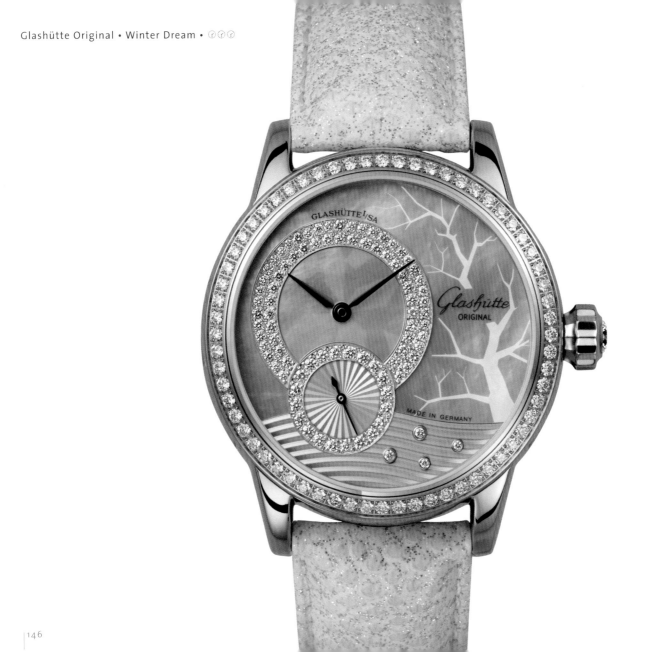

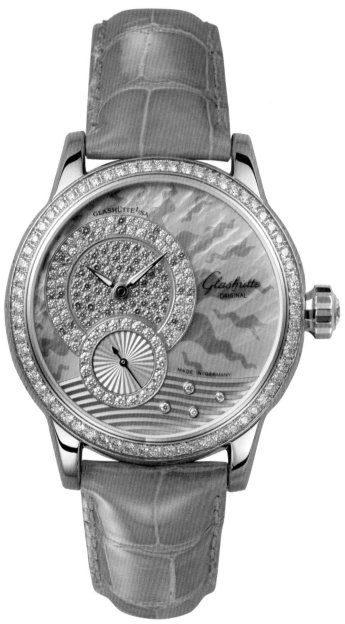

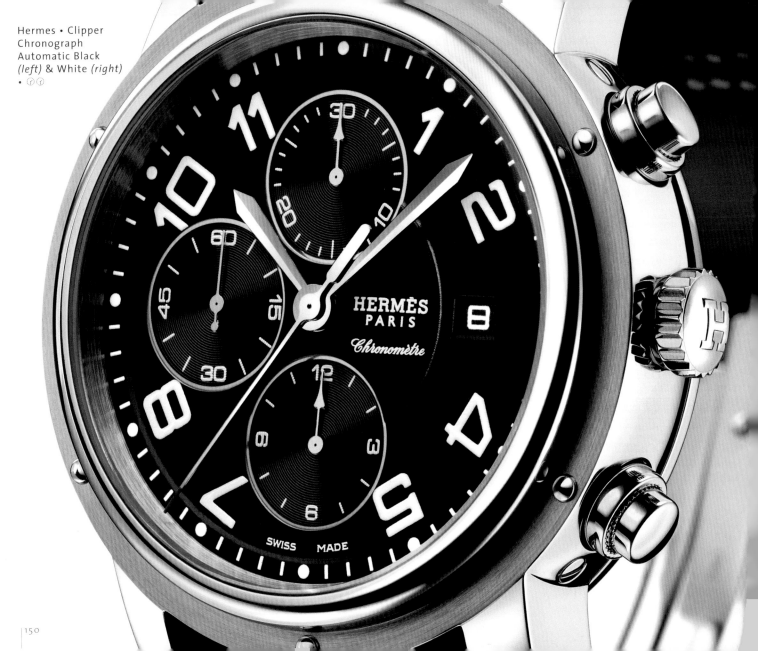

Hermes • Clipper
Chronograph
Automatic Black
(left) & White *(right)*

150

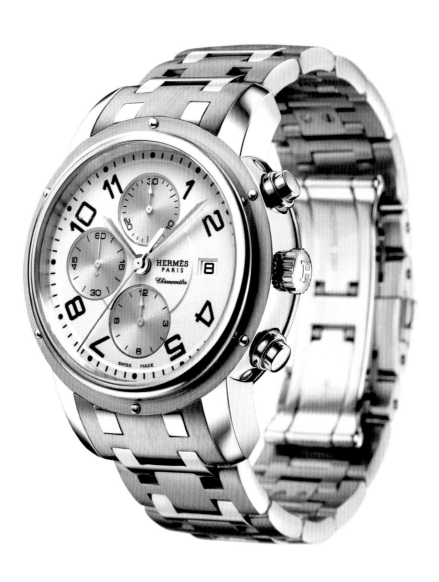

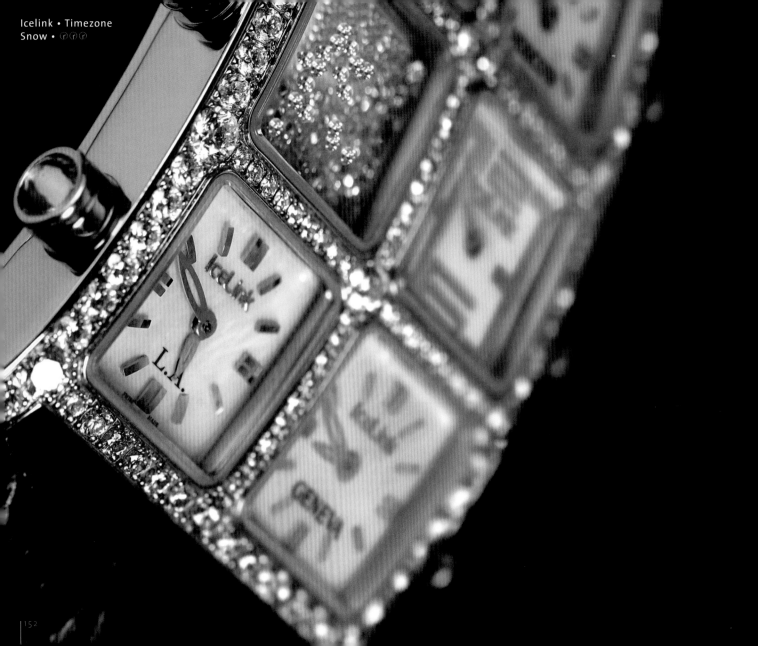

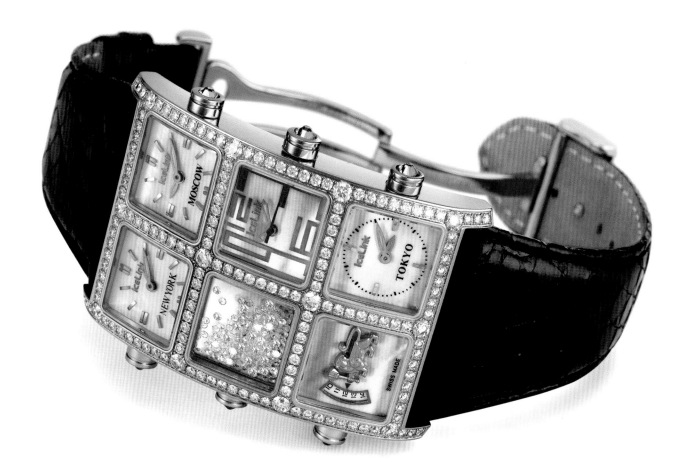

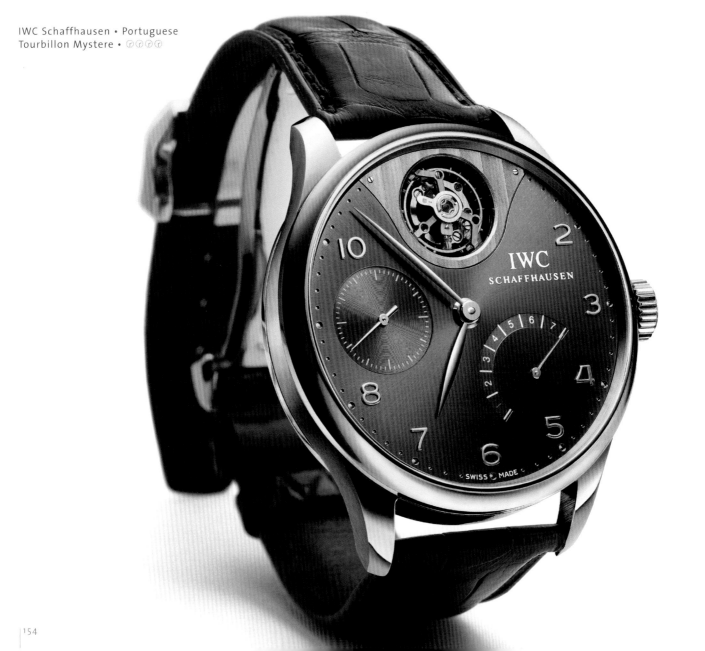

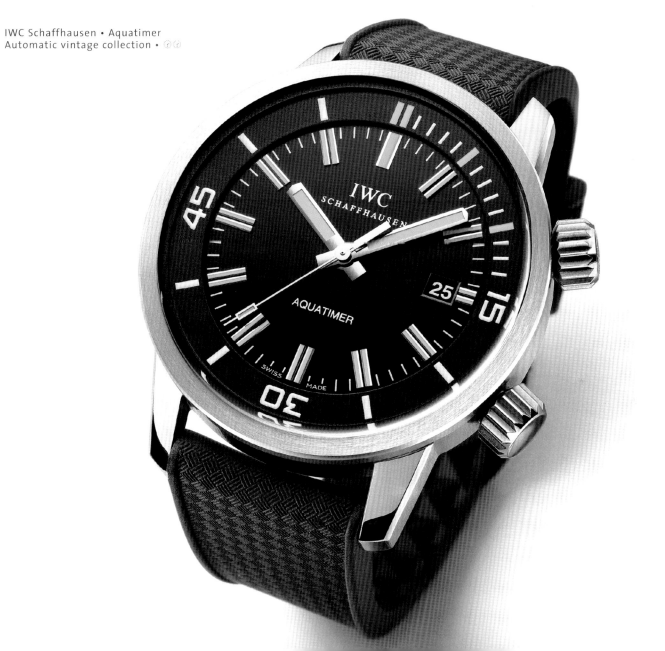

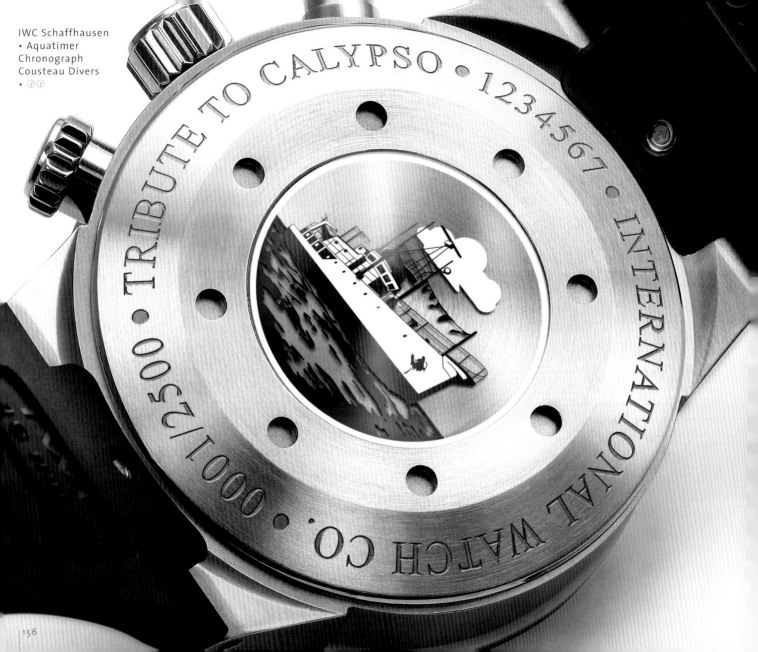

IWC Schaffhausen
• Aquatimer
Chronograph
Cousteau Divers
• 🌀🌀

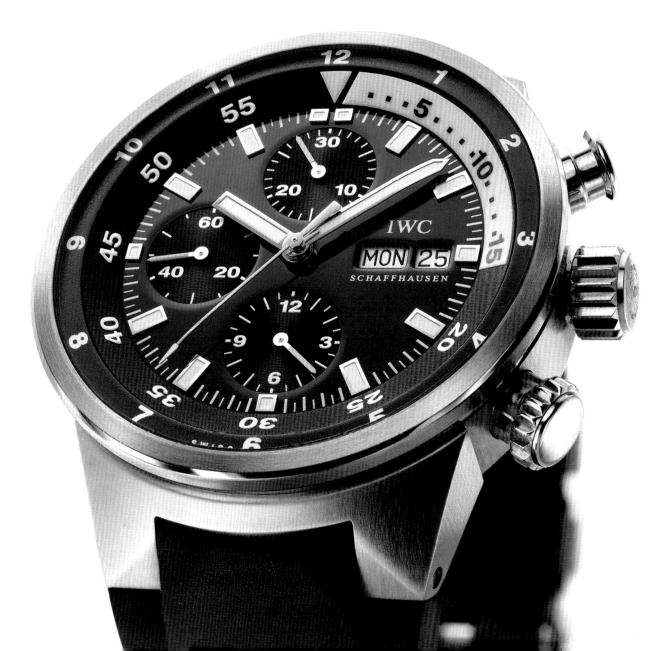

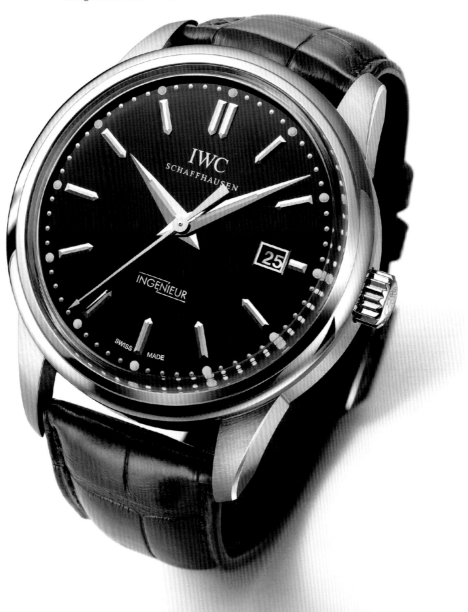

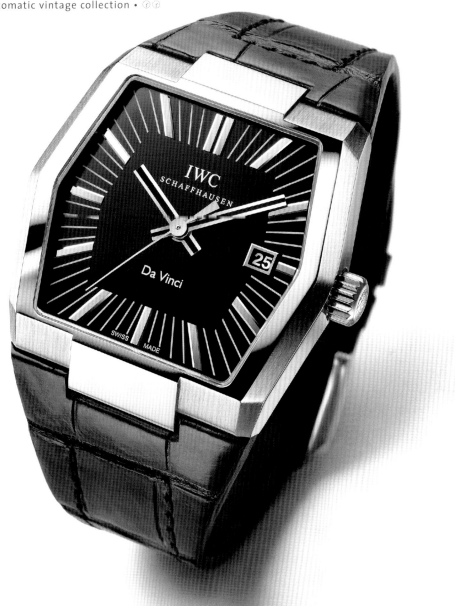

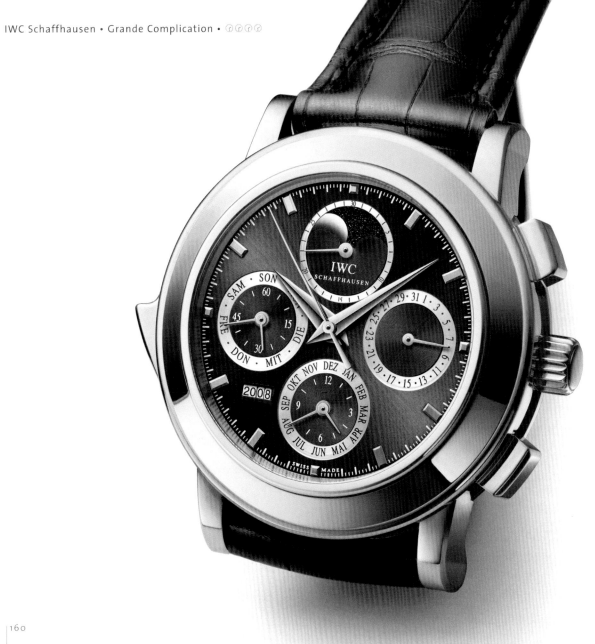

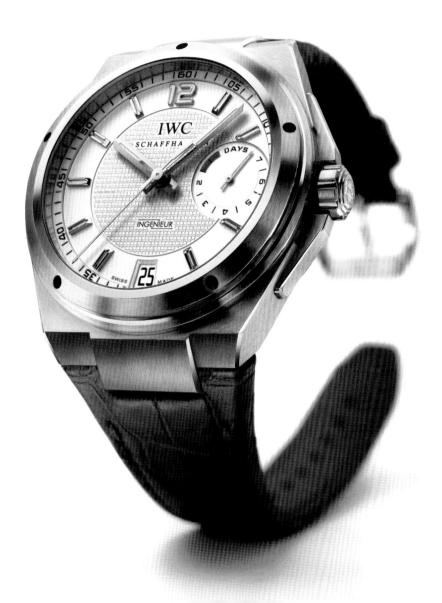

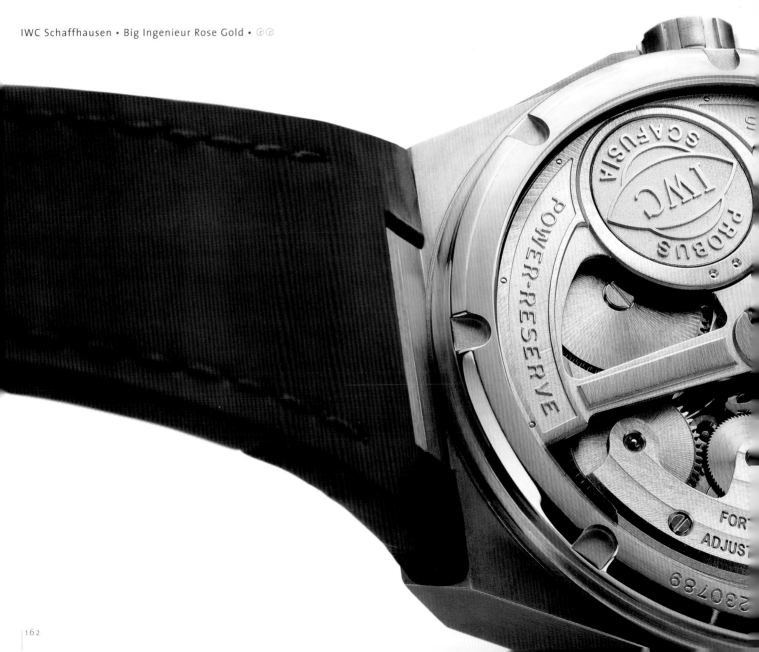

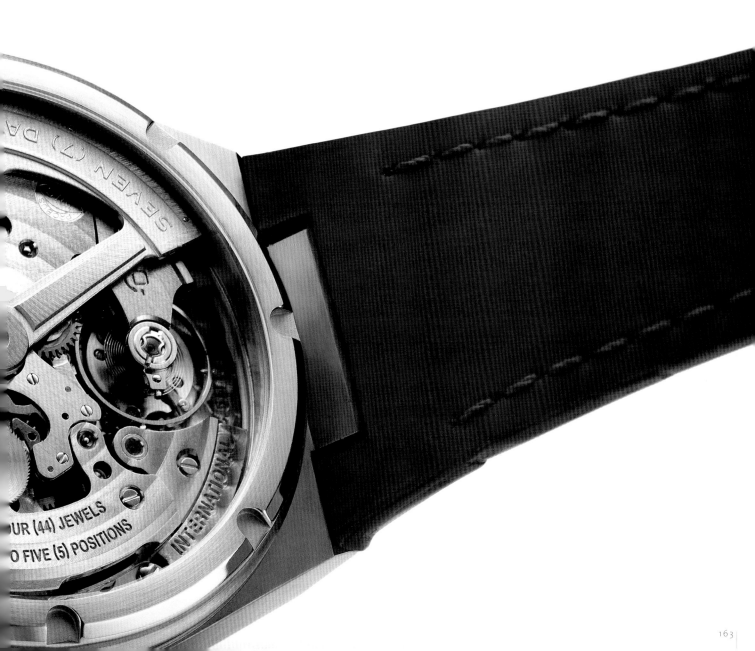

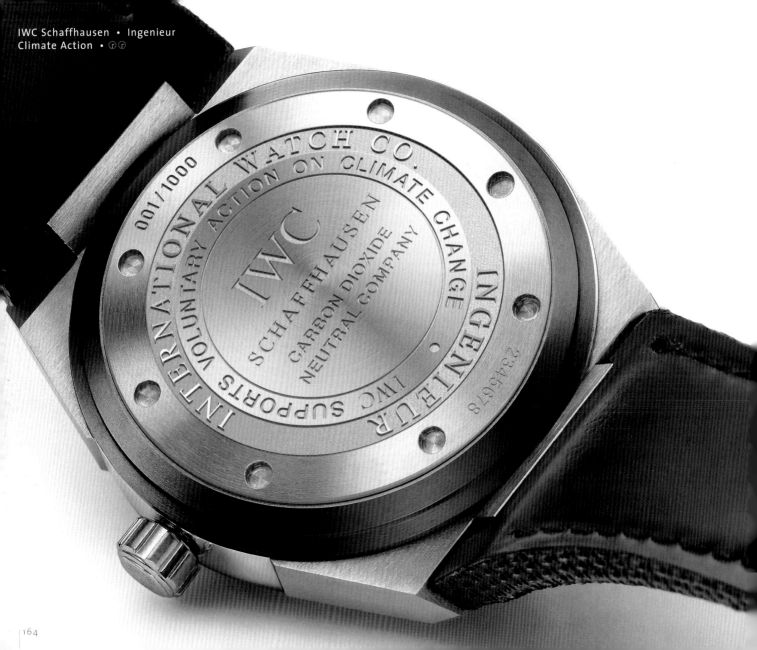

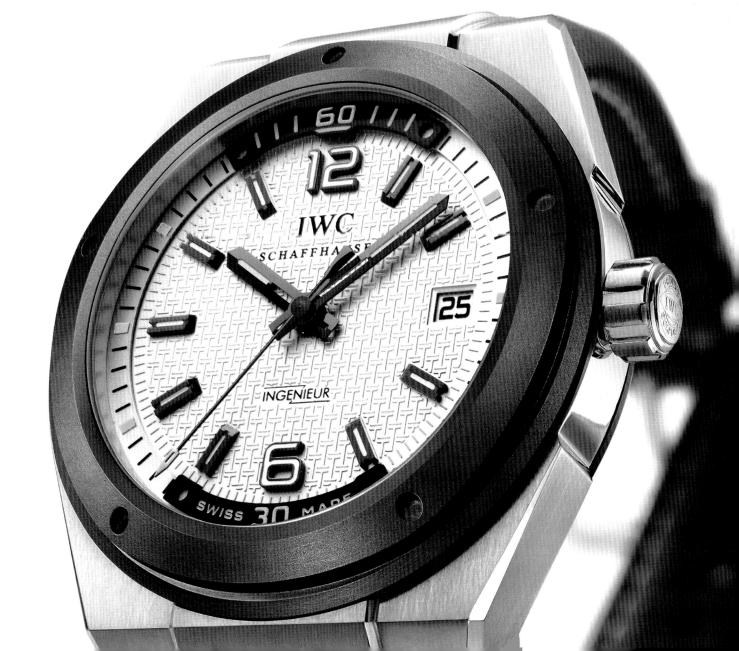

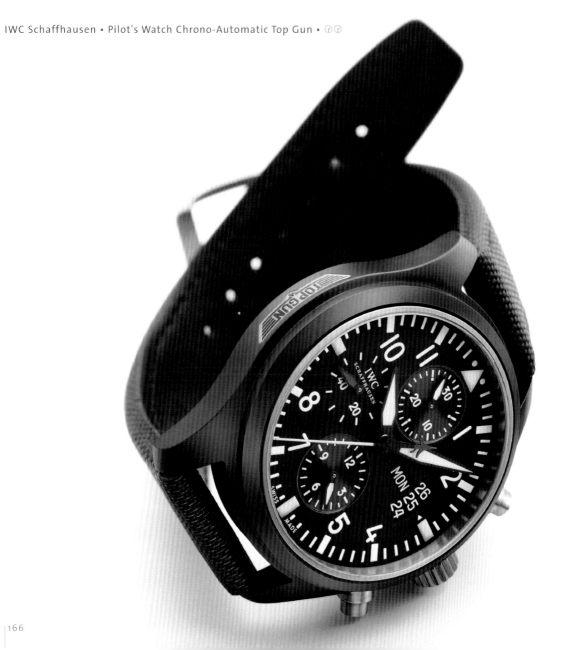

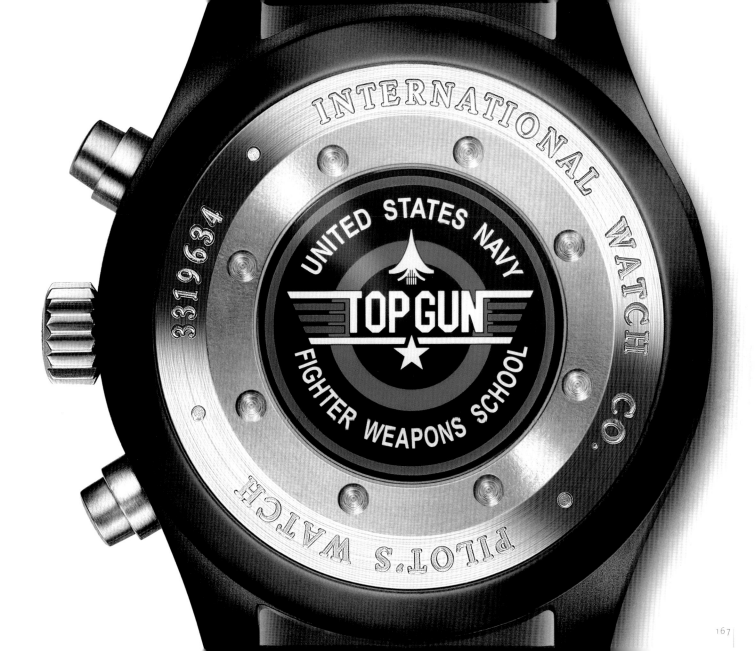

INTERNATIONAL WATCH CO.

331963A

UNITED STATES NAVY

TOP GUN

FIGHTER WEAPONS SCHOOL

PILOT'S WATCH

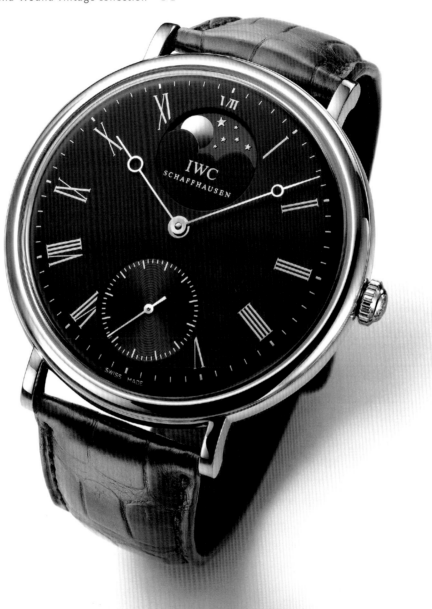

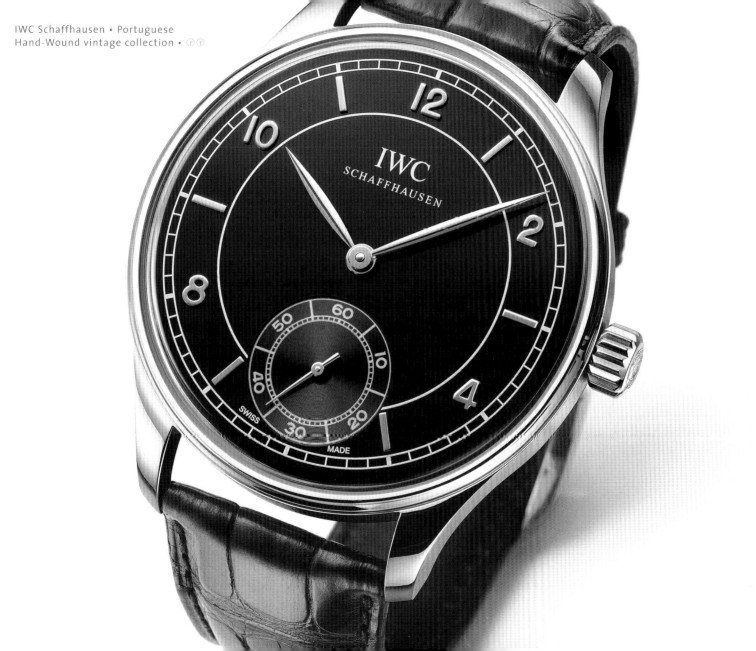

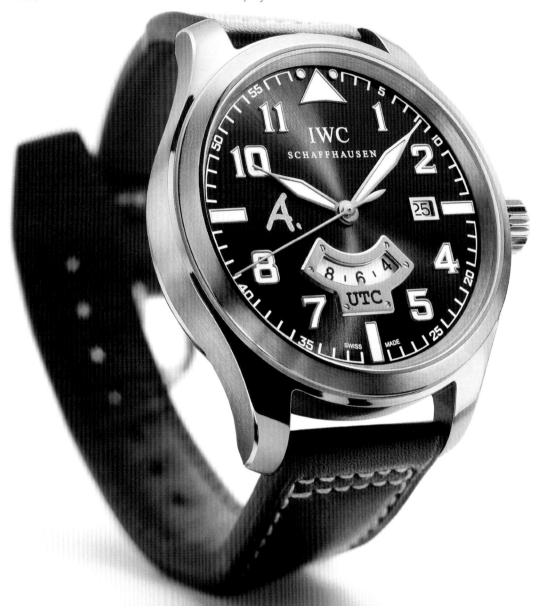

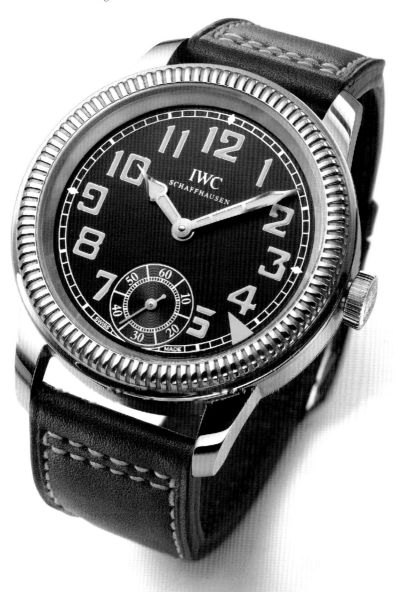

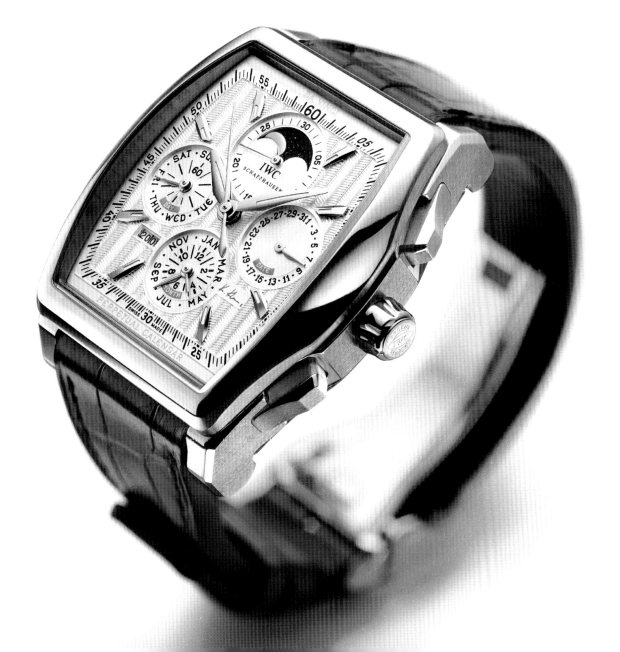

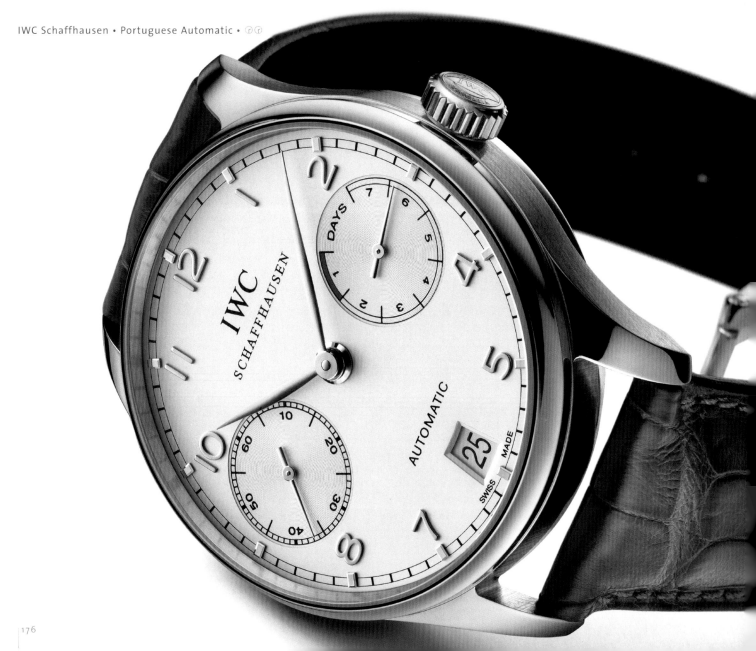

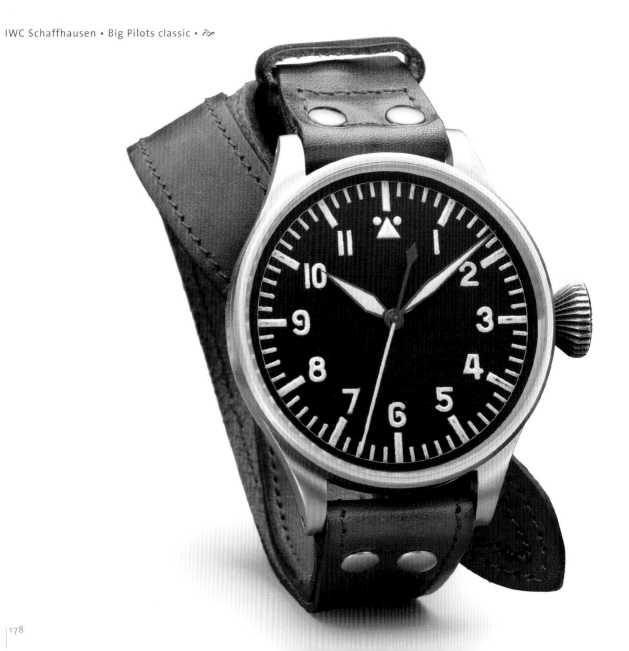

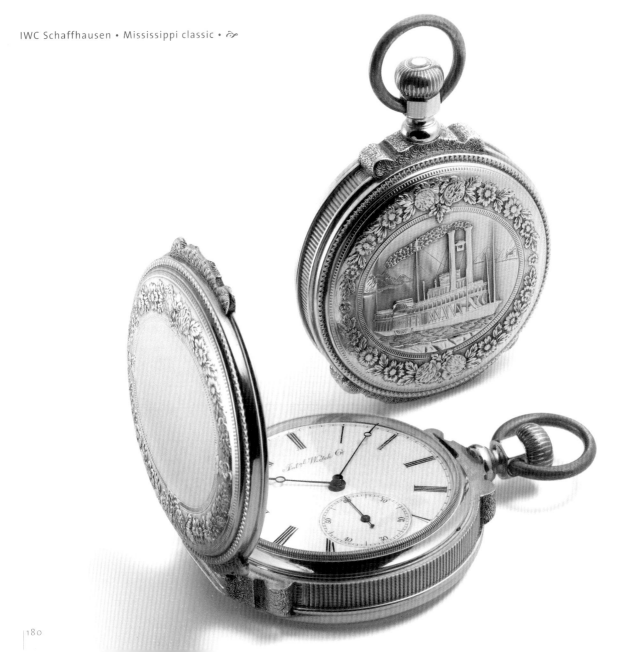

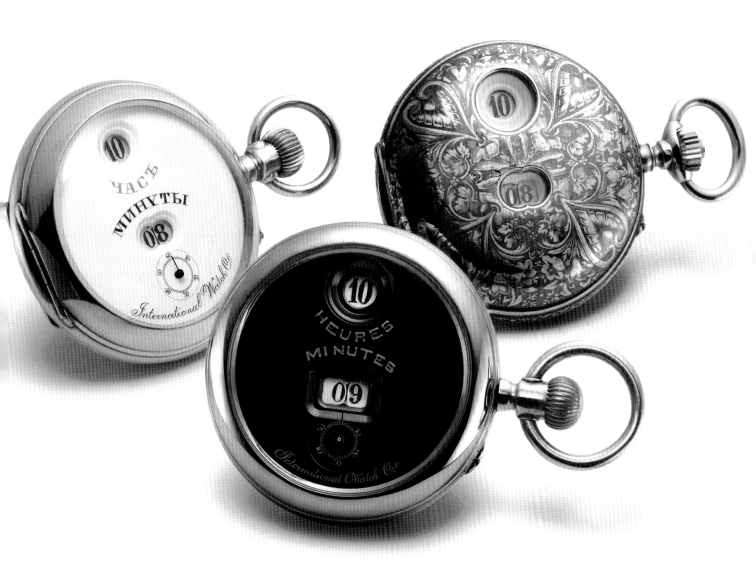

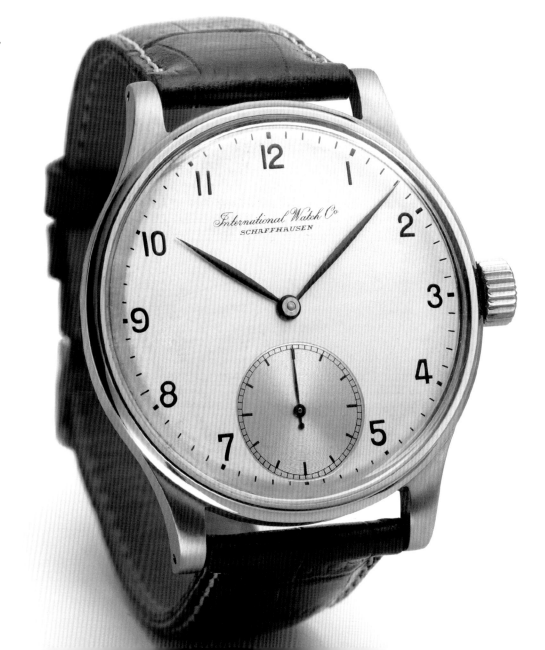

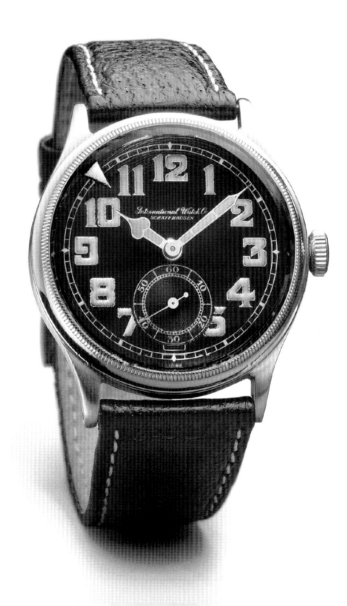

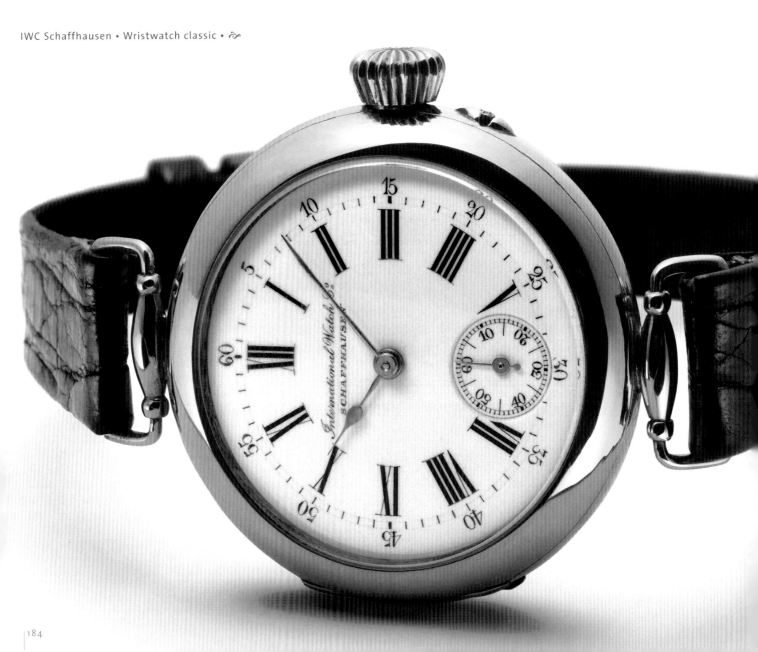

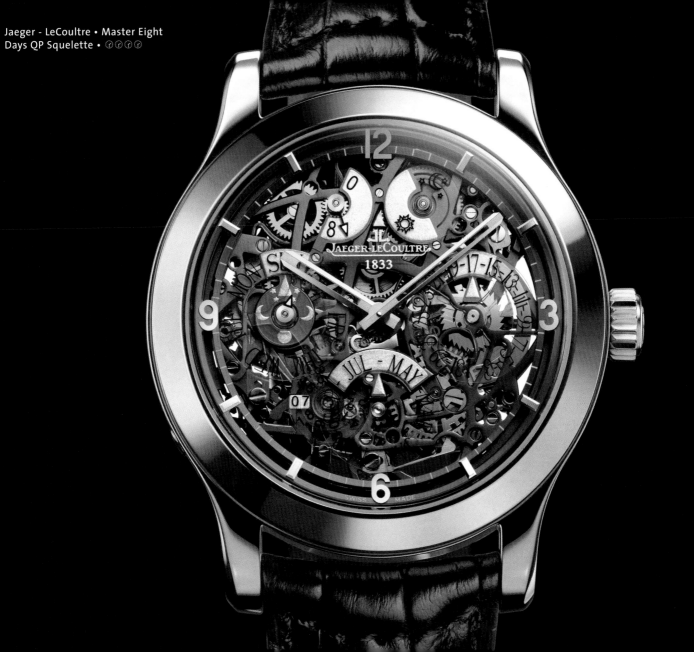

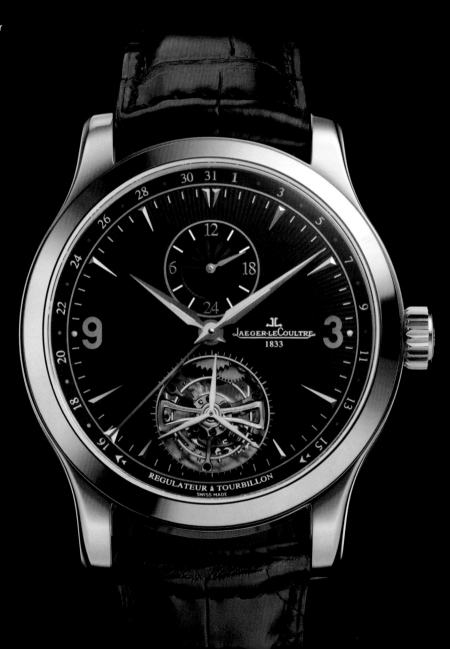

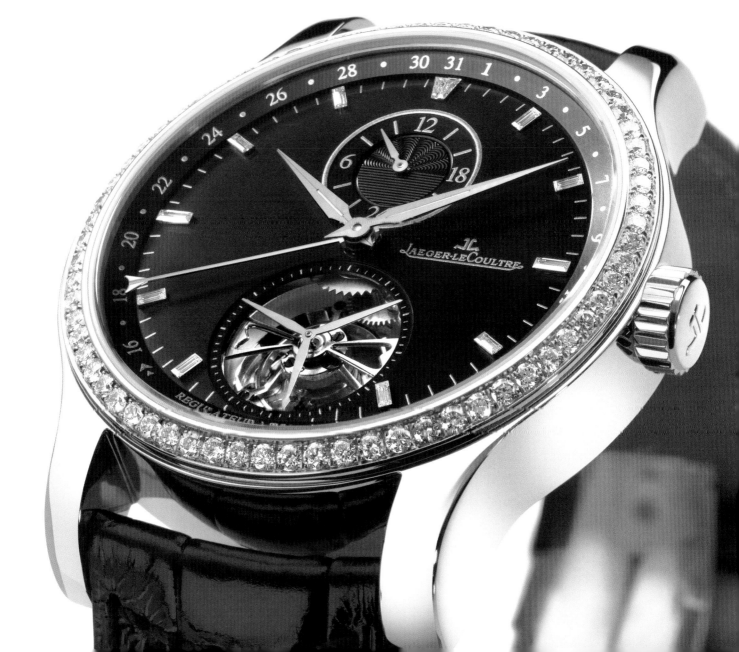

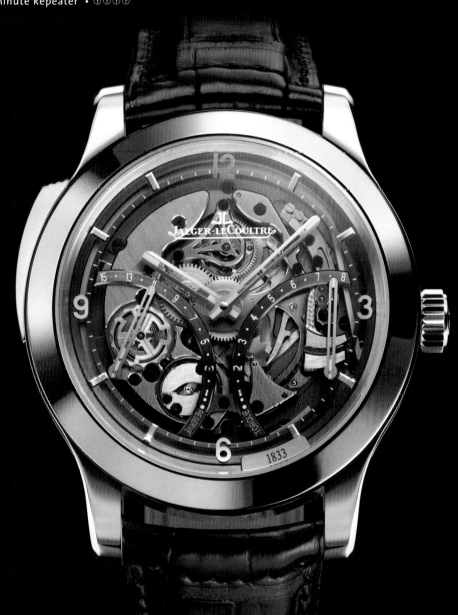

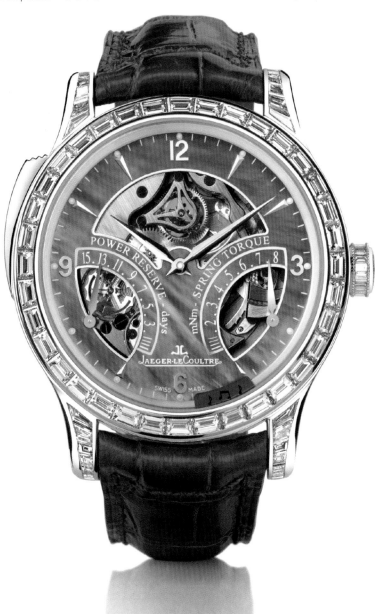

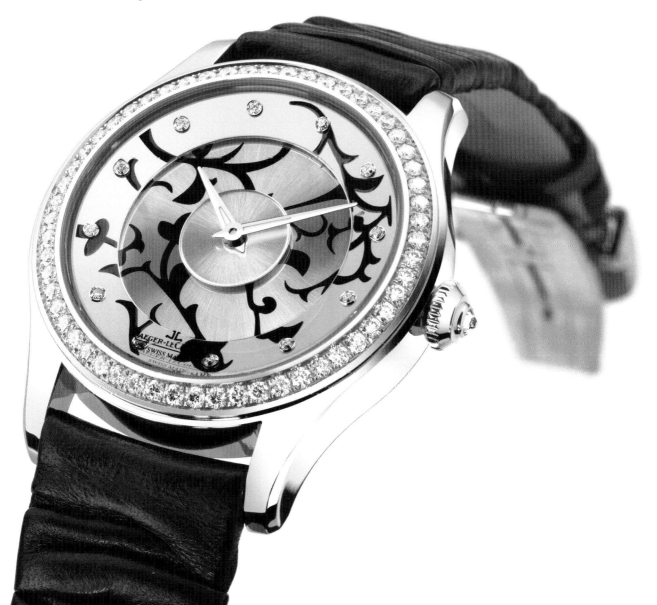

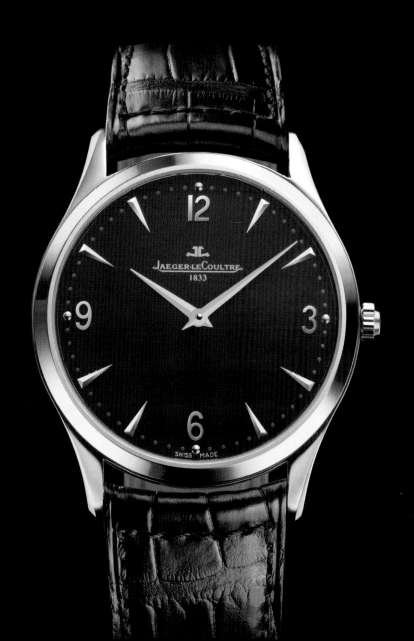

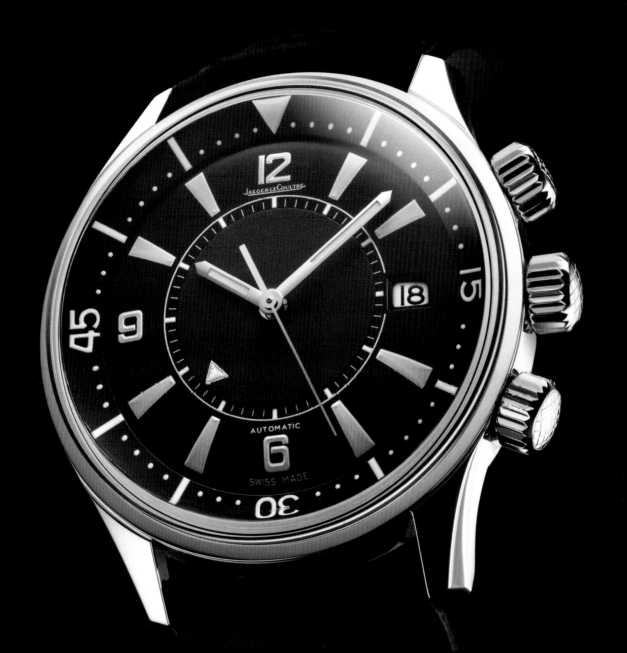

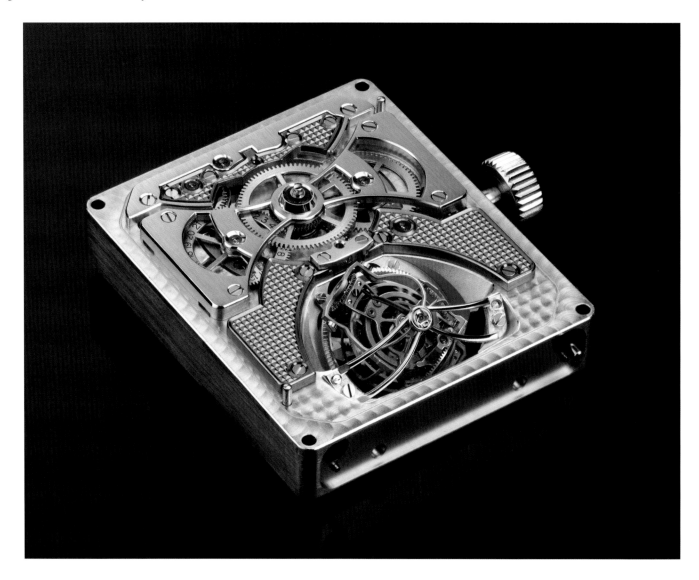

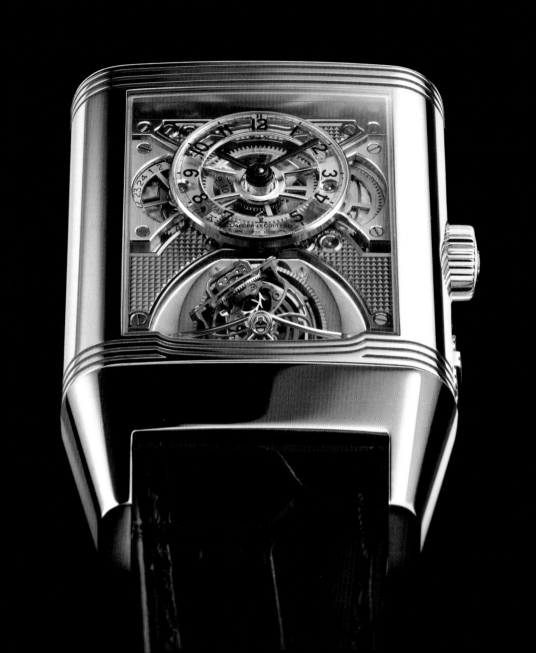

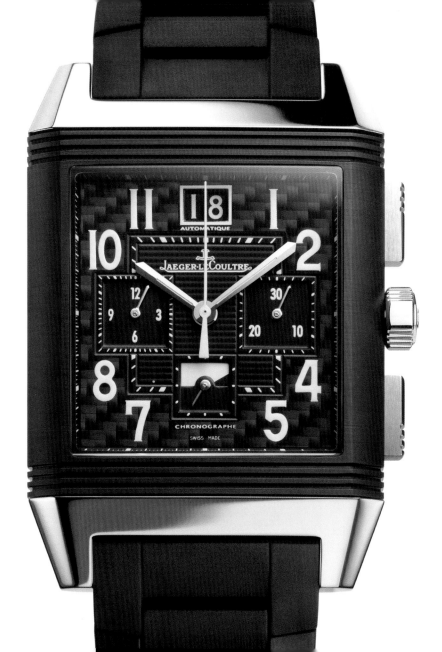

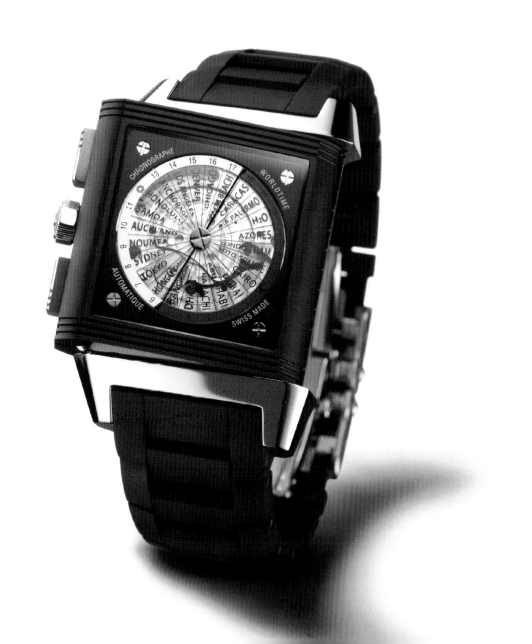

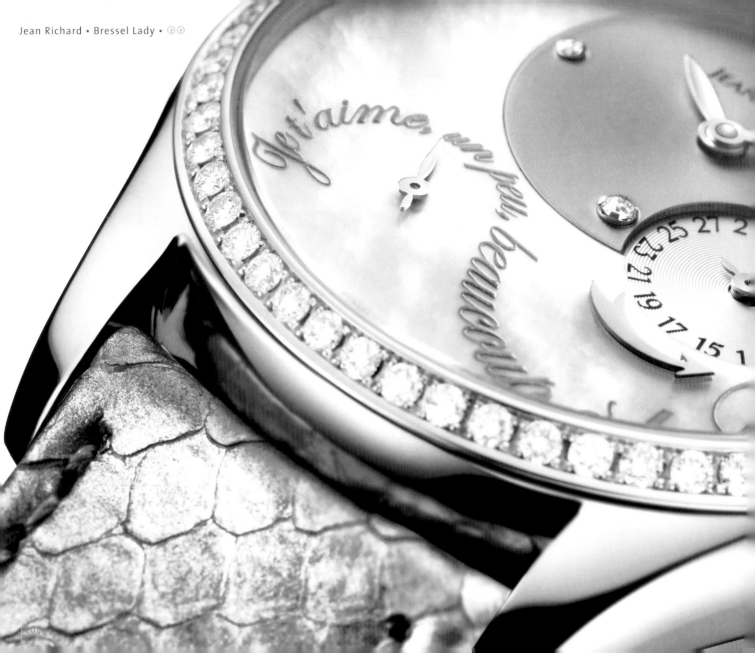

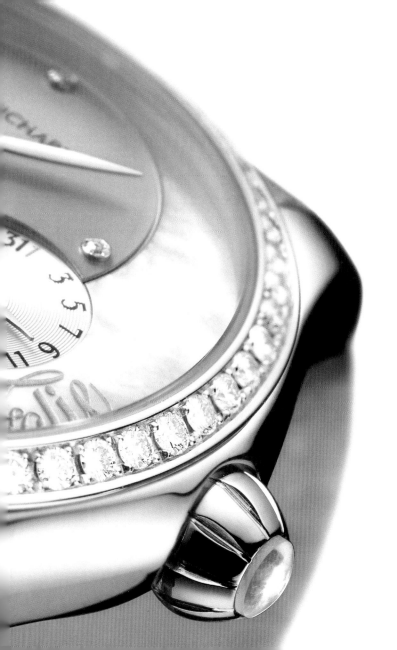

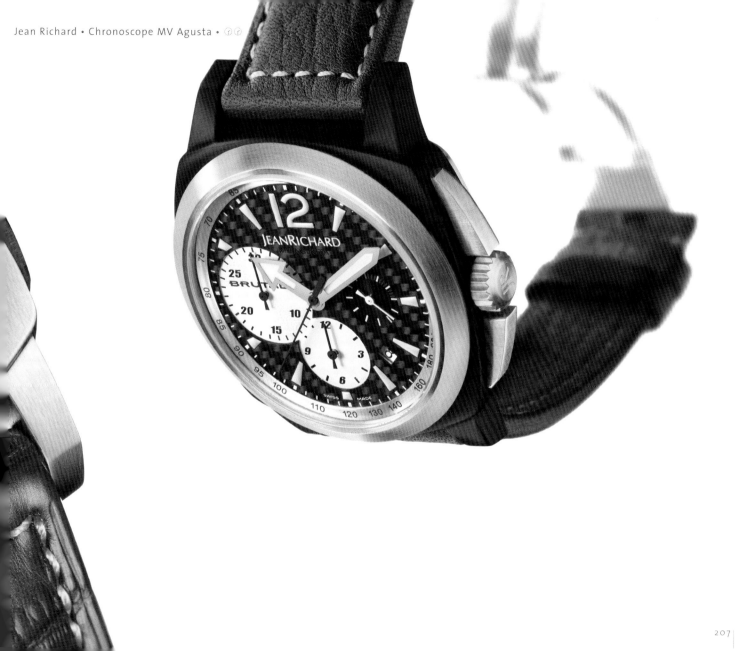

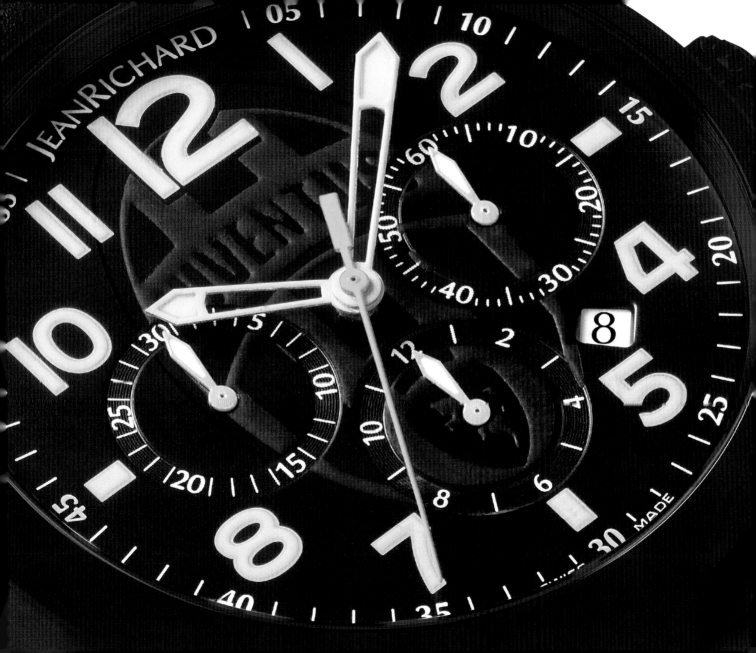

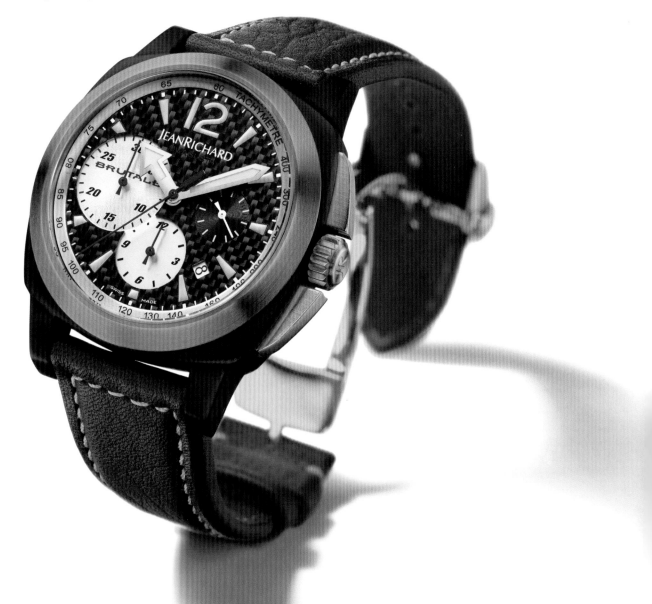

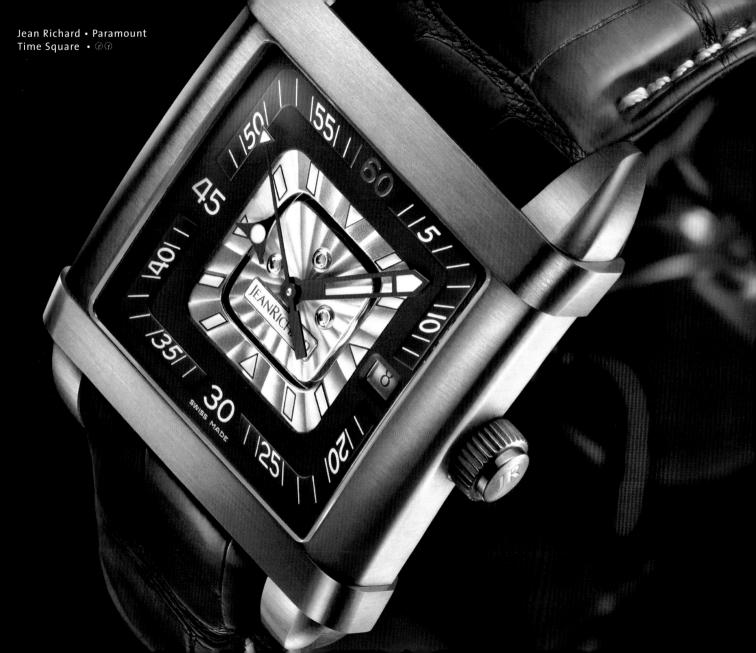

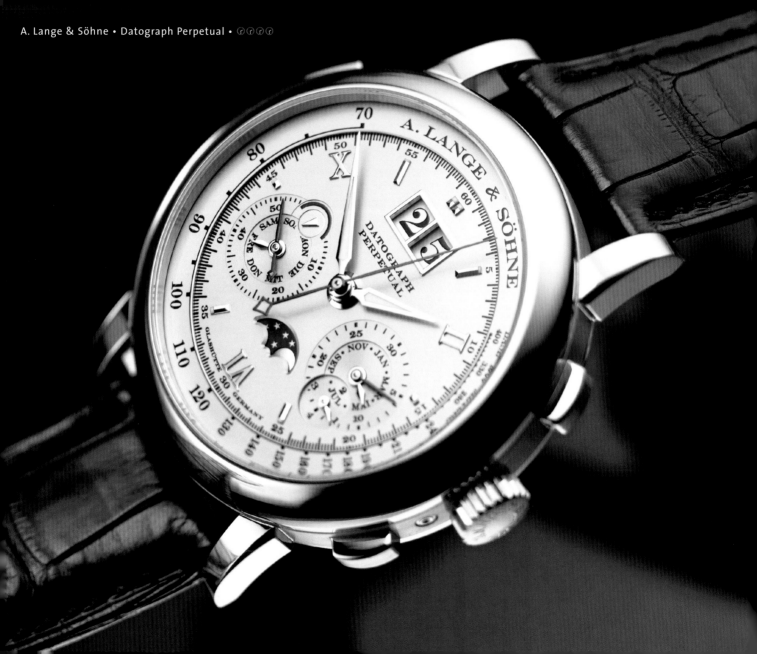

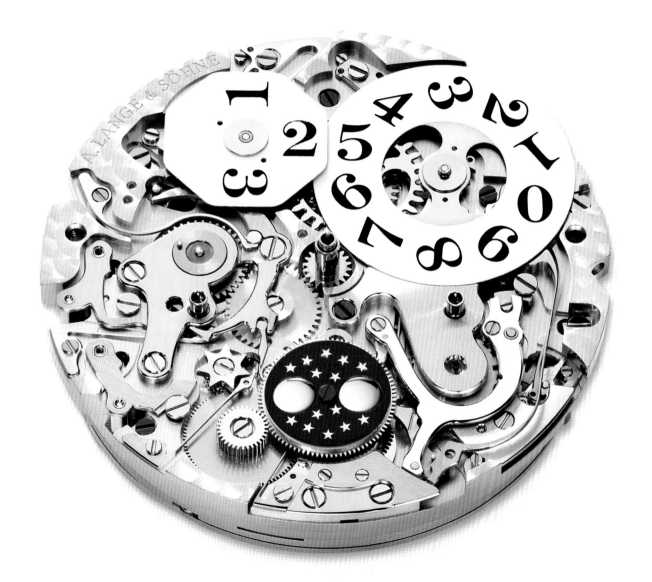

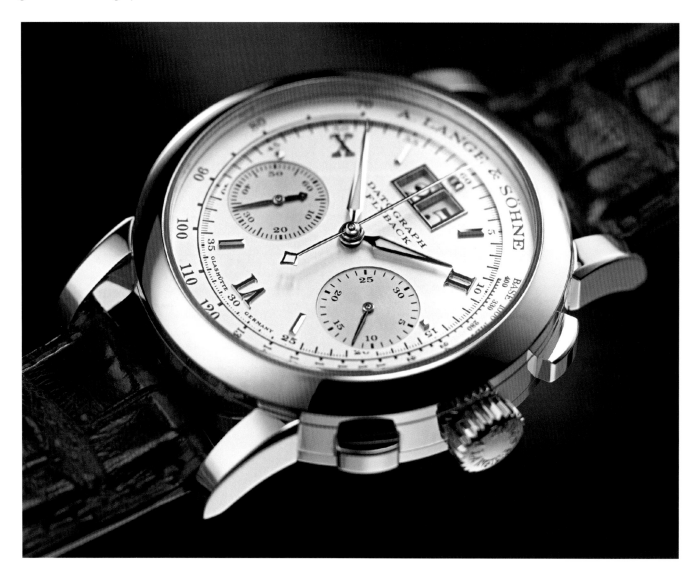

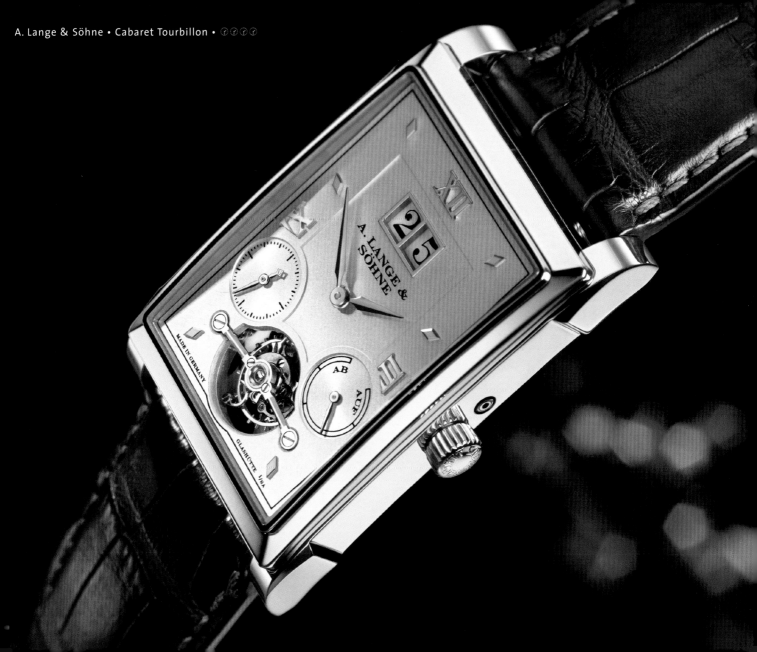

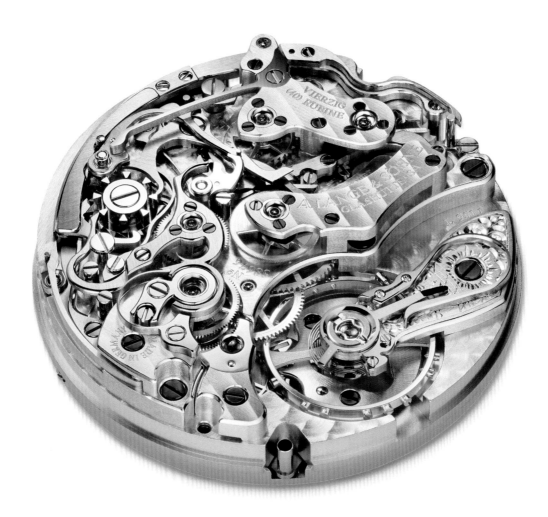

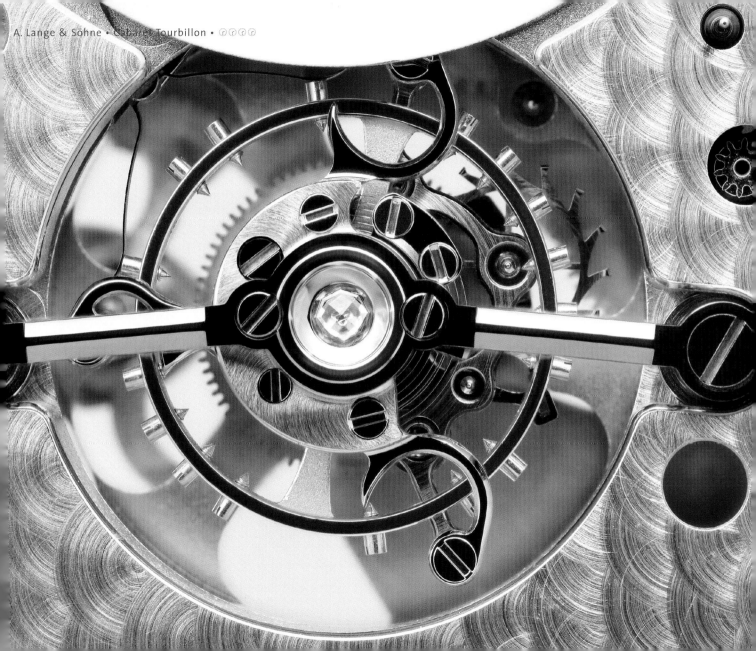

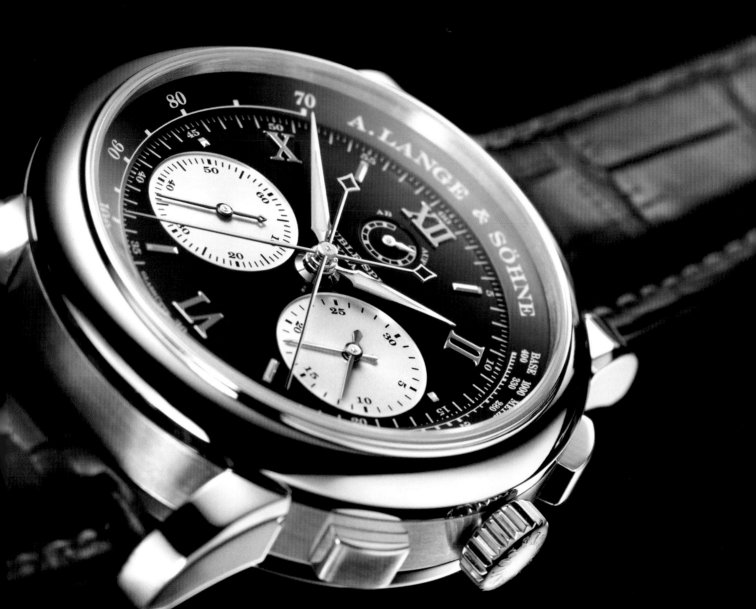

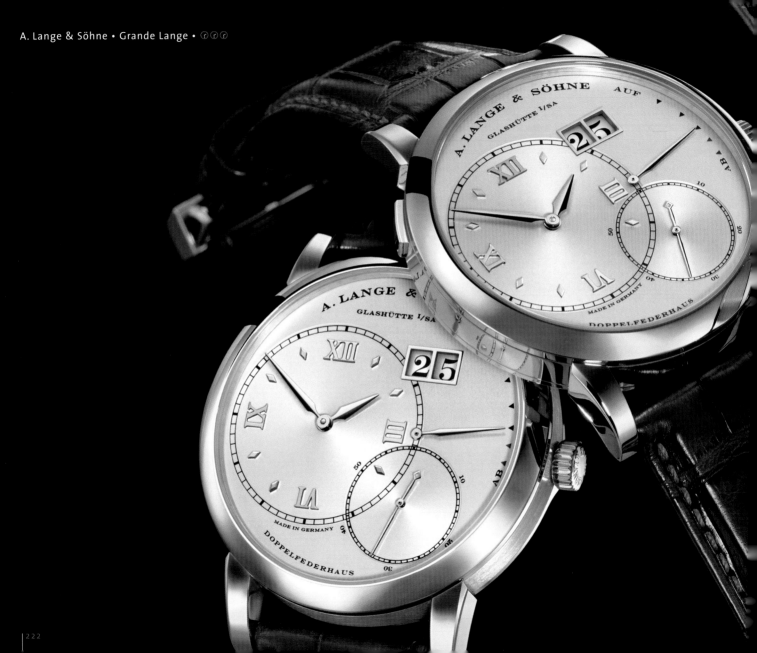

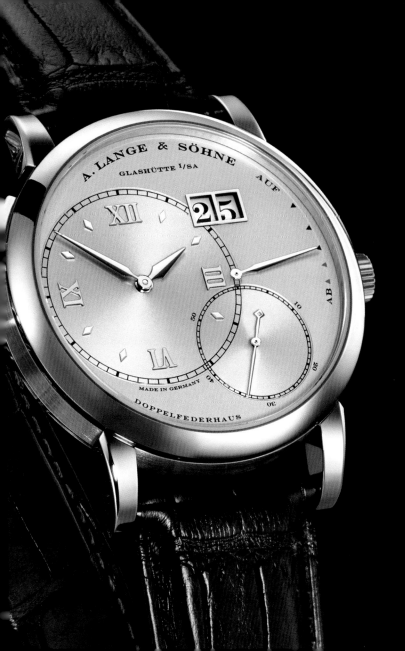

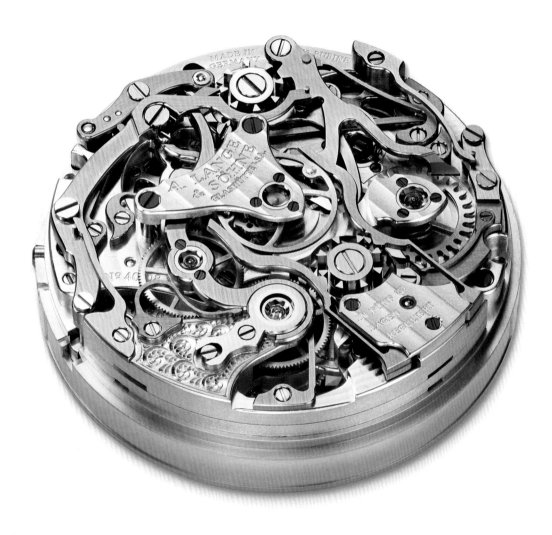

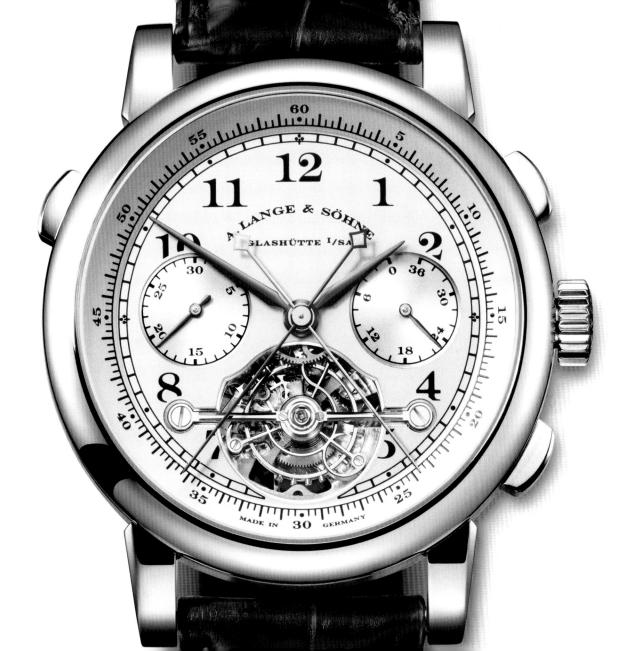

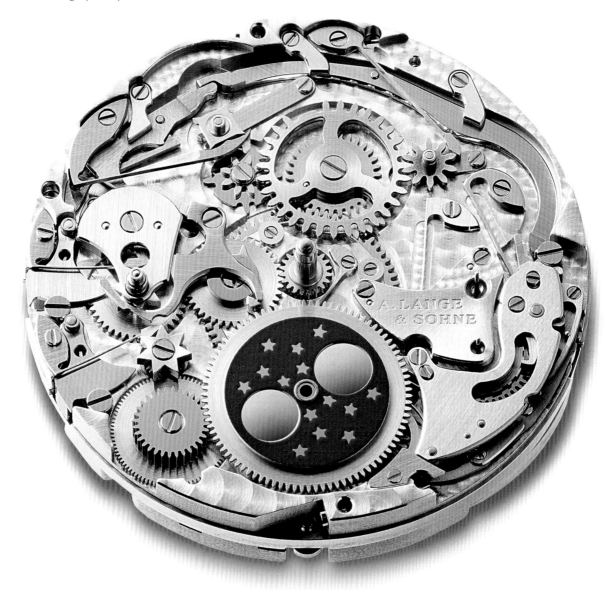

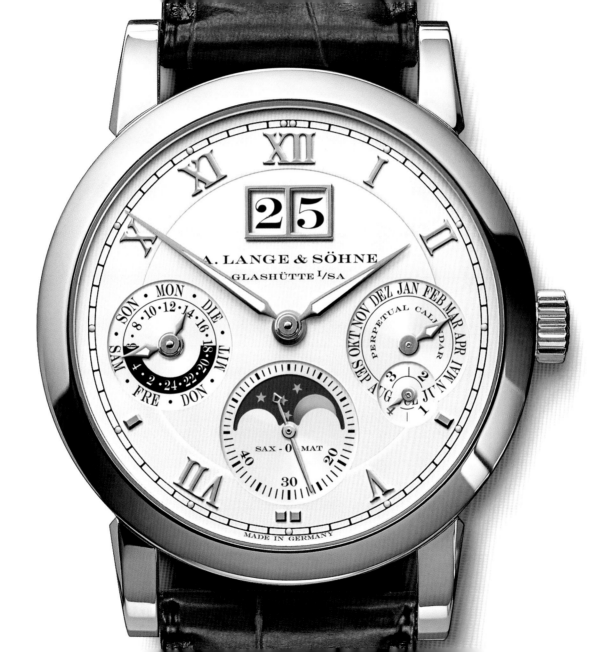

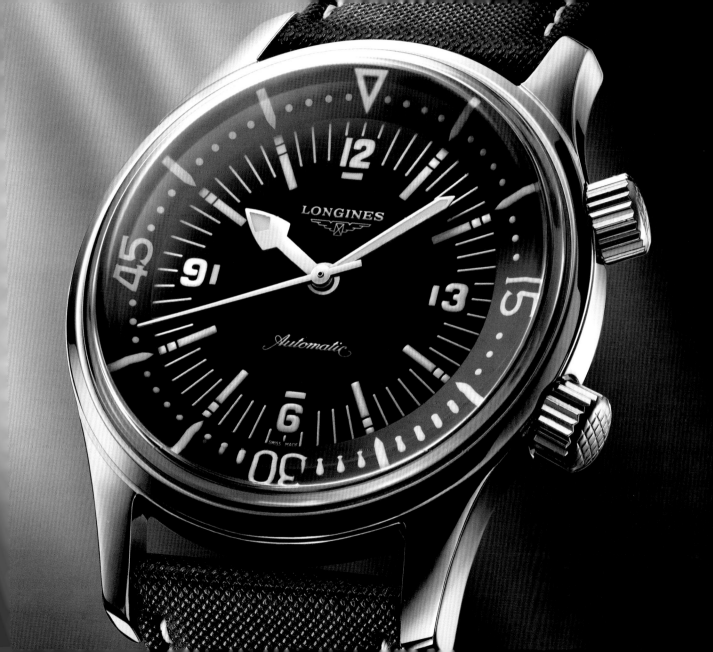

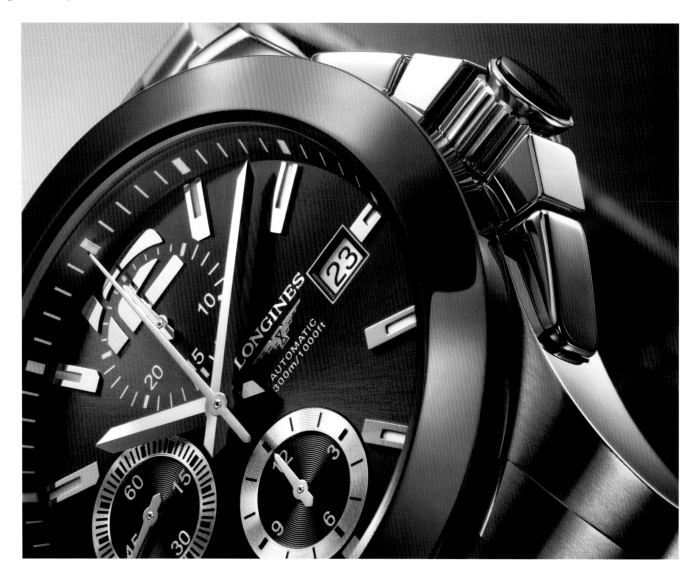

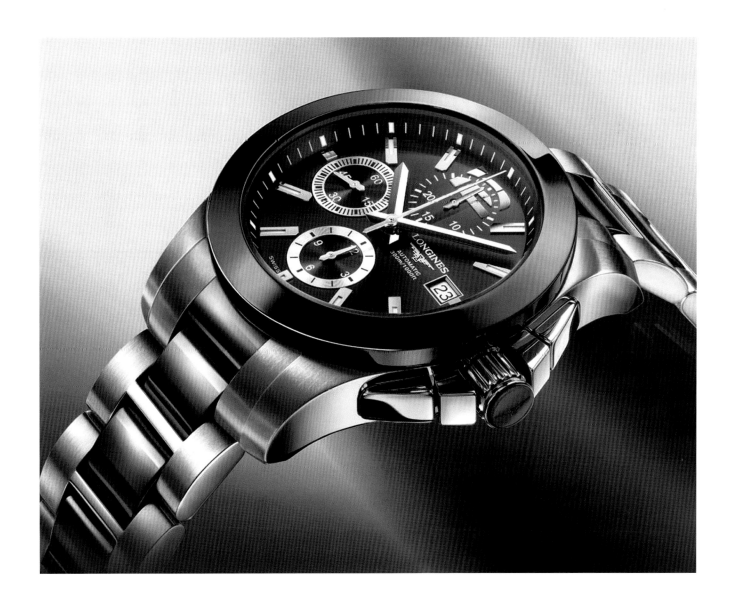

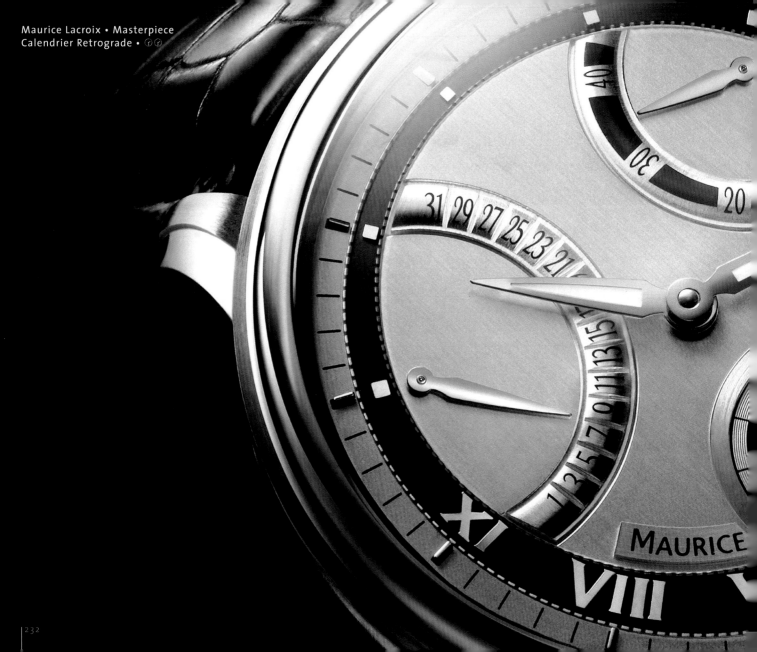

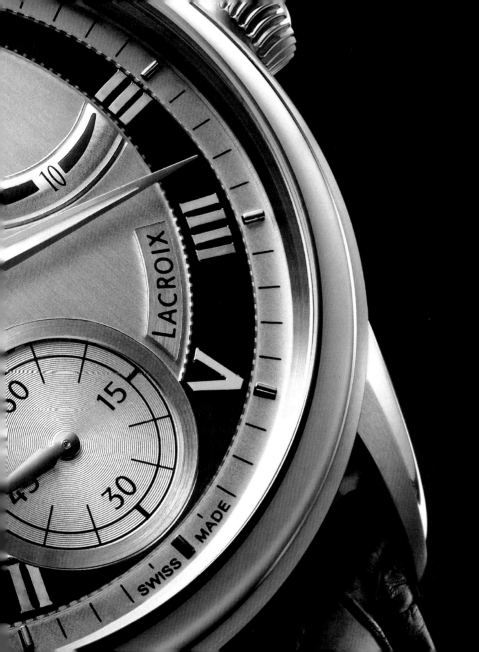

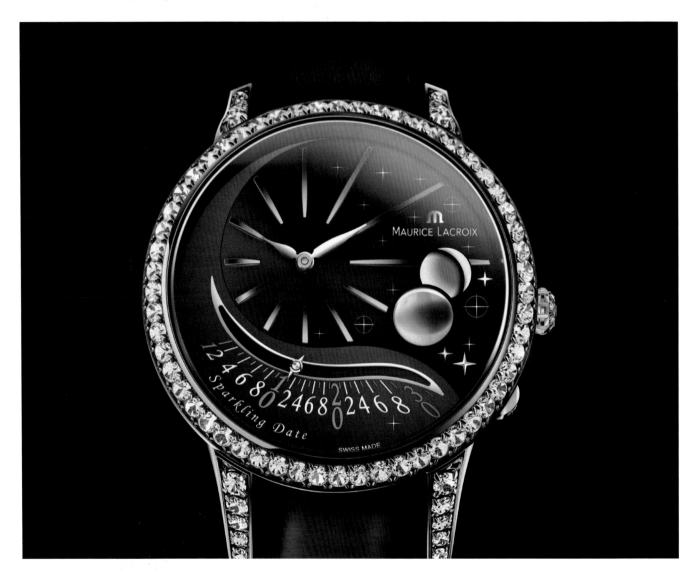

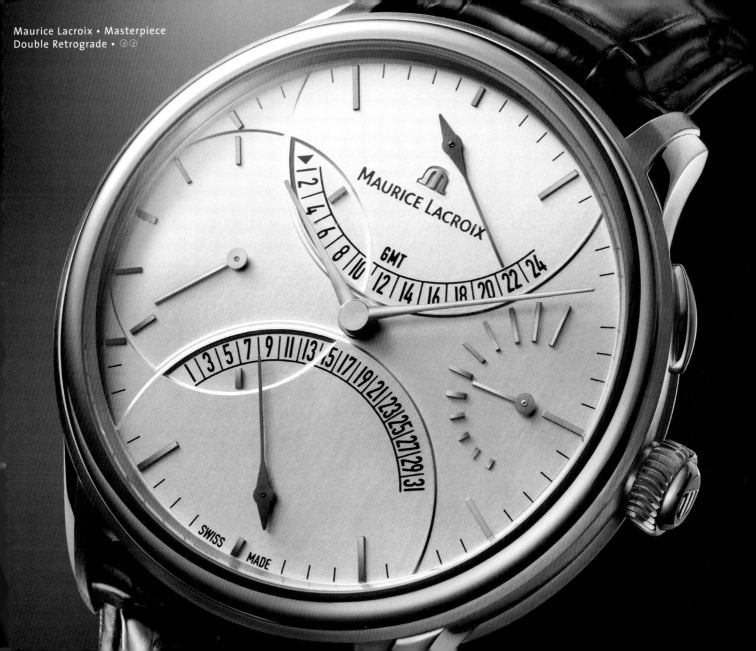

Maurice Lacroix • Masterpiece
Double Retrograde • ⓡⓡ

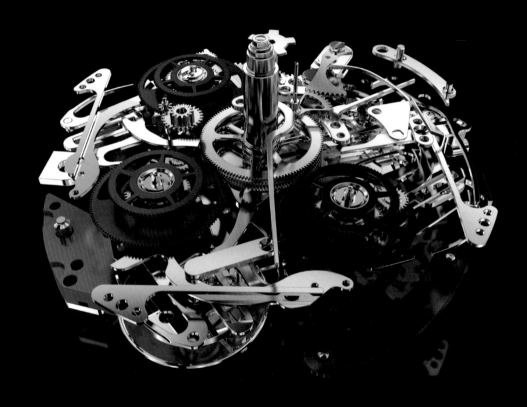

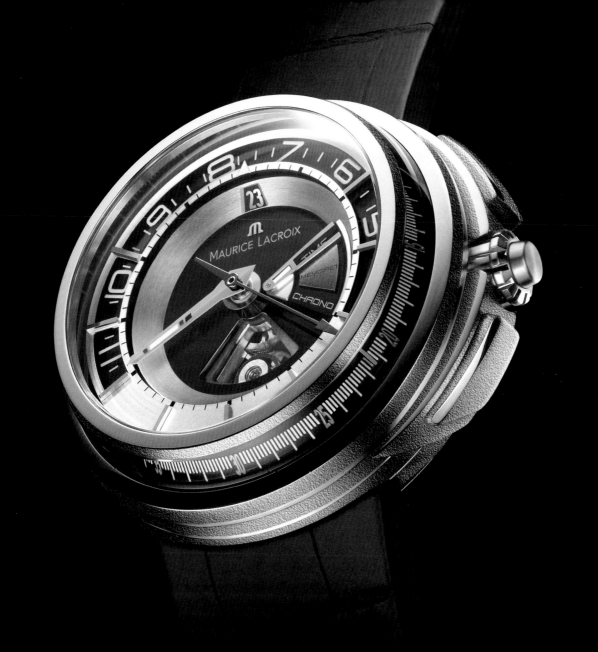

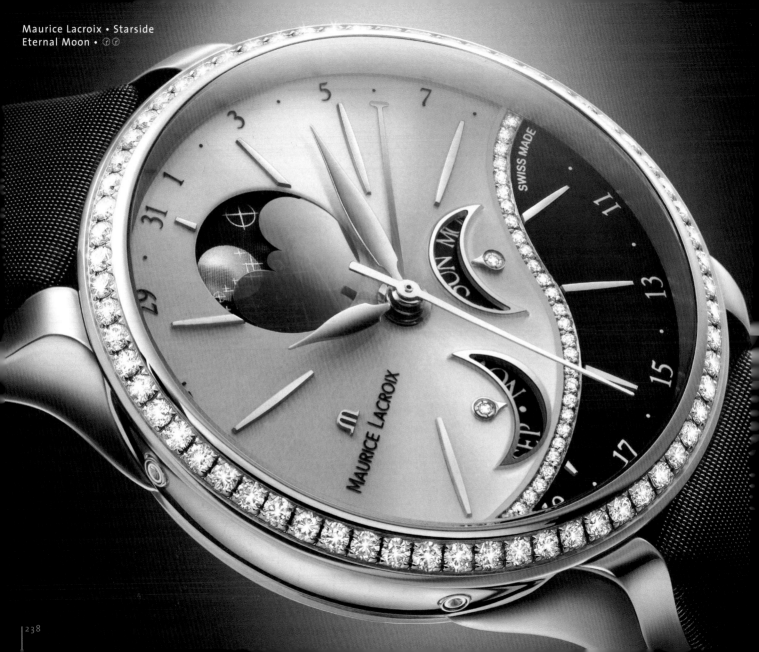

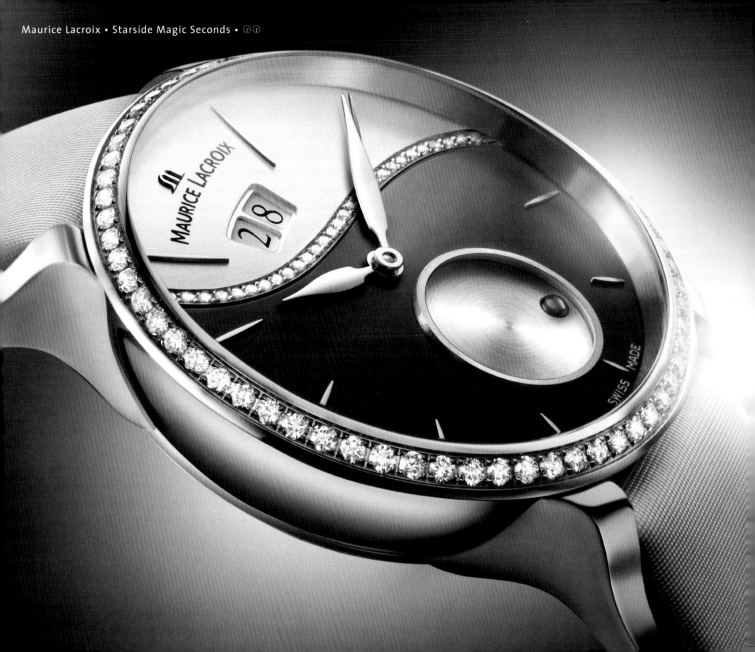

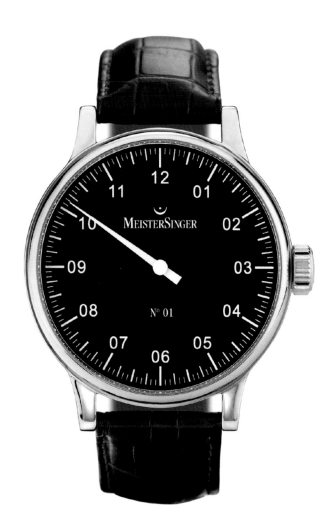

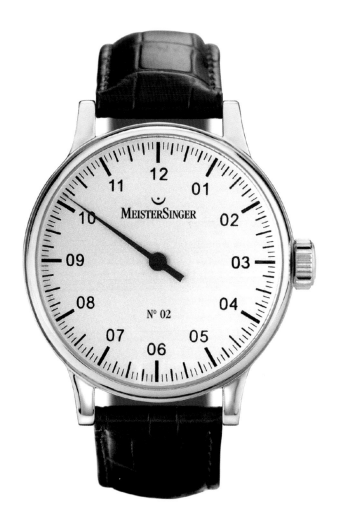

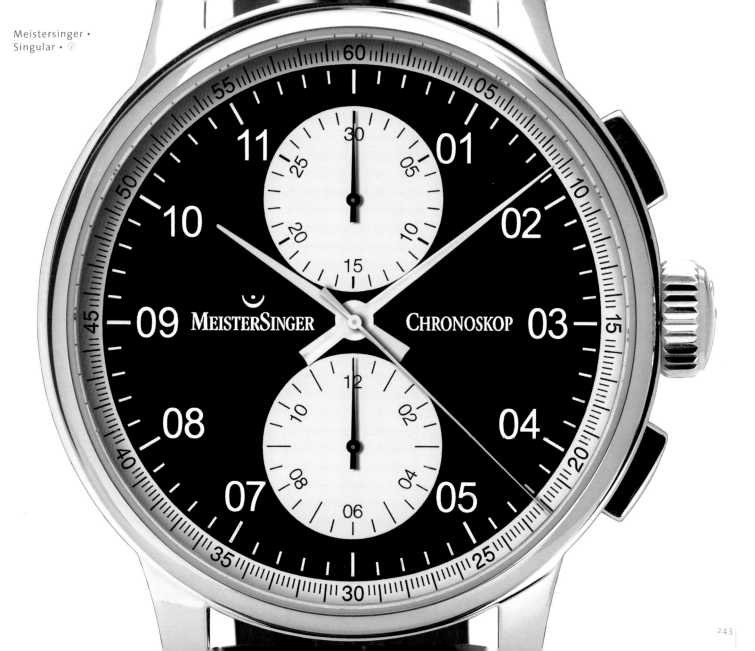

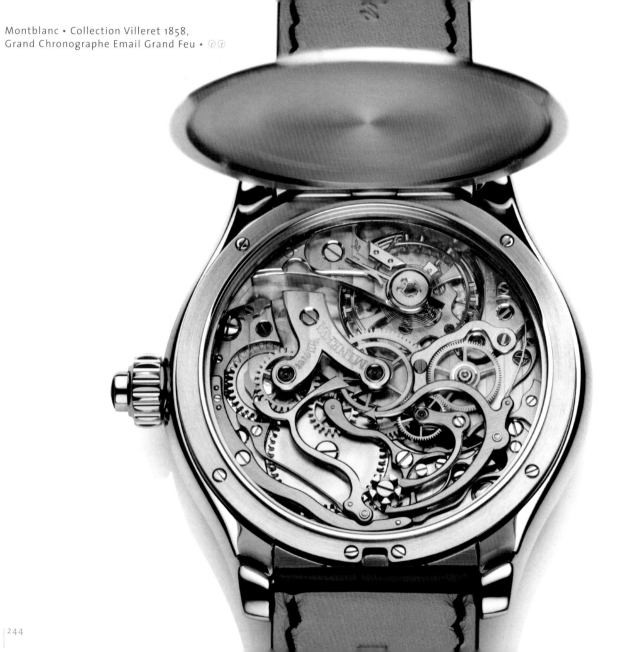

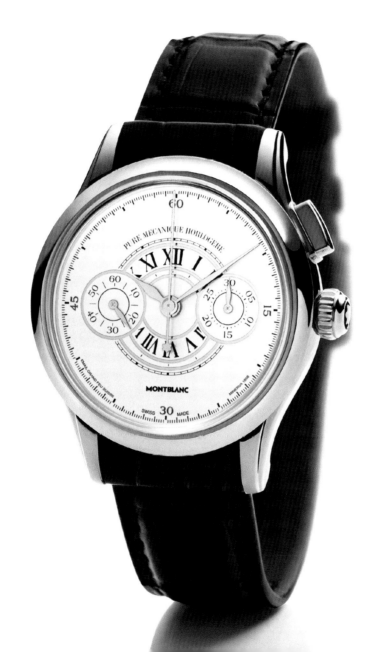

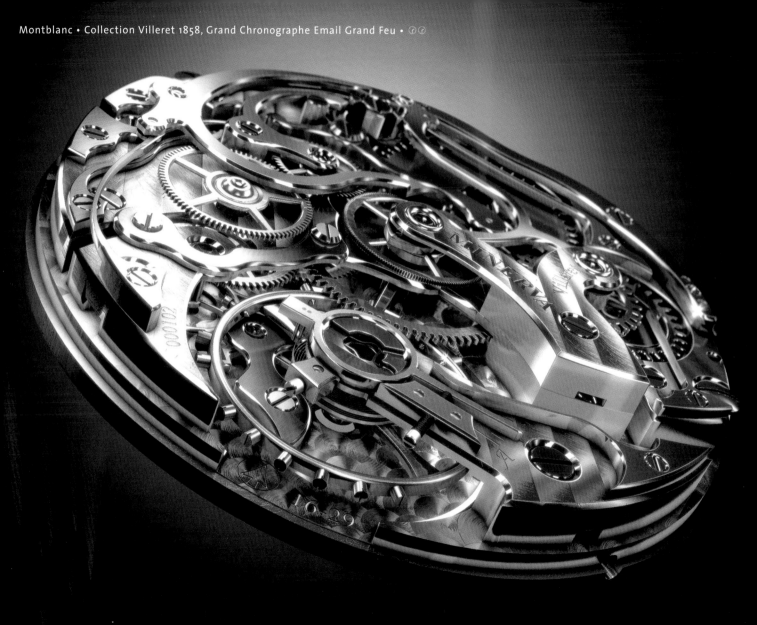

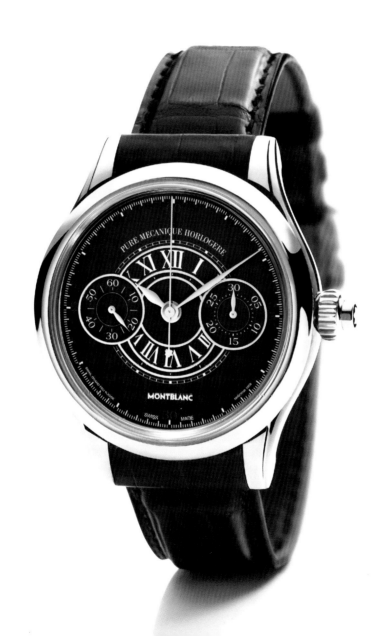

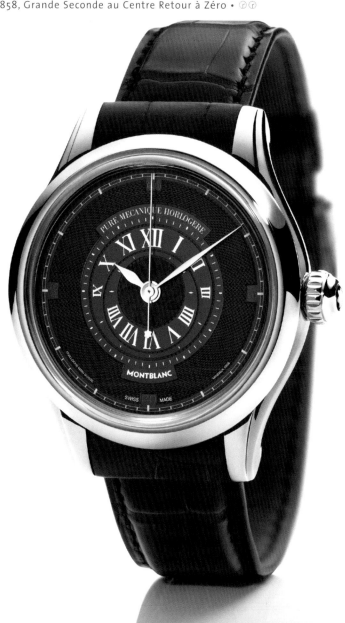

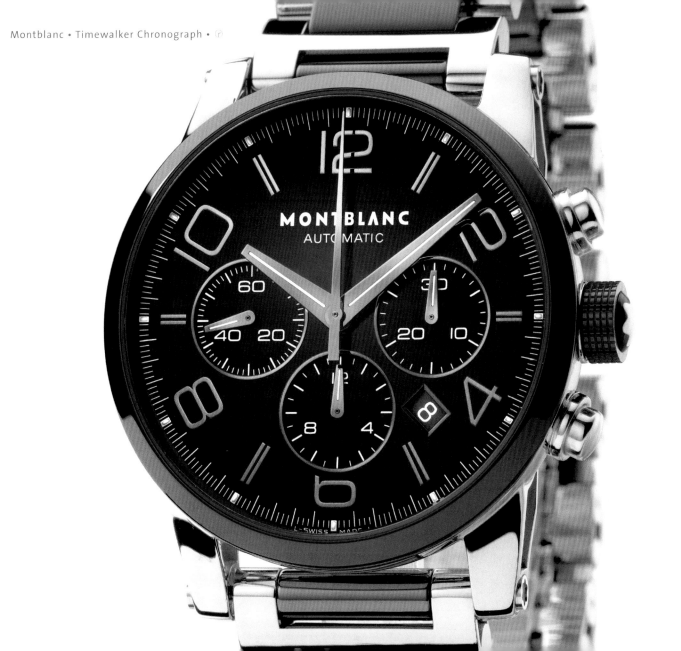

MONTBLANC
LE LOCLE

D.N POWER RESERVE - UP

THIRTY-THREE (33) JEWELS

SWISS MADE

Cal. MB R100

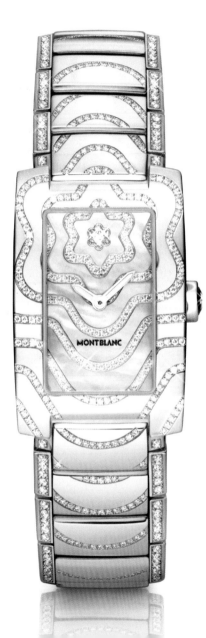

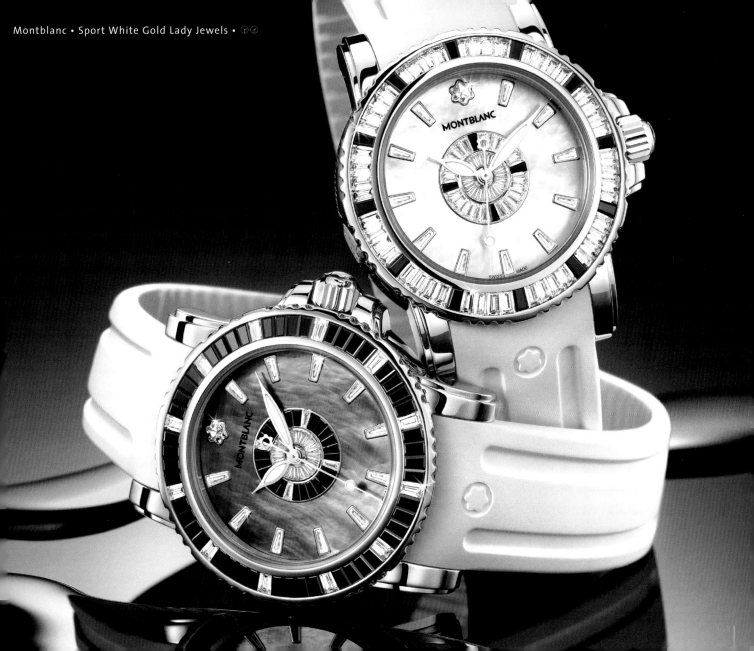

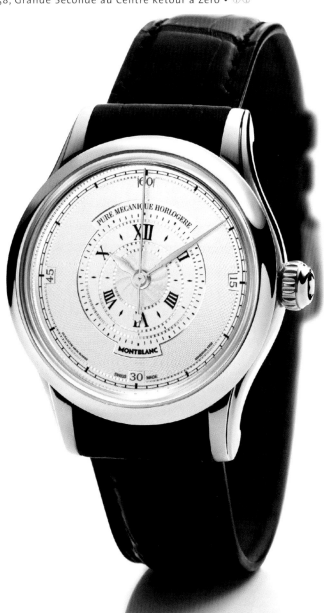

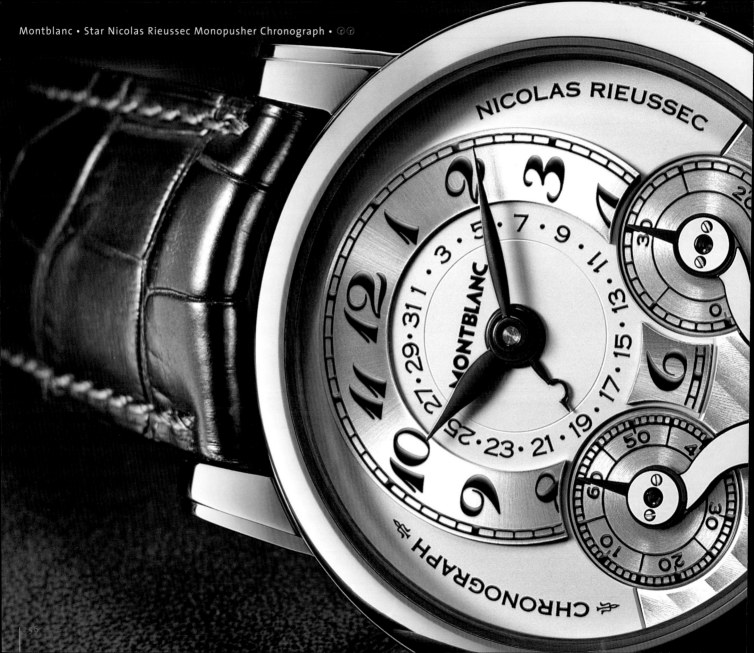

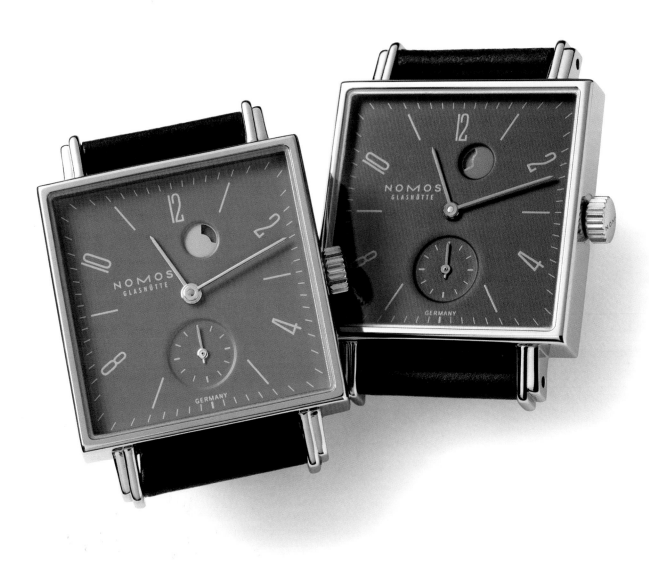

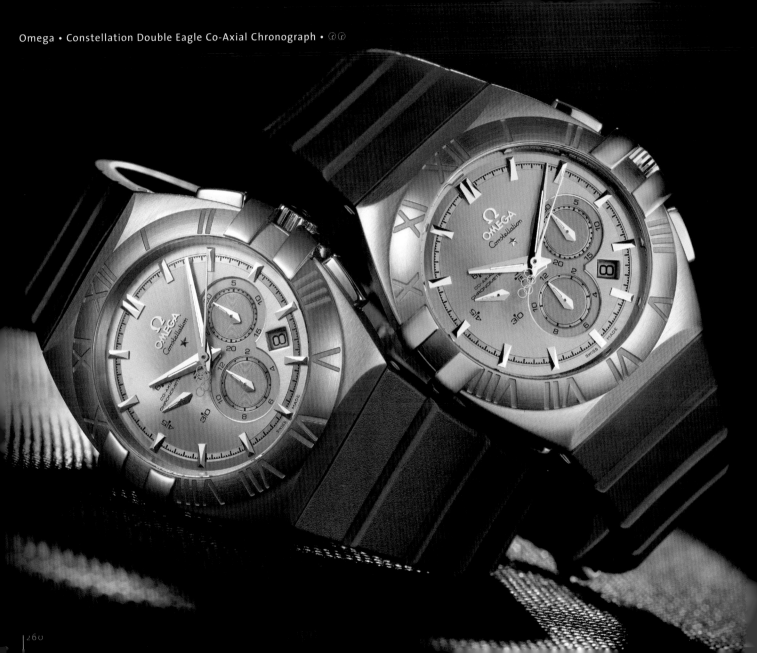

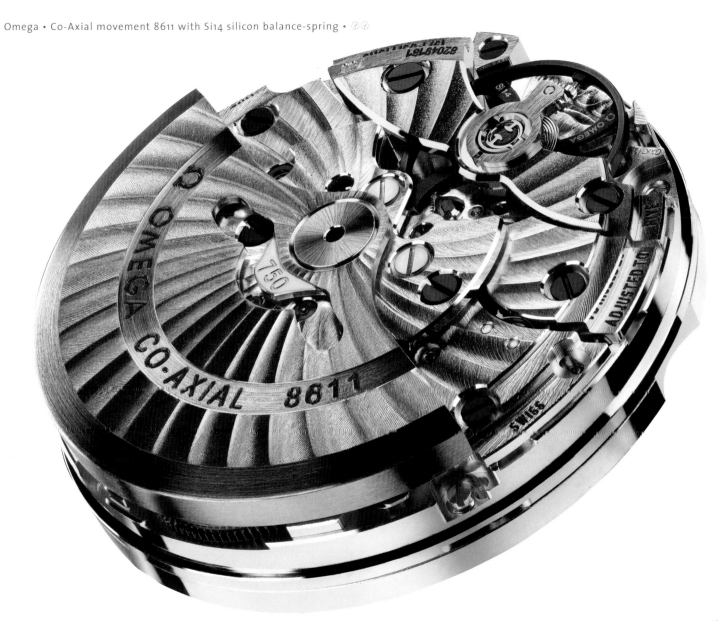

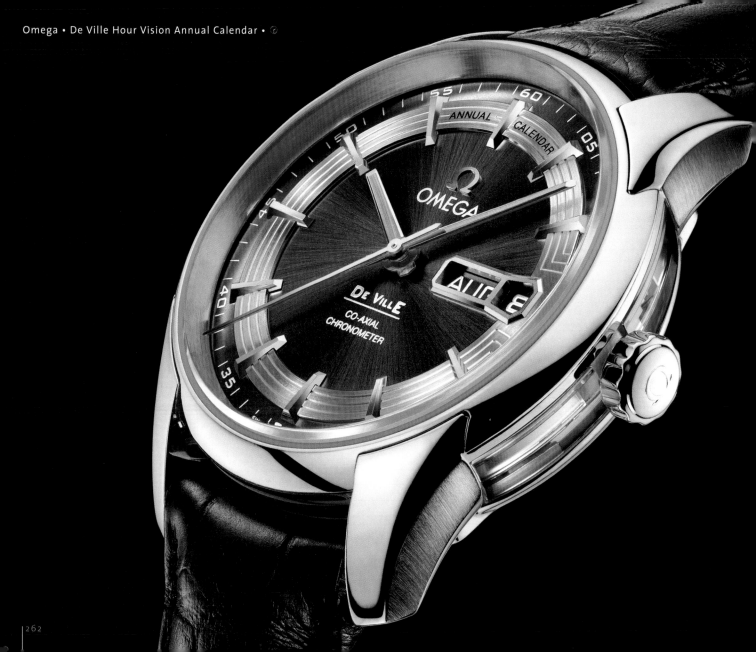

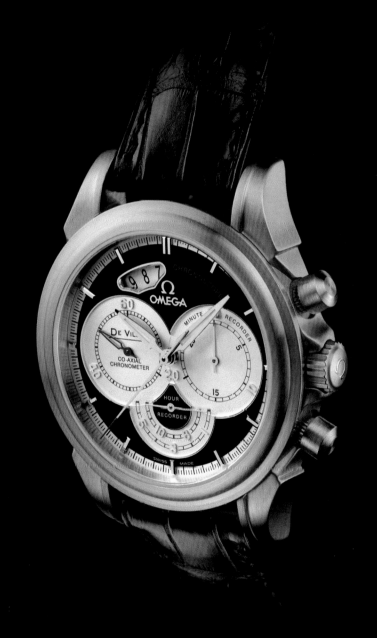

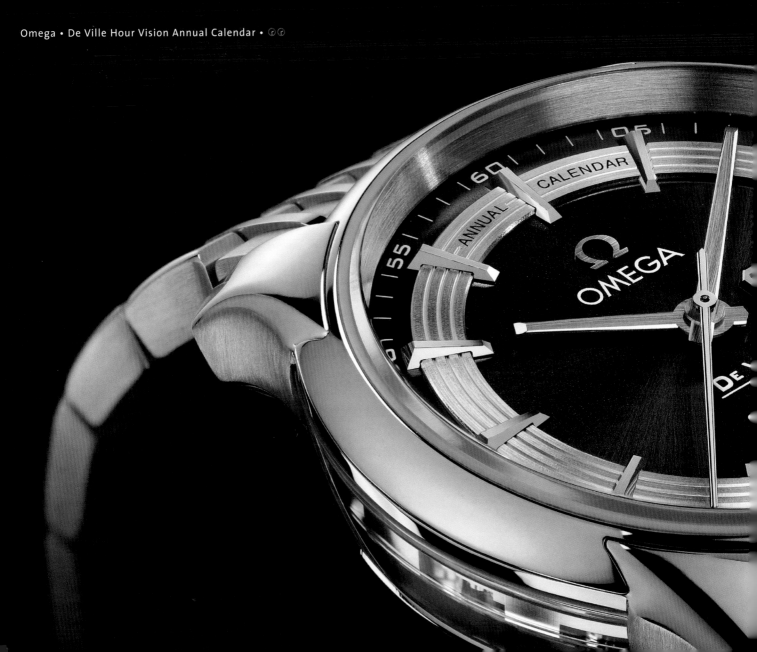

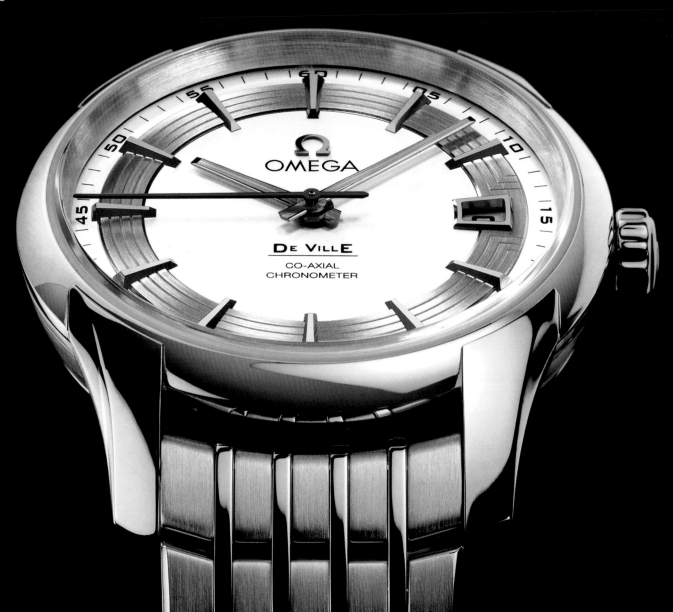

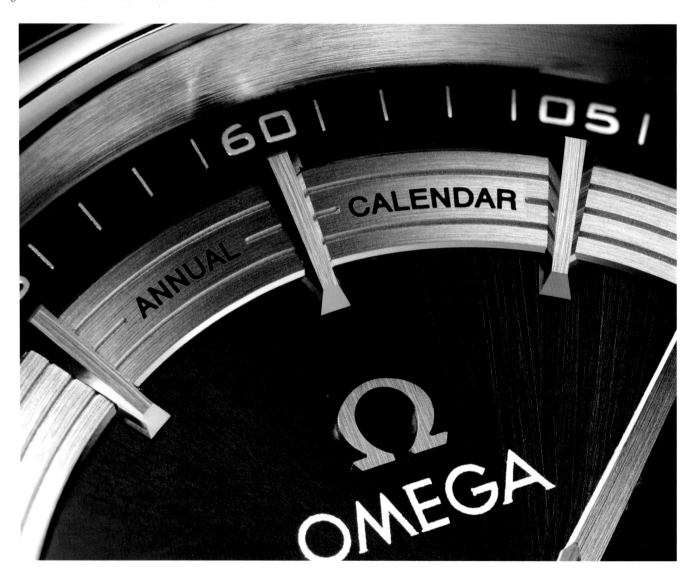

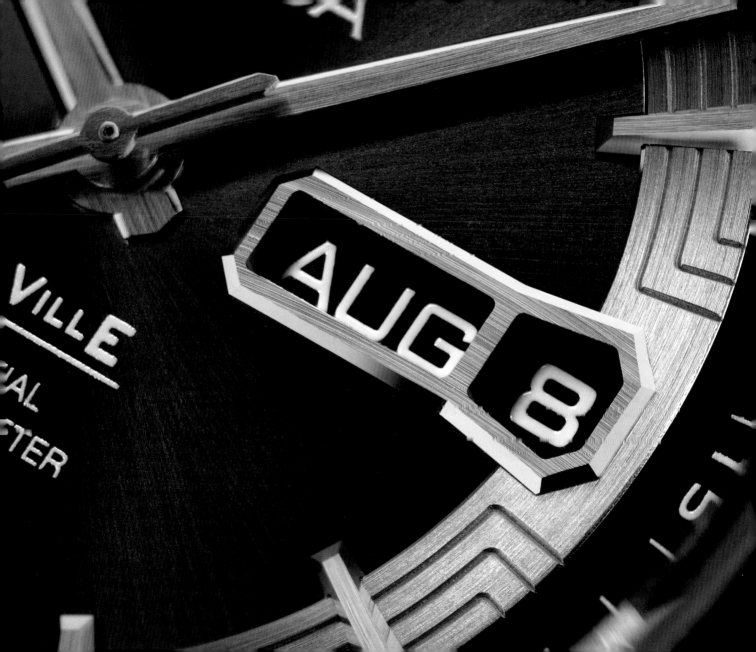

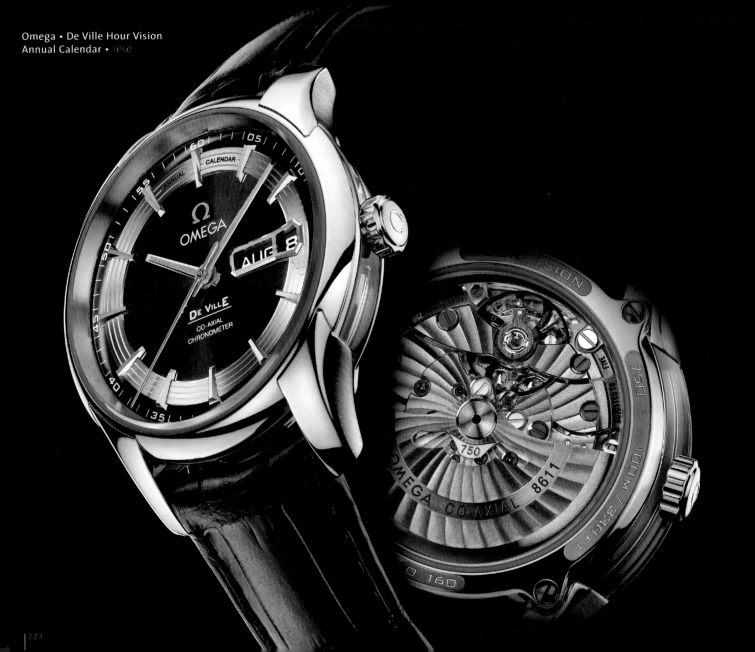
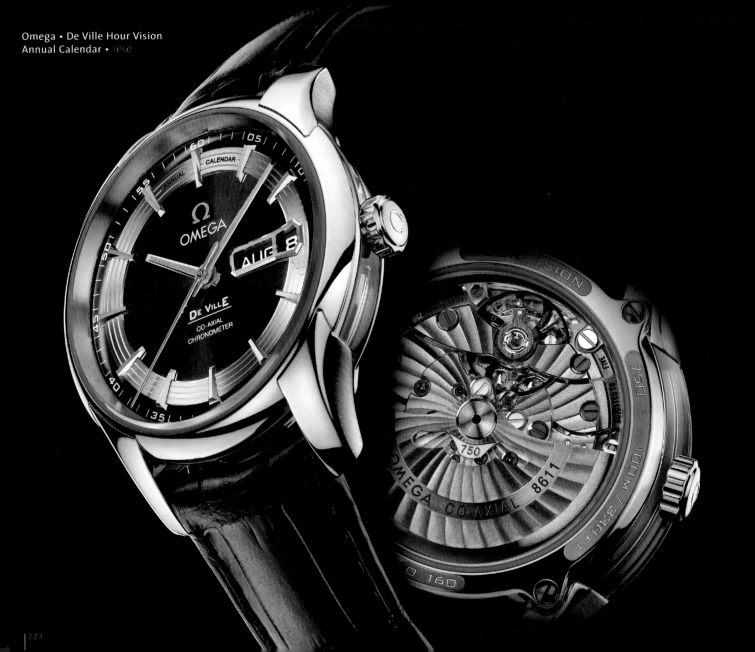

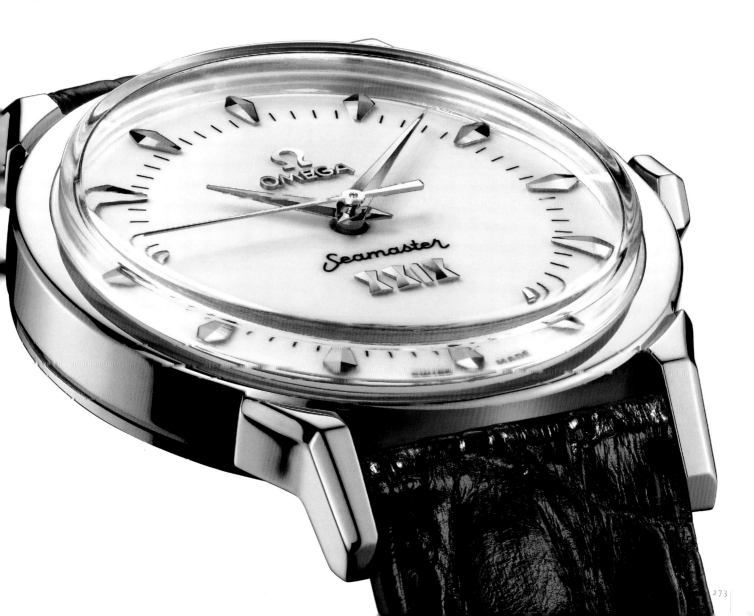

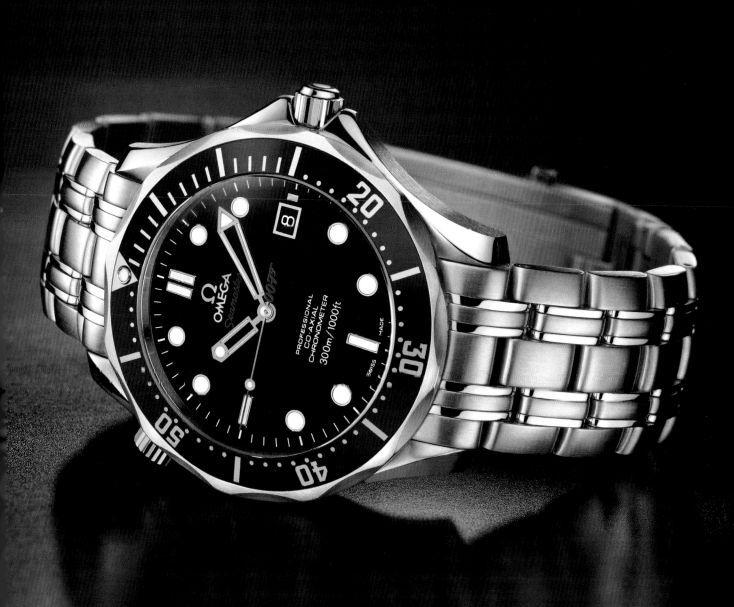

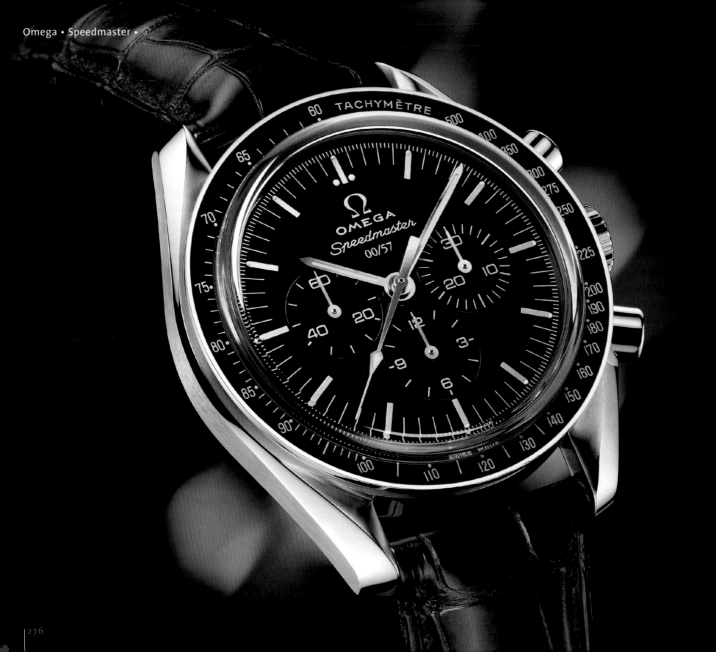

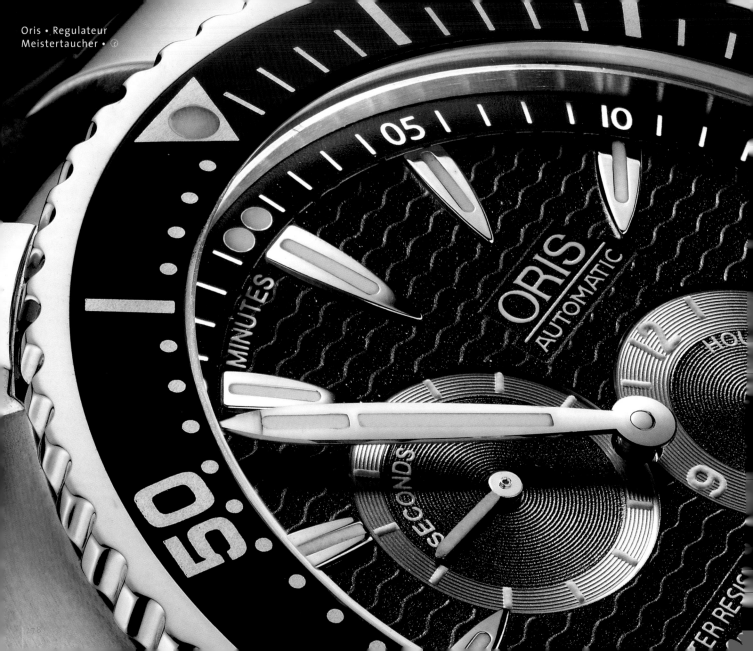

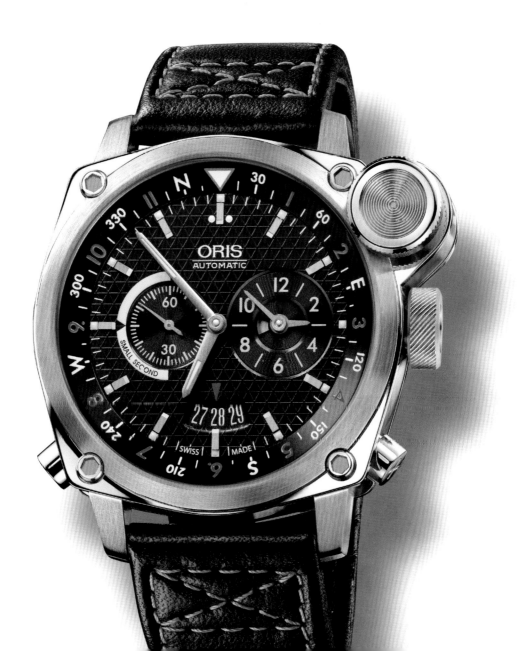

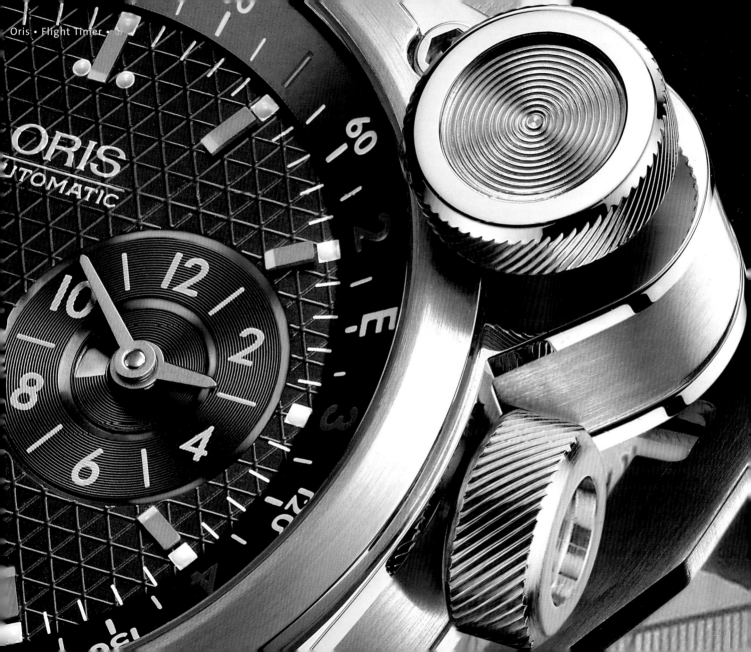

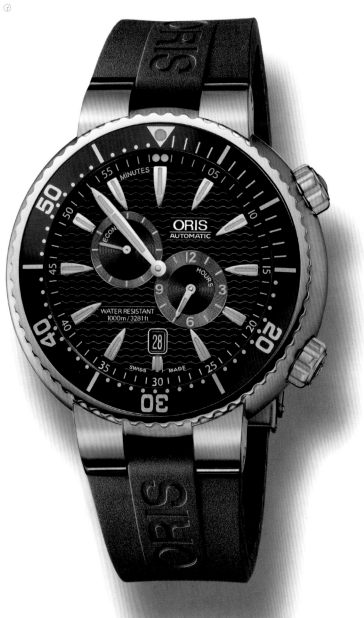

ORIS 7601

SWISS MADE

Oris Williams Limited Edition

18K GOLD 750

WR 3 BAR

Celebrating the 30th Anniversary of the Williams F1 Team

CRYSTAL

SAPPHIRE

WILLIAMS

1978 - 2008

ORIS

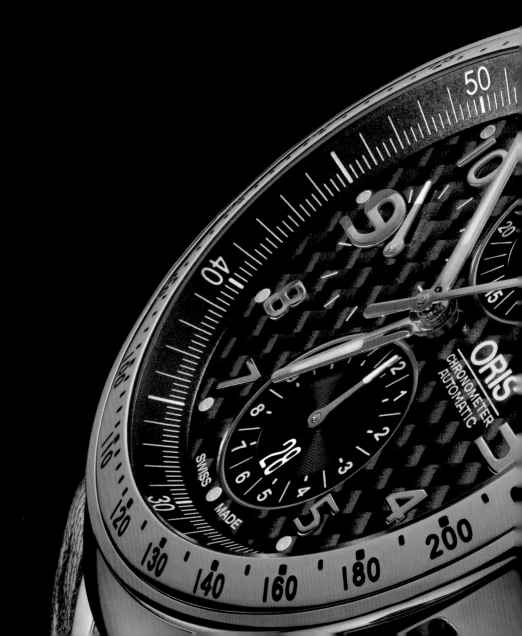

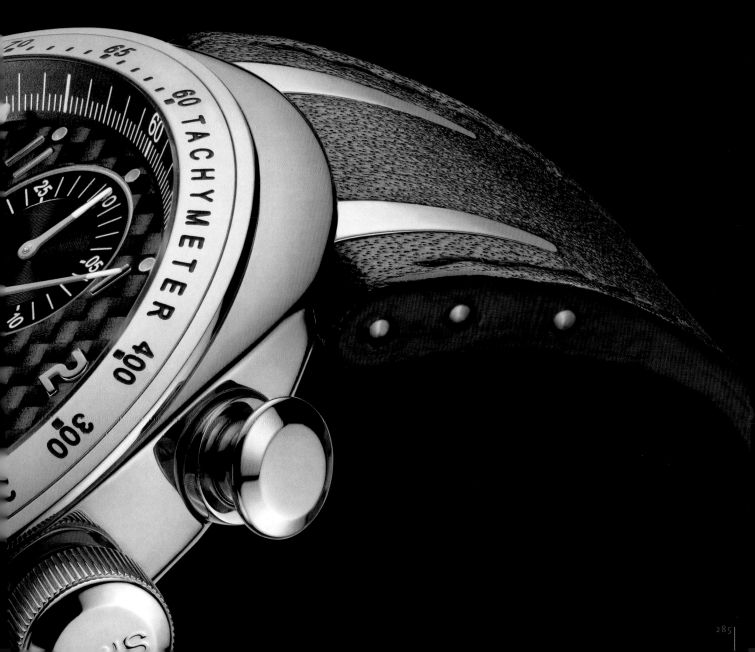

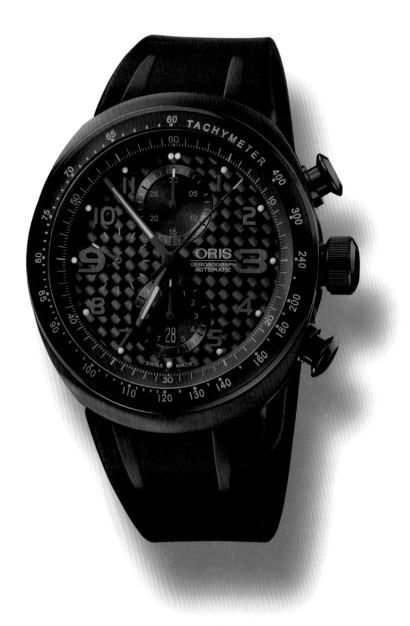

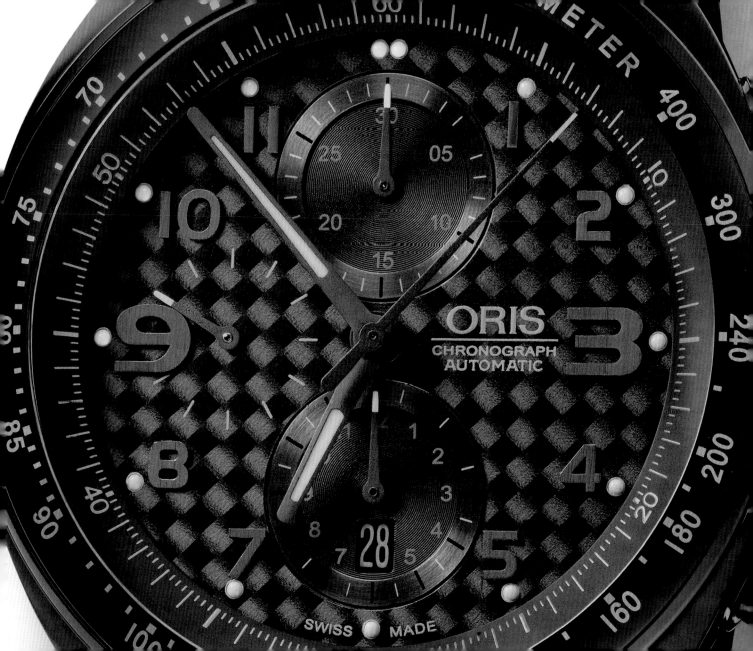

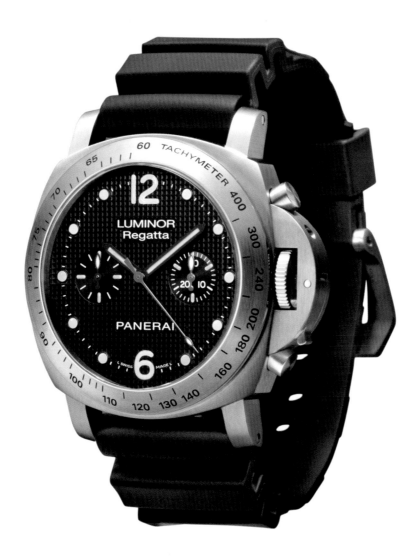

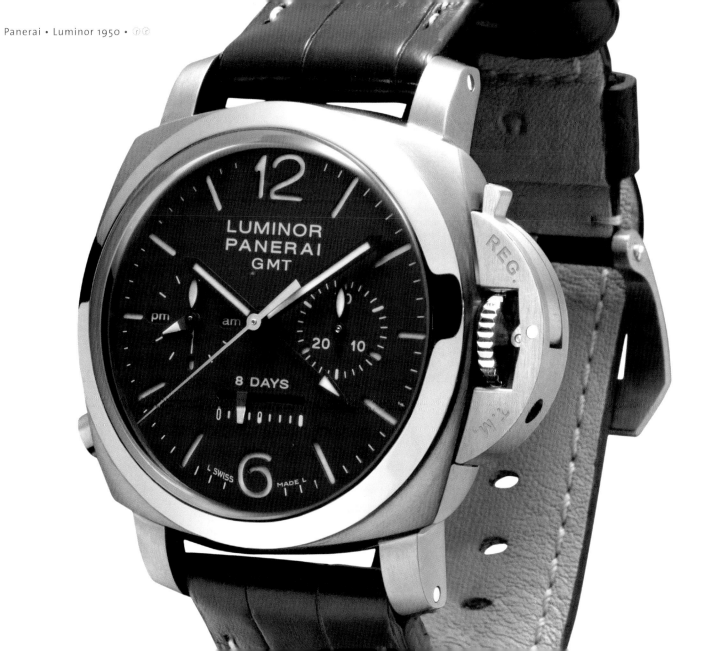

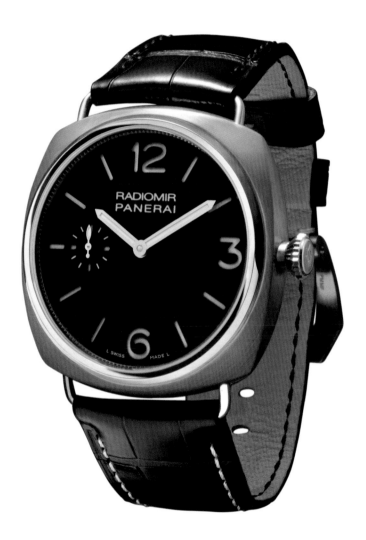

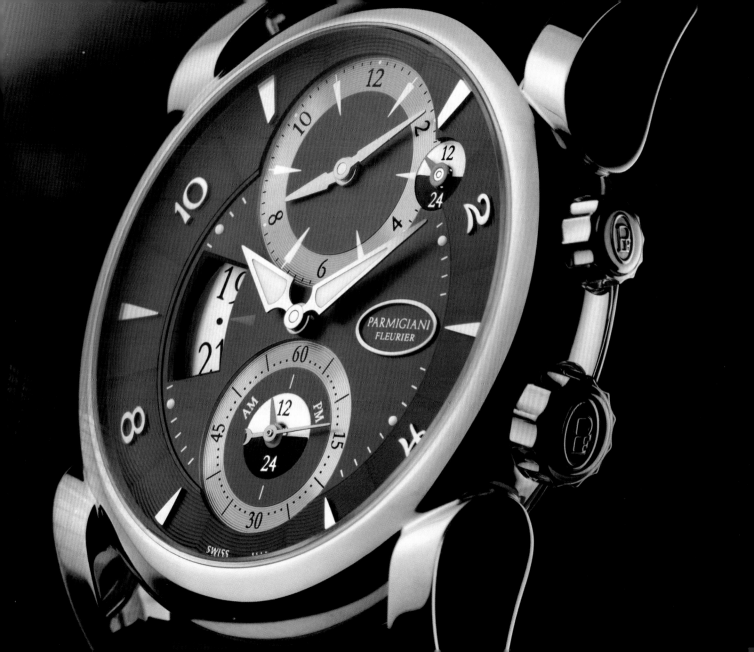

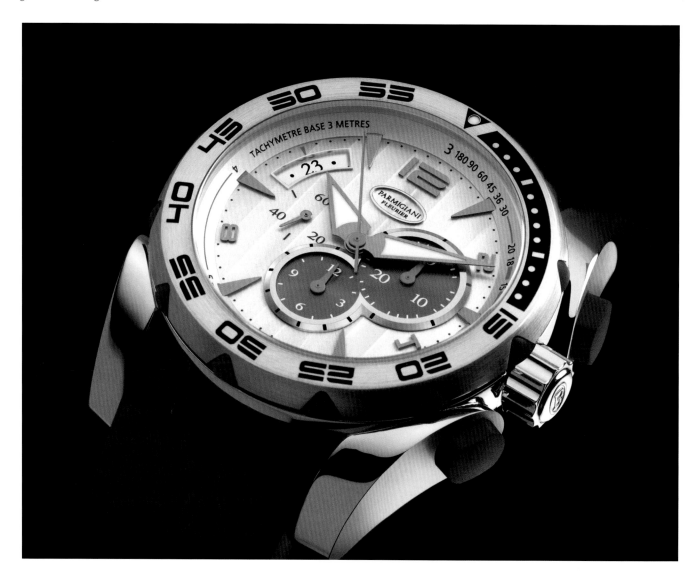

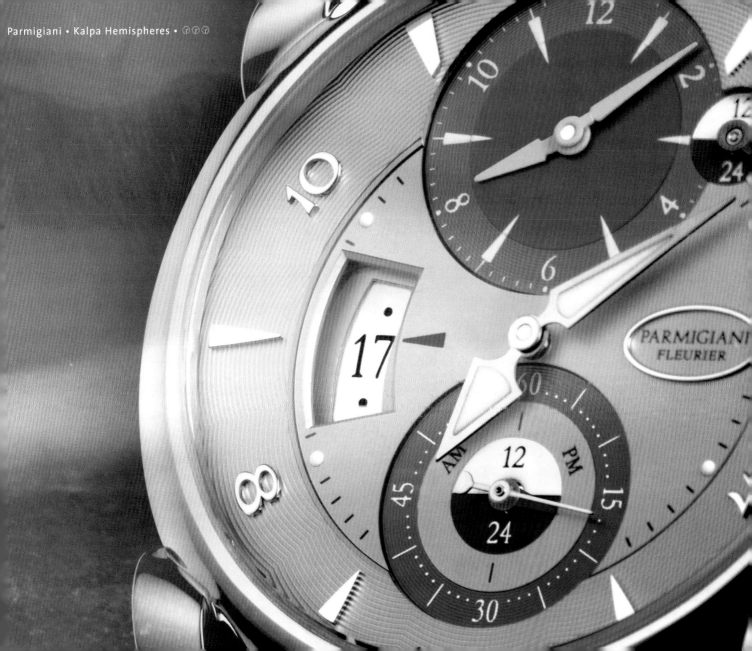

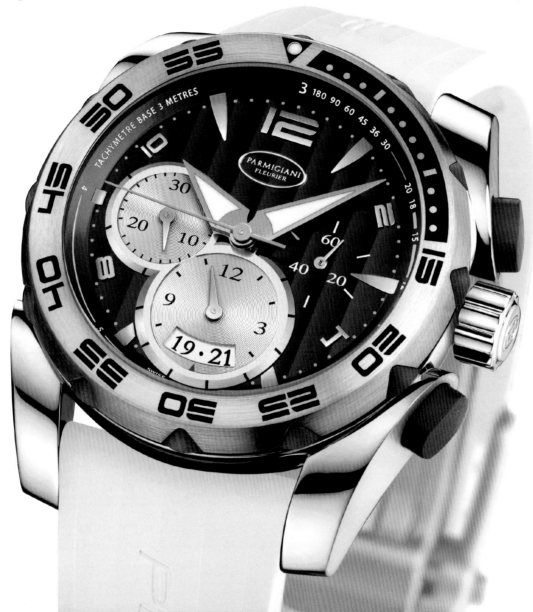

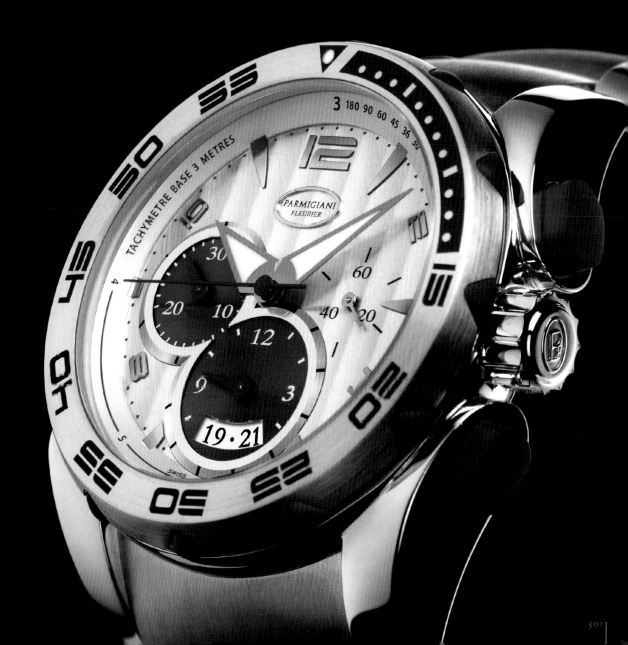

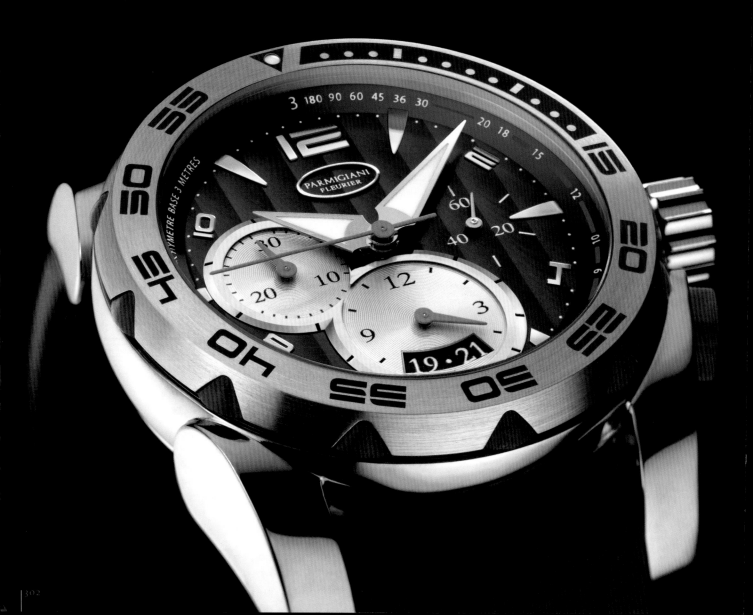

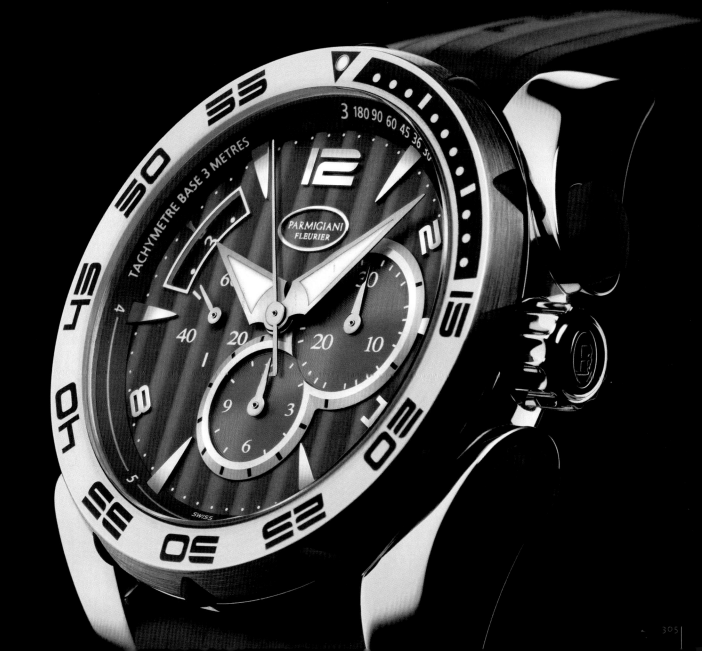

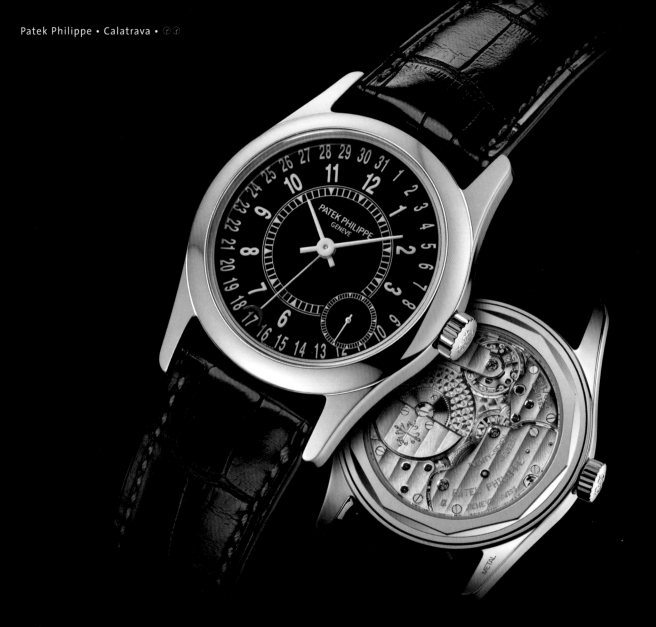

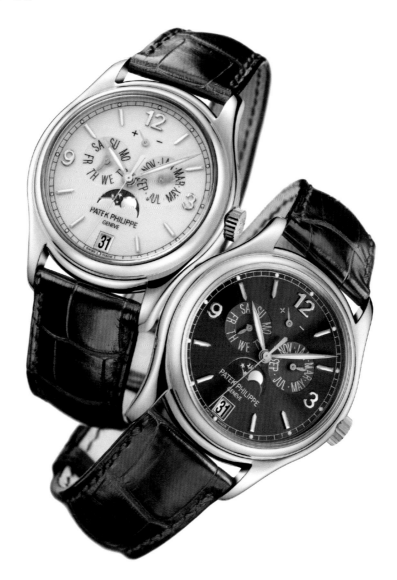

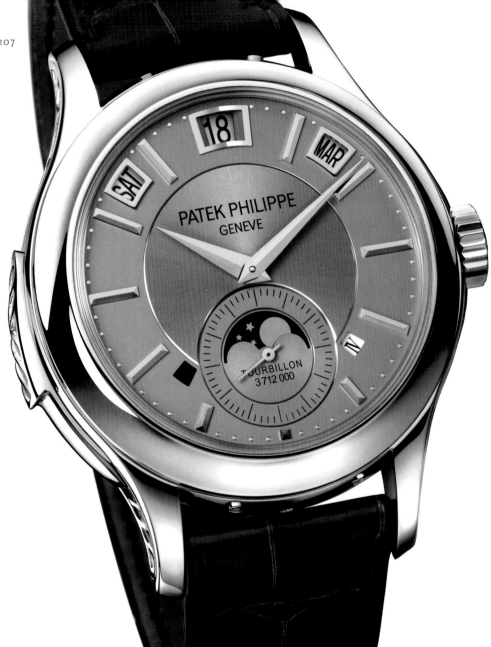

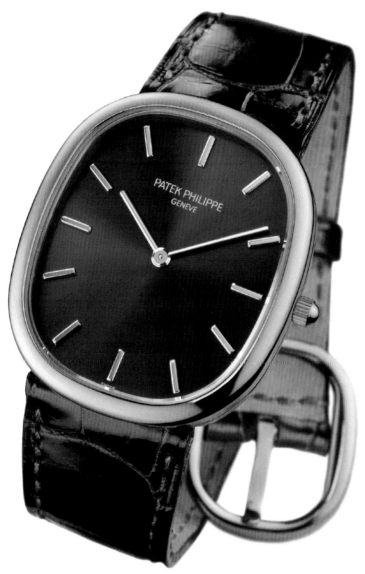

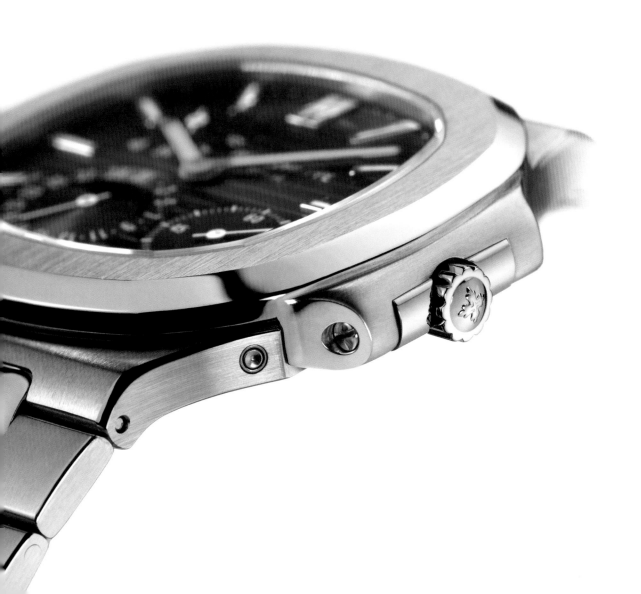

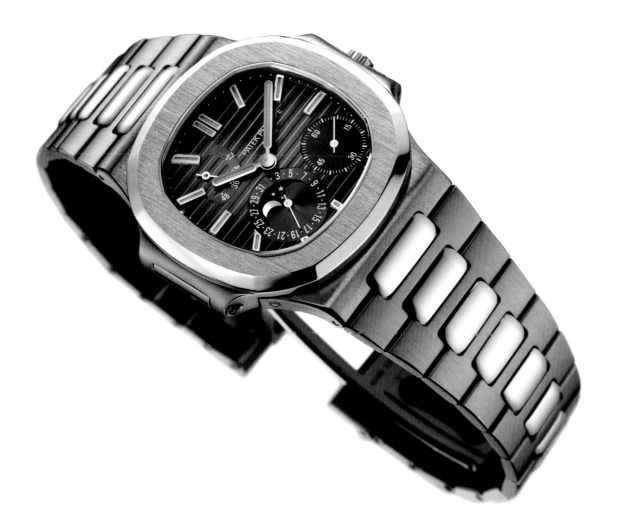

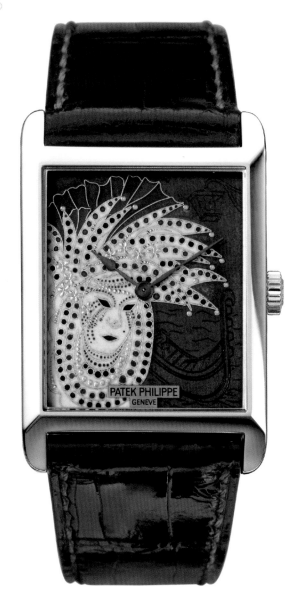

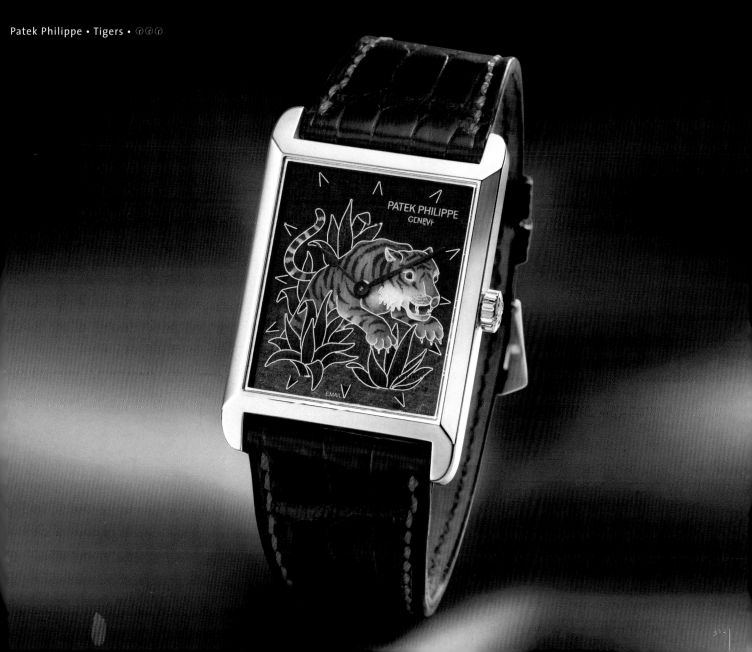

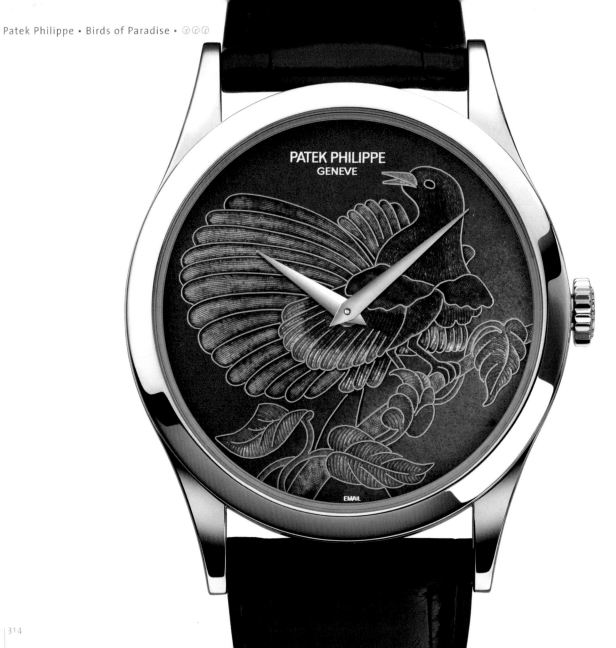

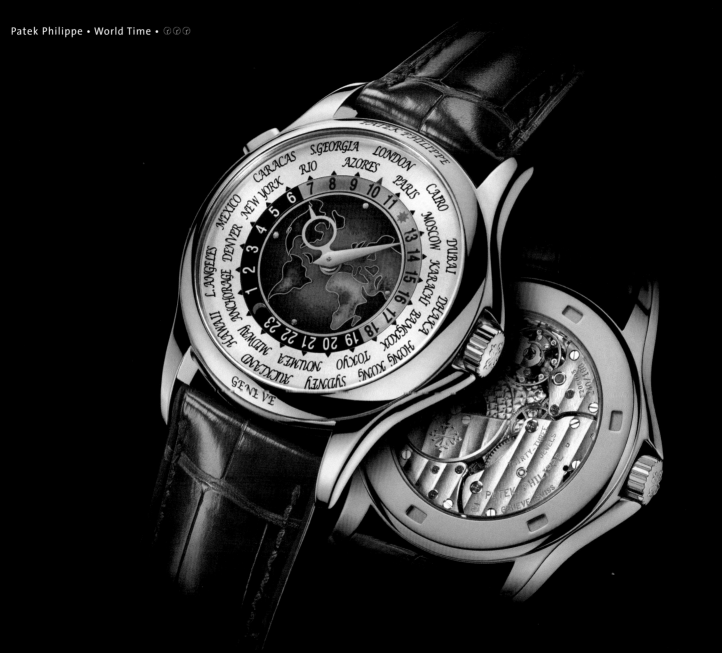

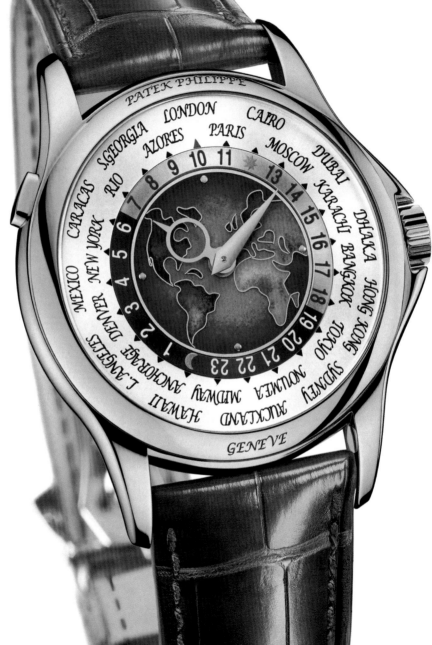

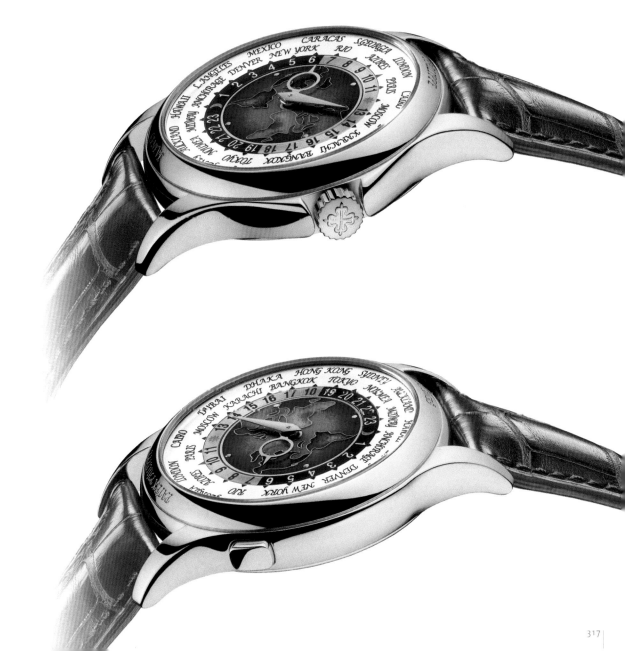

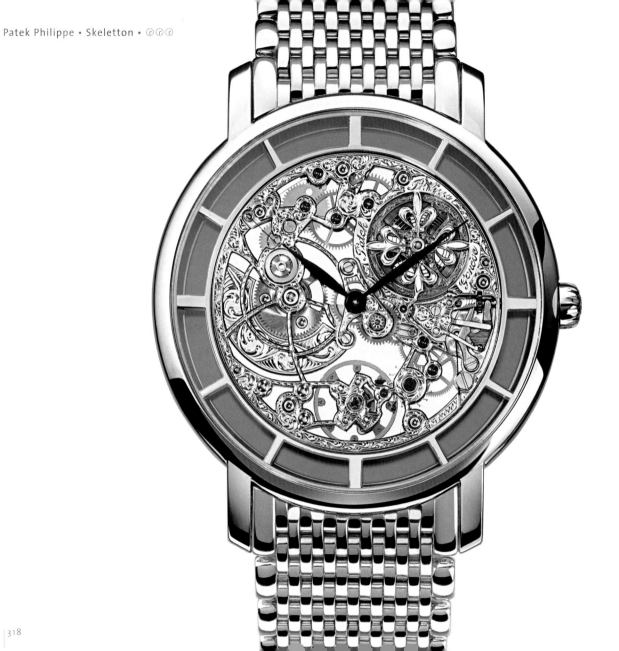

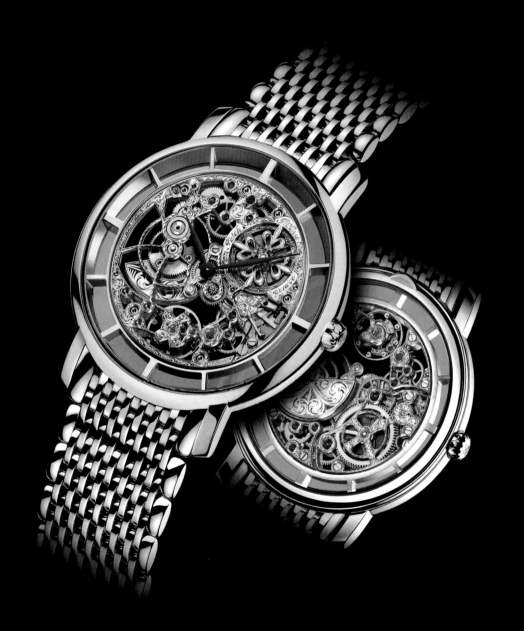

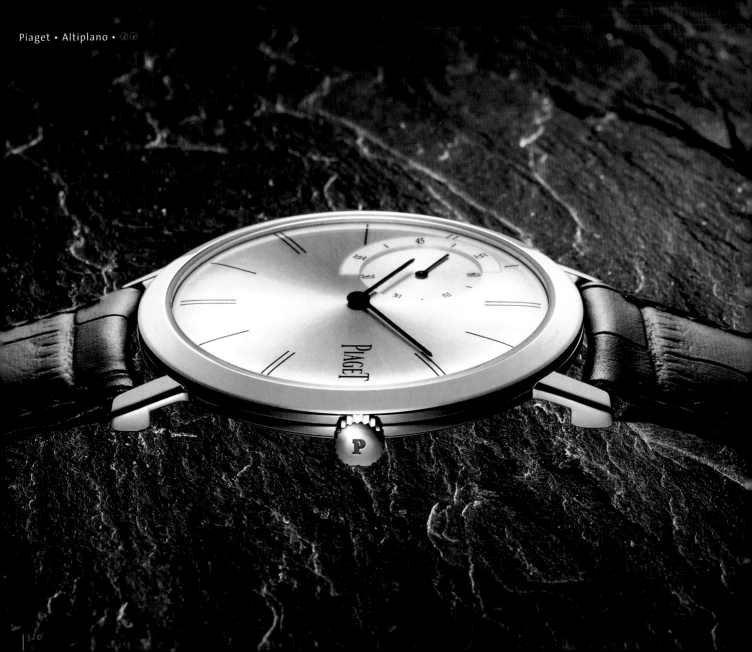

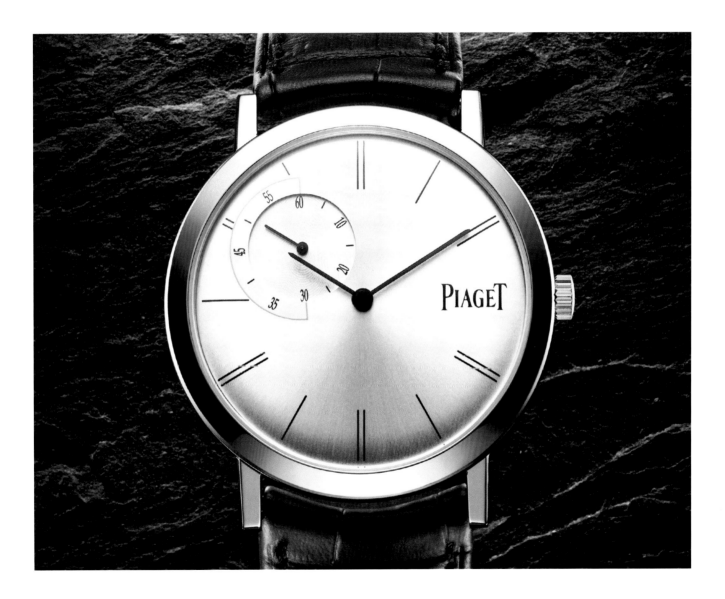

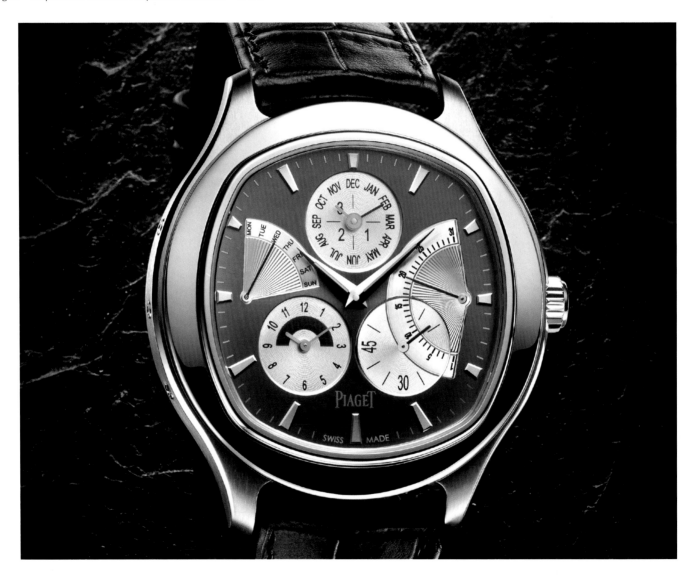

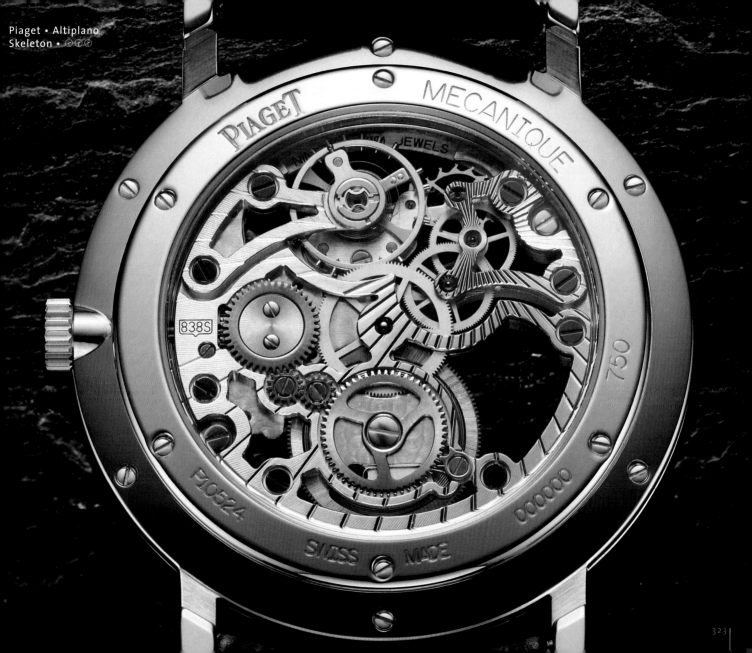

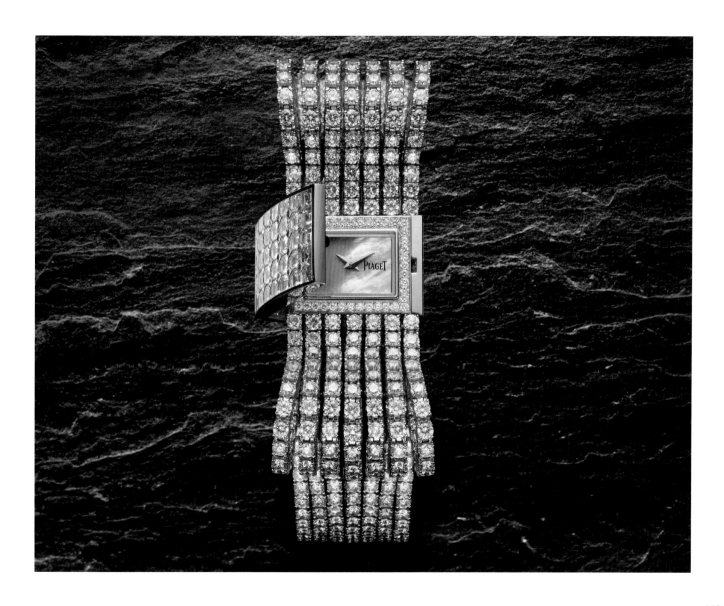

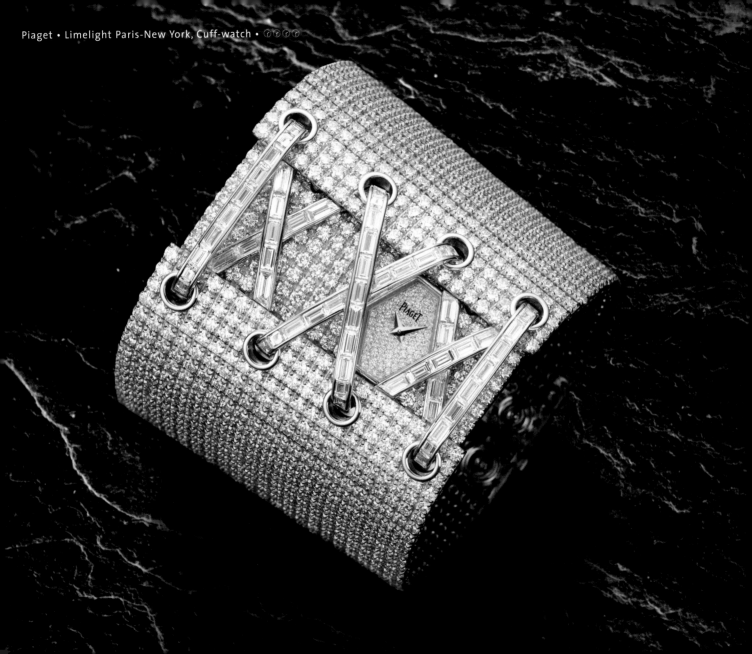

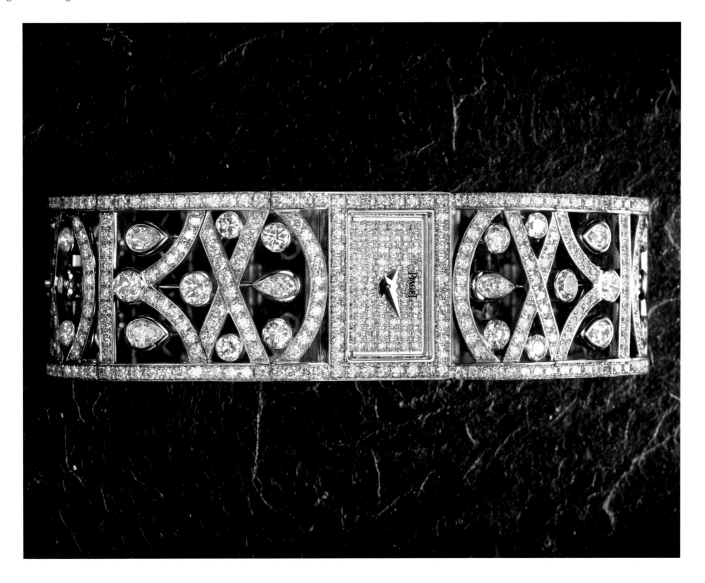

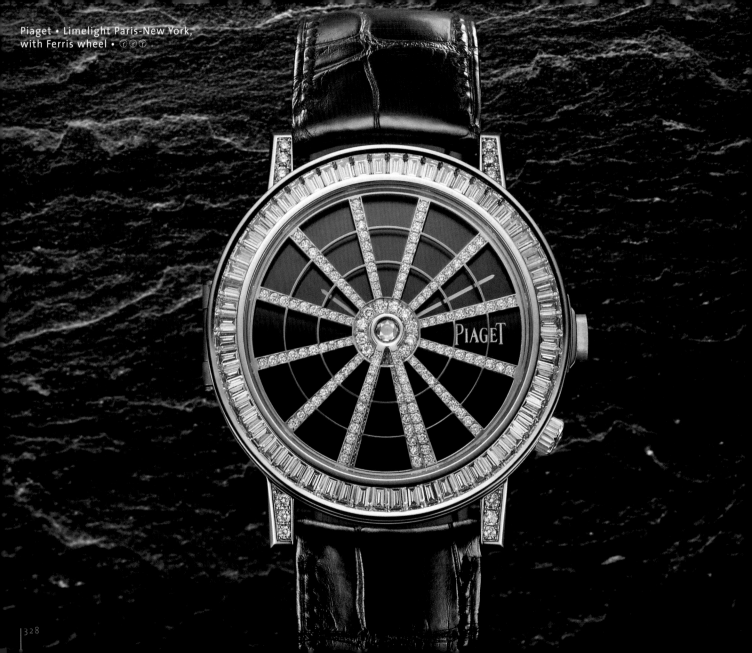

PIAGET

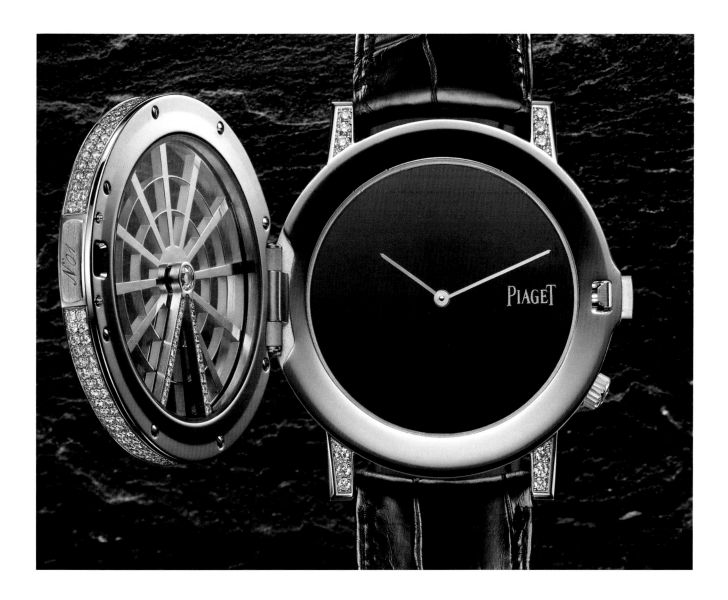

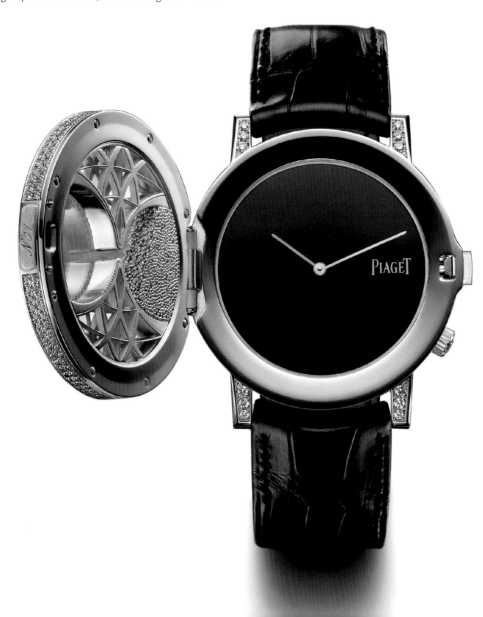

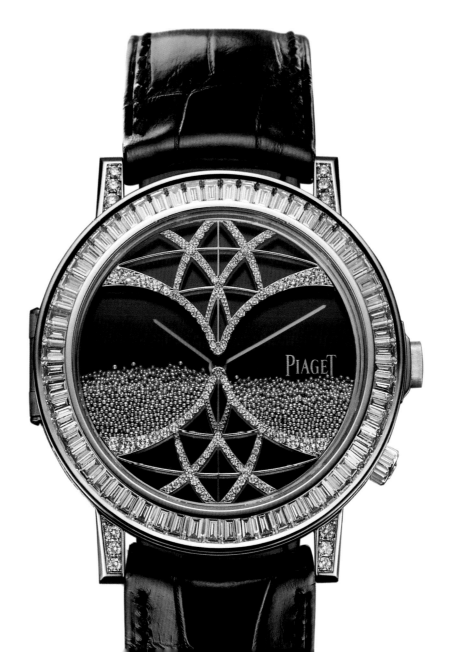

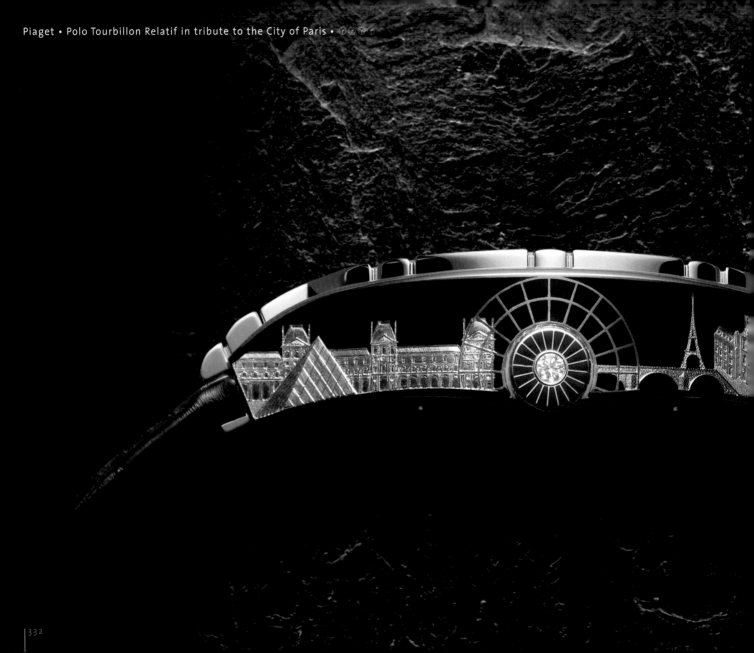

Piaget • Polo Tourbillon Relatif
in tribute to the City of Paris
• 🌀🌀🌀🌀

PIAGET

Paris

N°00

P10562

987709

750

SWISS MADE

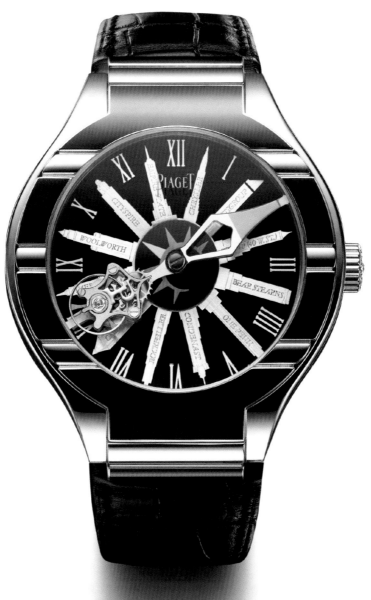

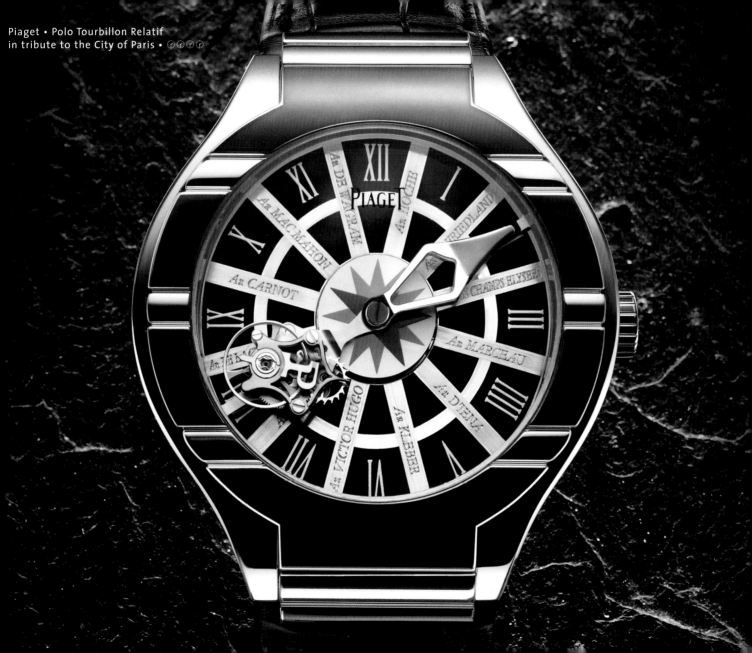

Piaget • Polo Tourbillon Relatif
in tribute to the City of Paris • ⊕⊕⊕⊕

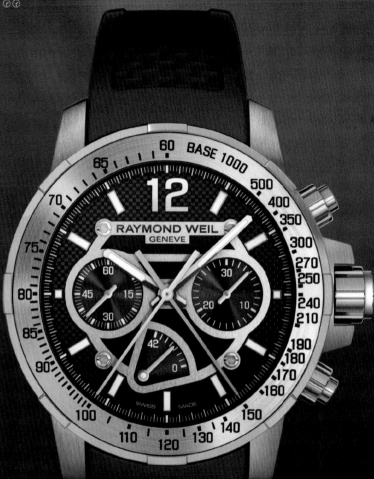

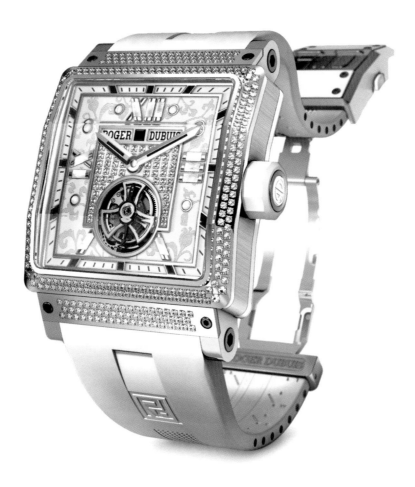

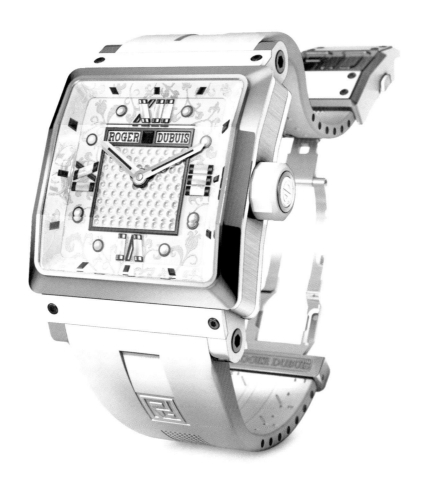

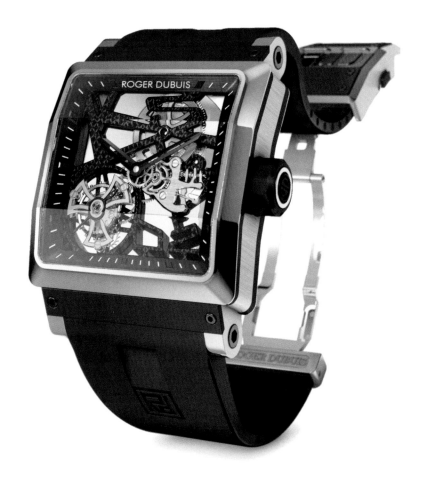

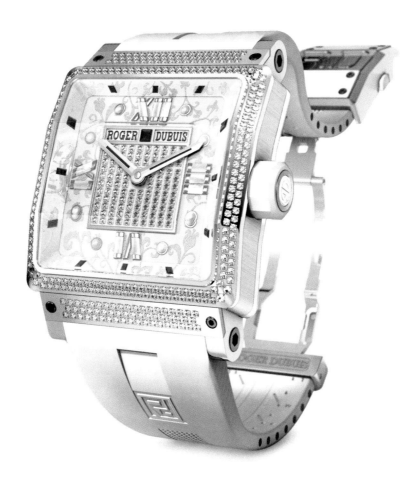

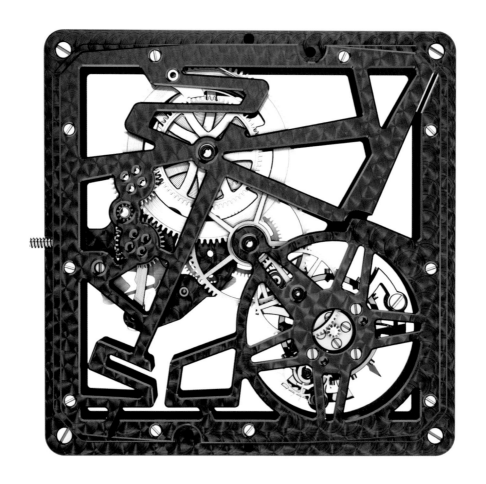

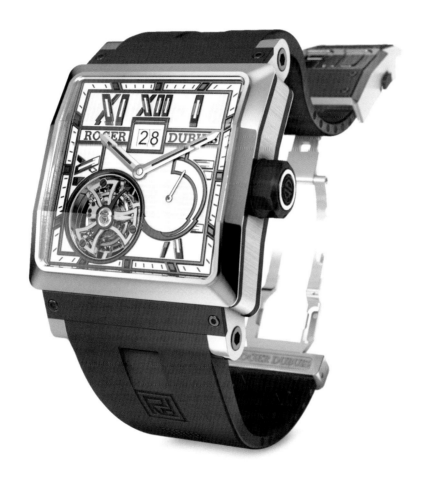

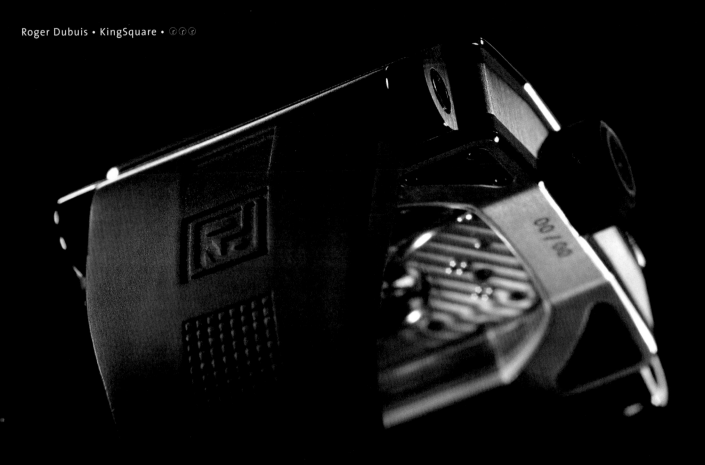

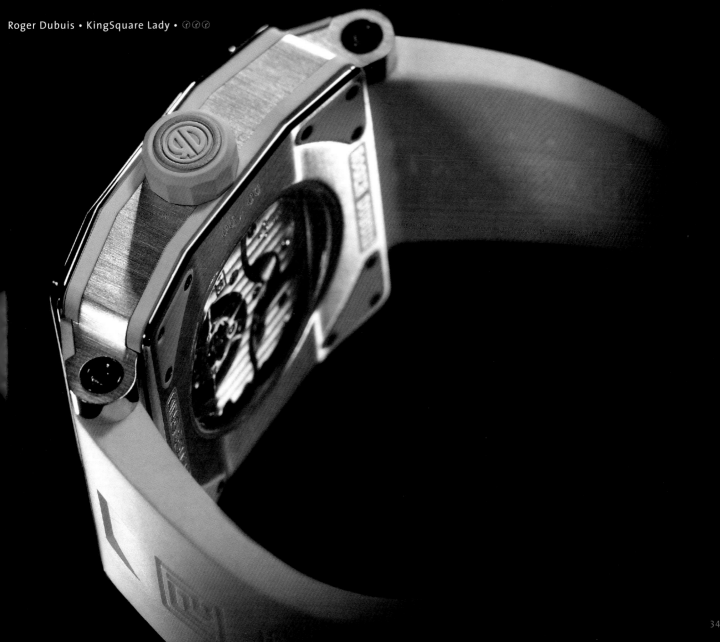

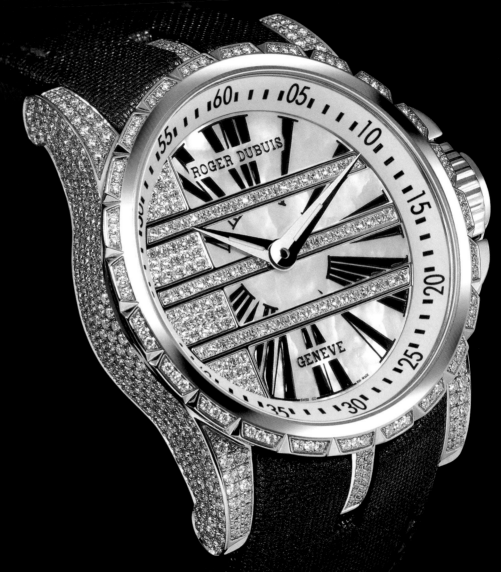

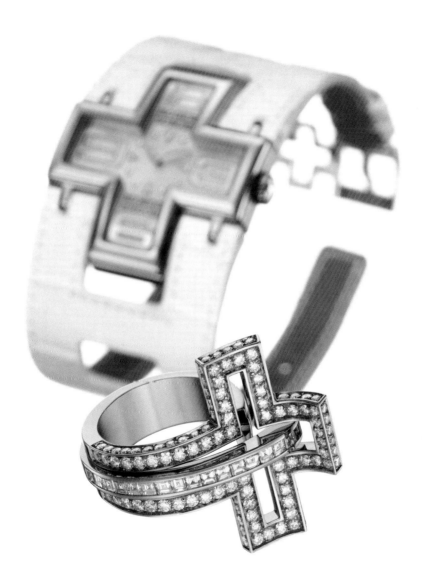

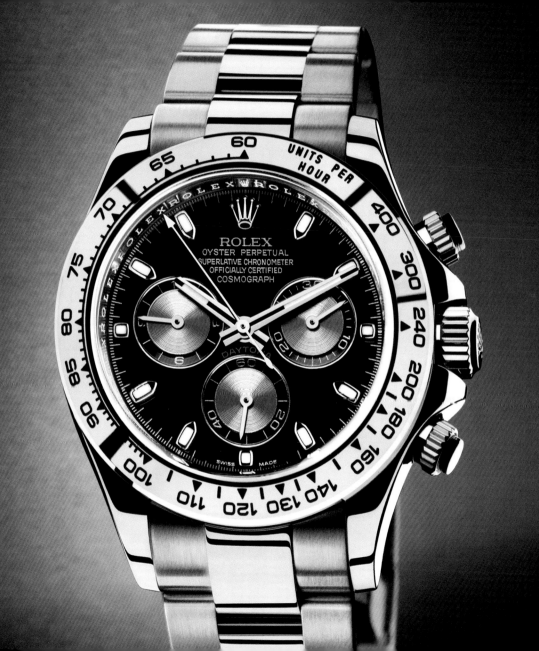

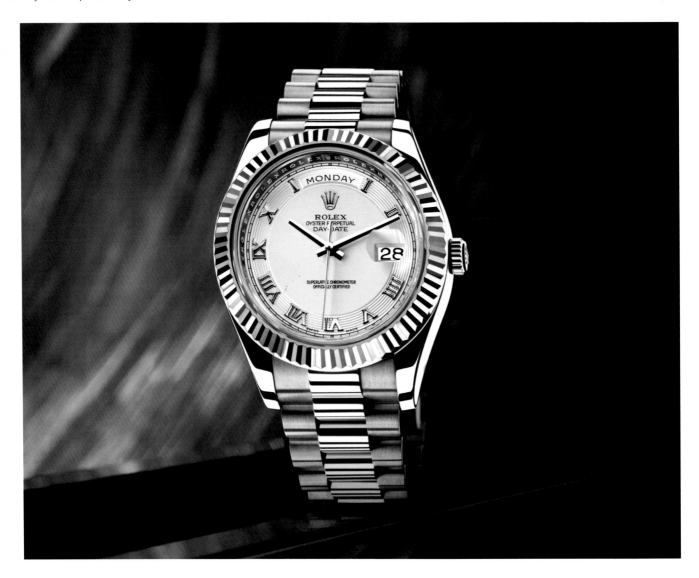

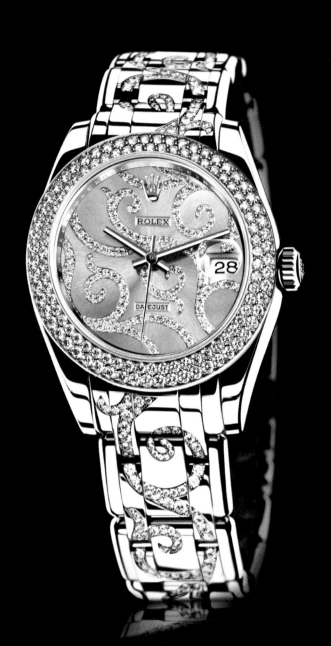

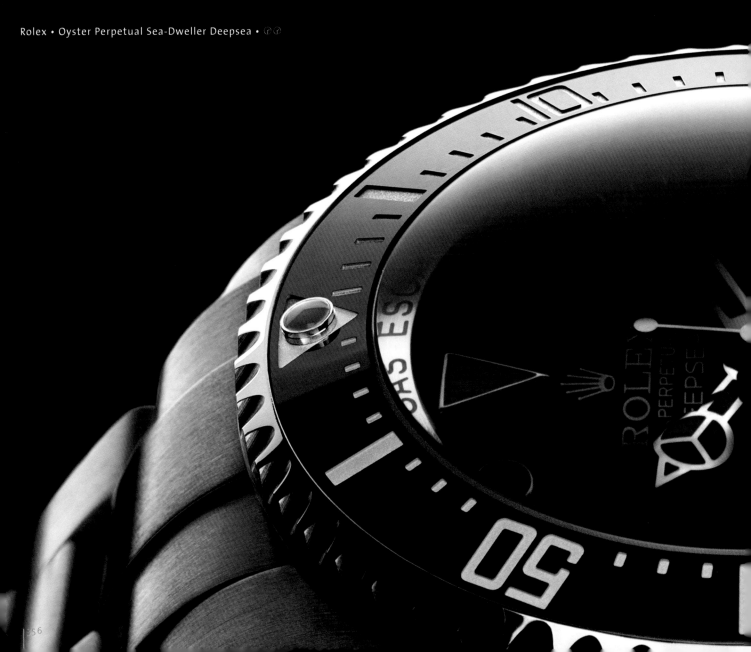

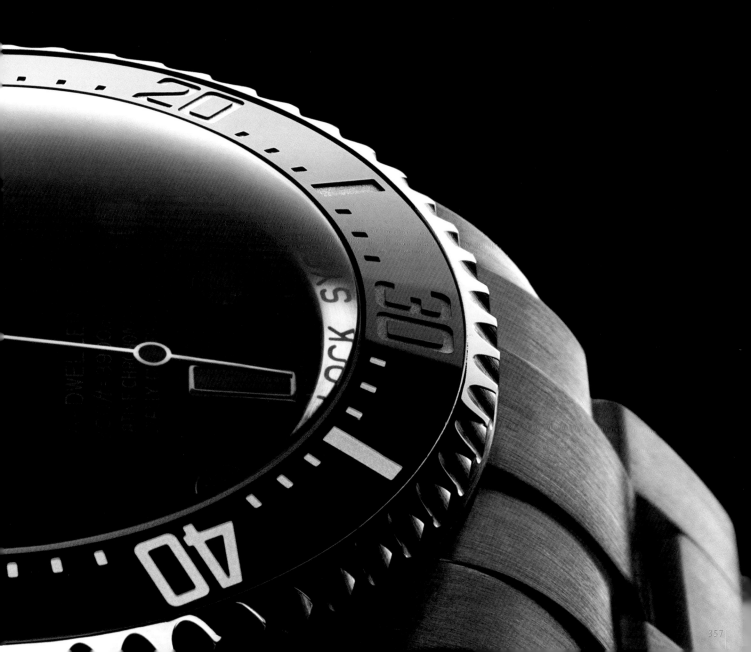

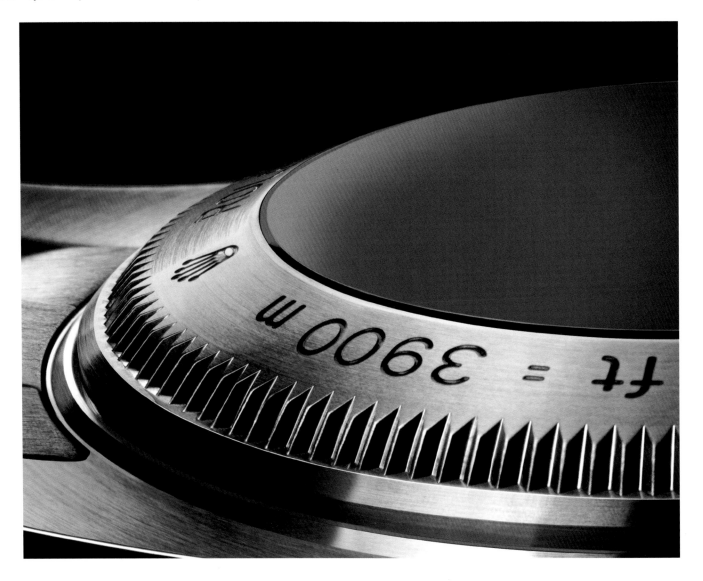

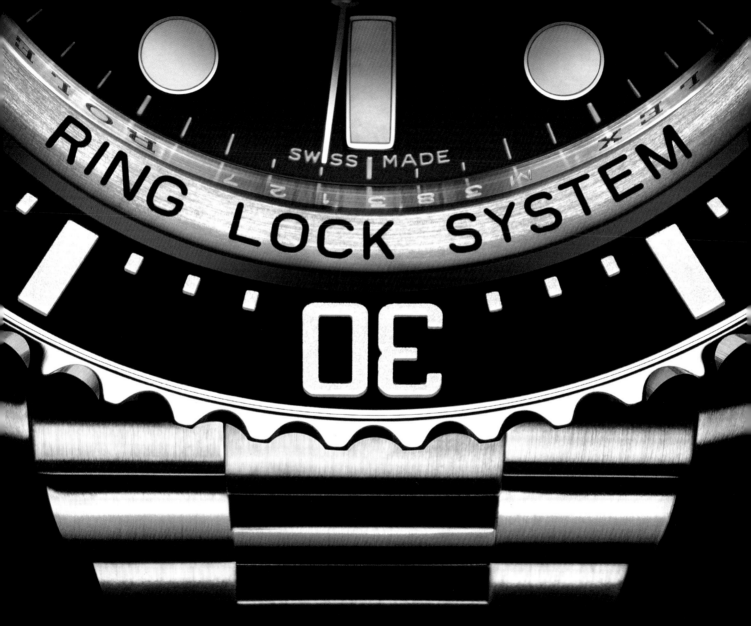

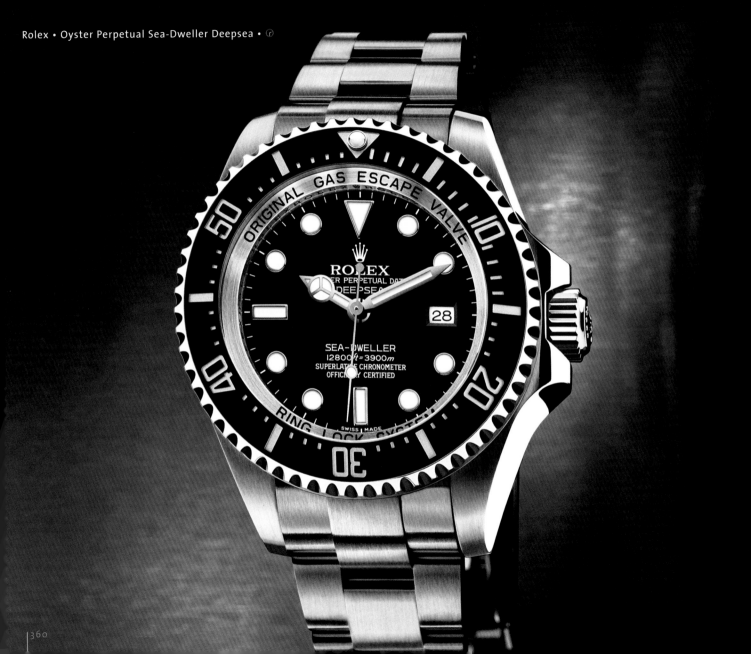

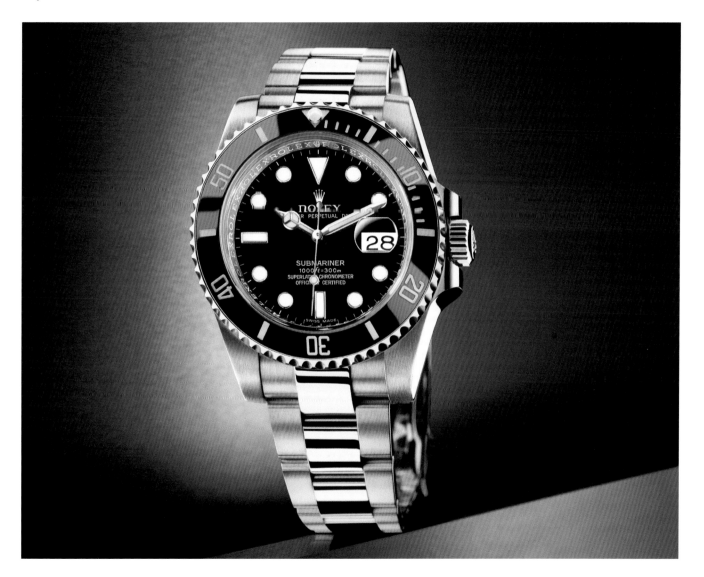

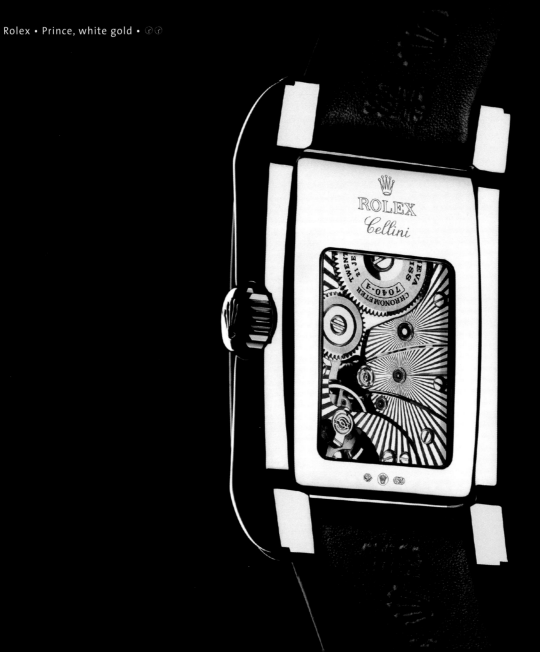

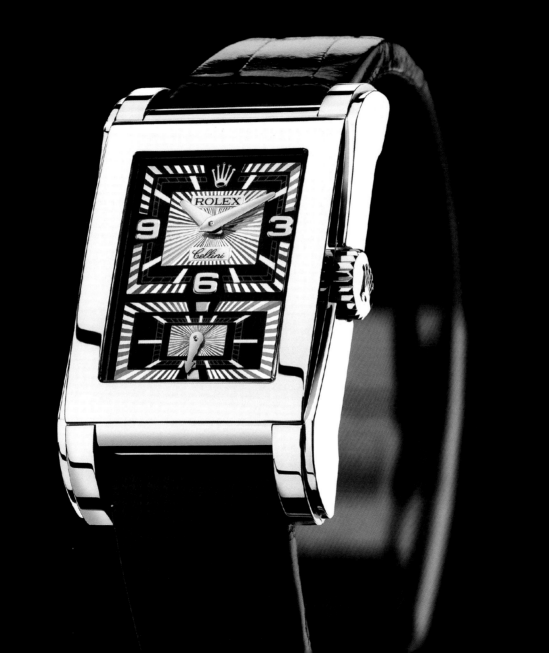

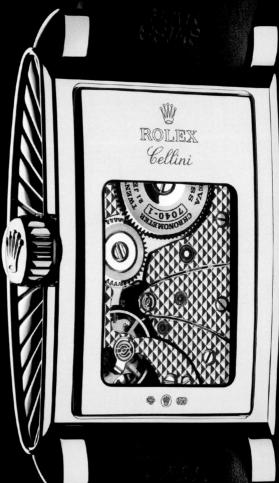

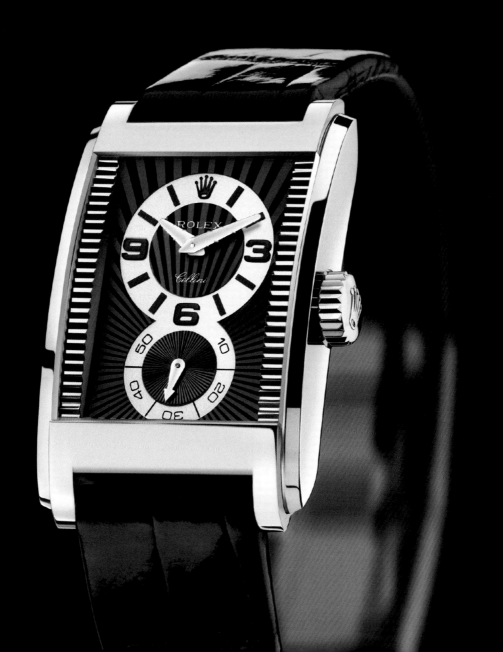

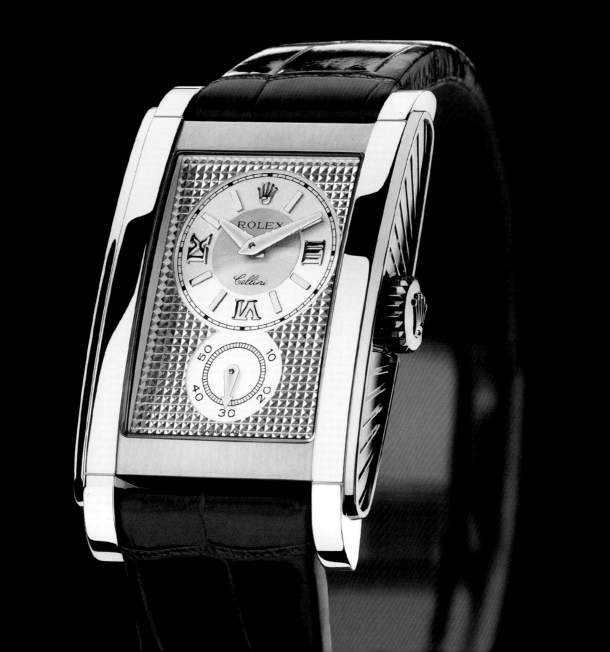

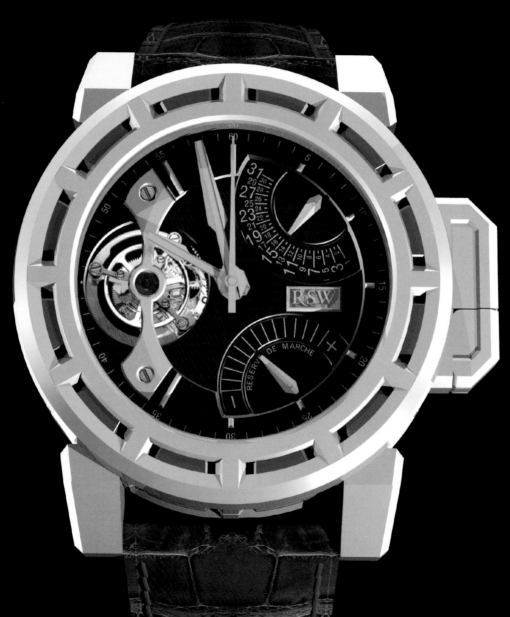

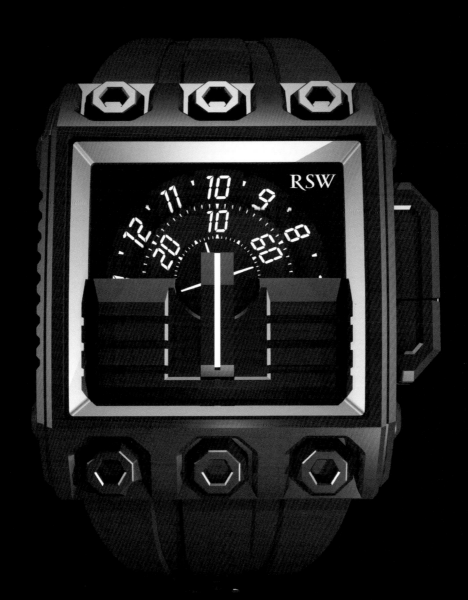

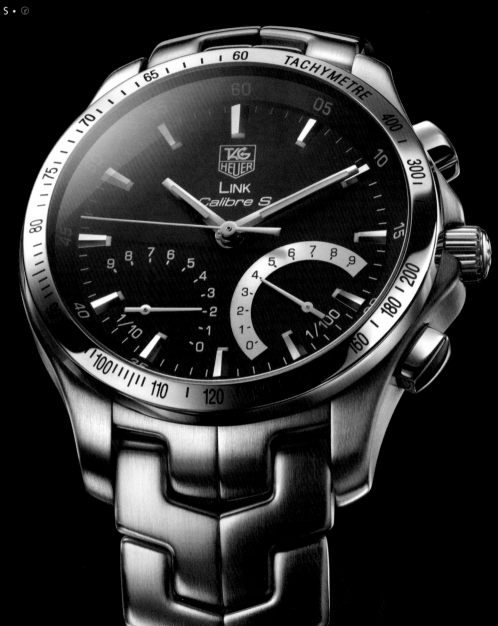

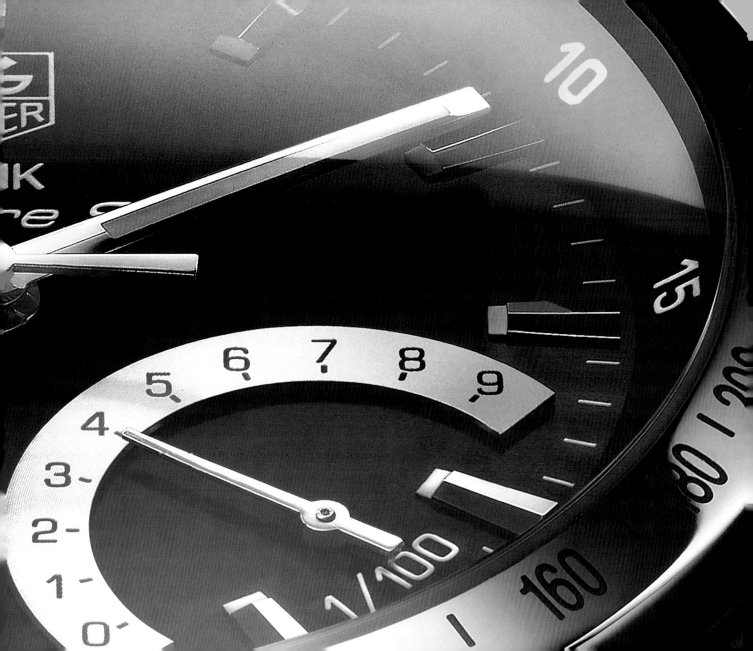

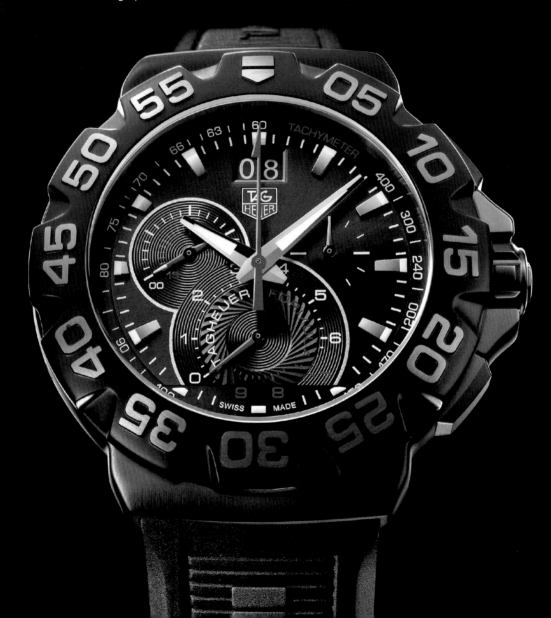

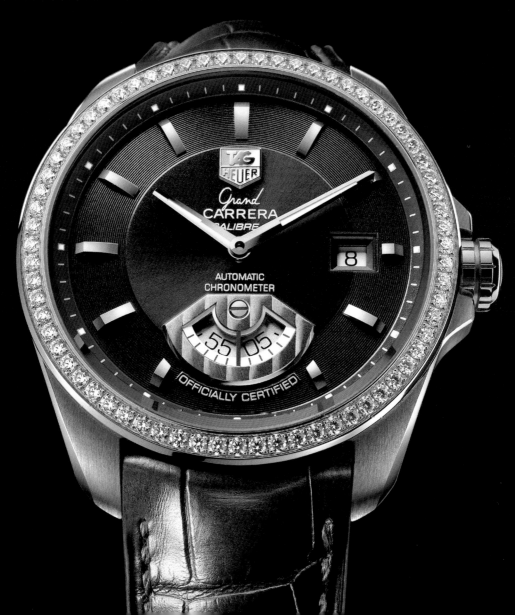

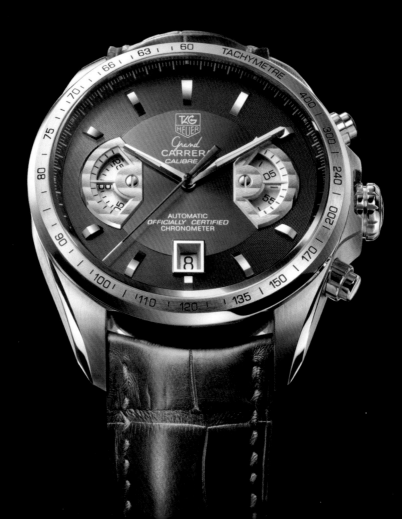

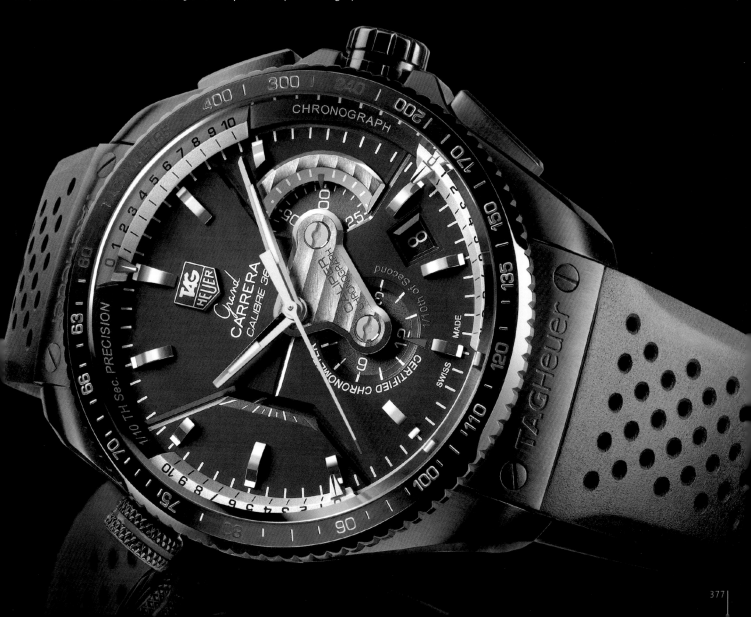

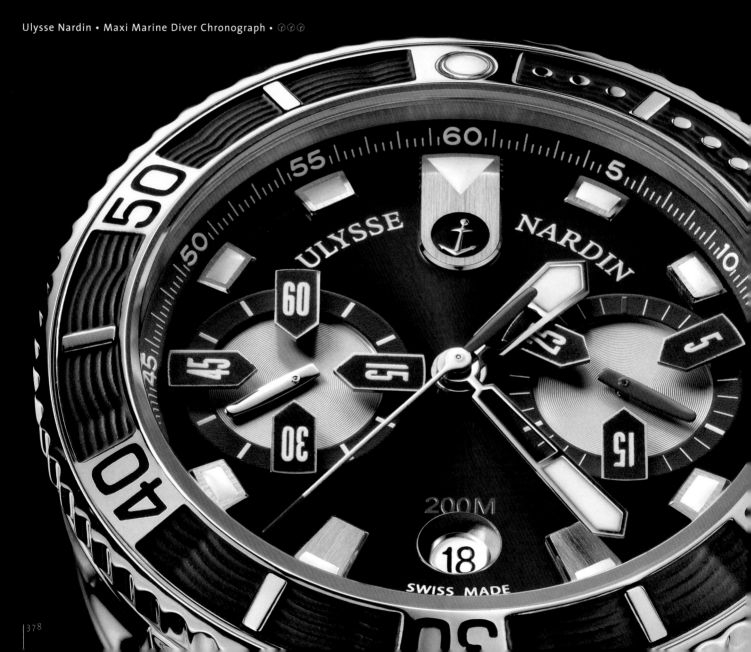

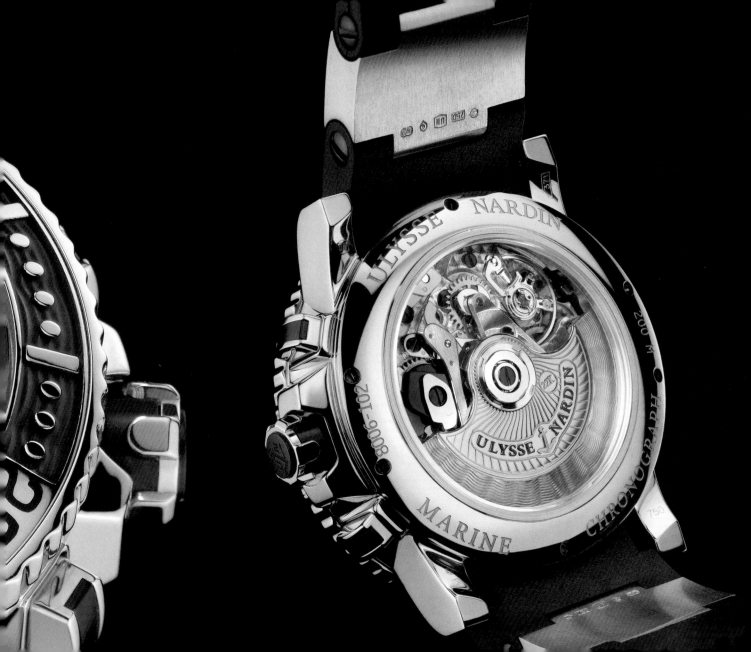

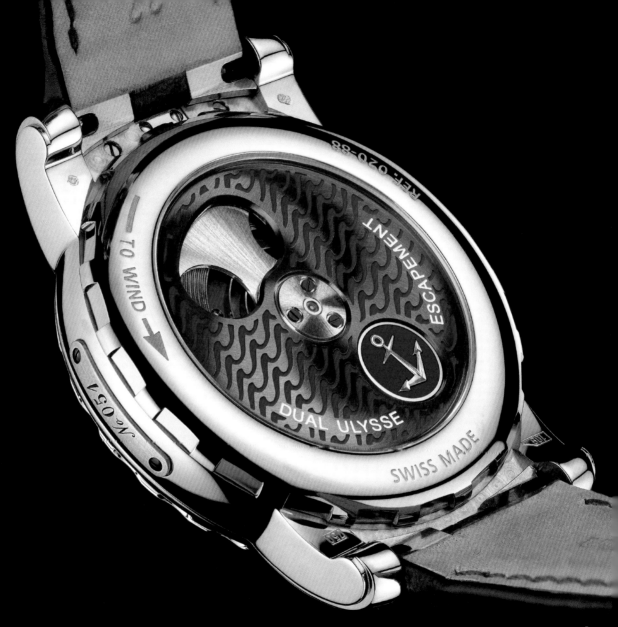

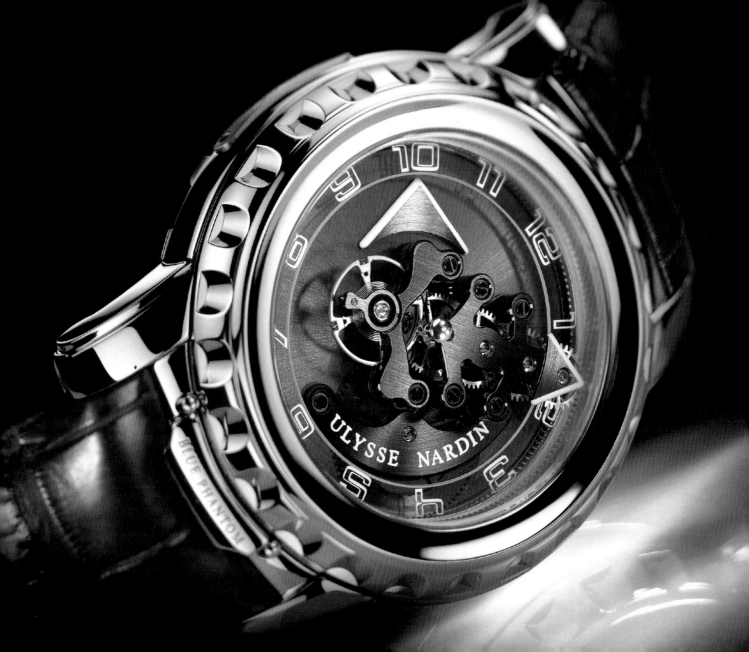

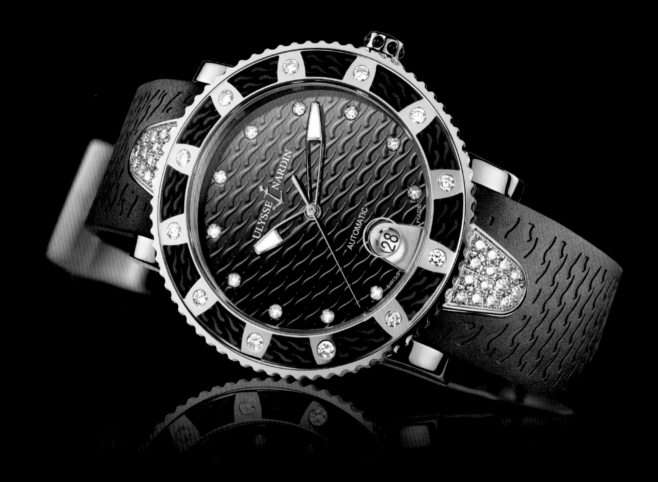

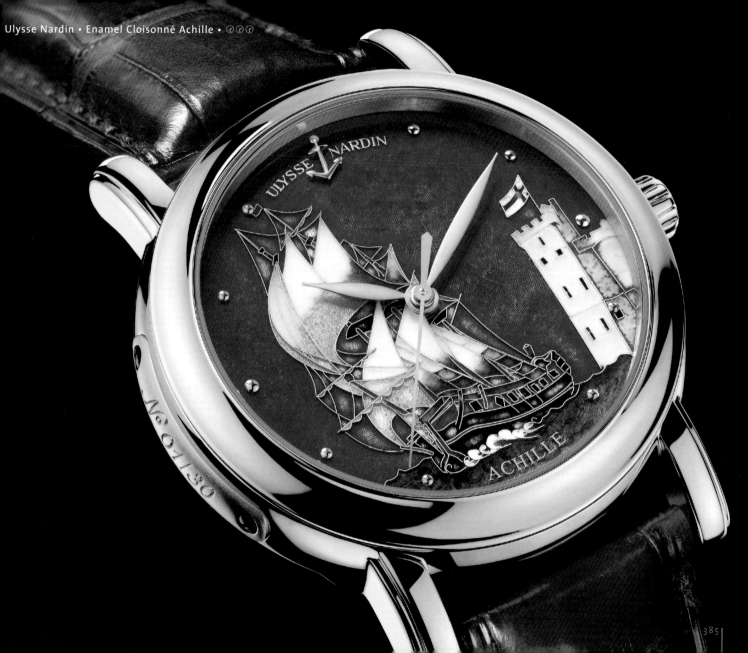

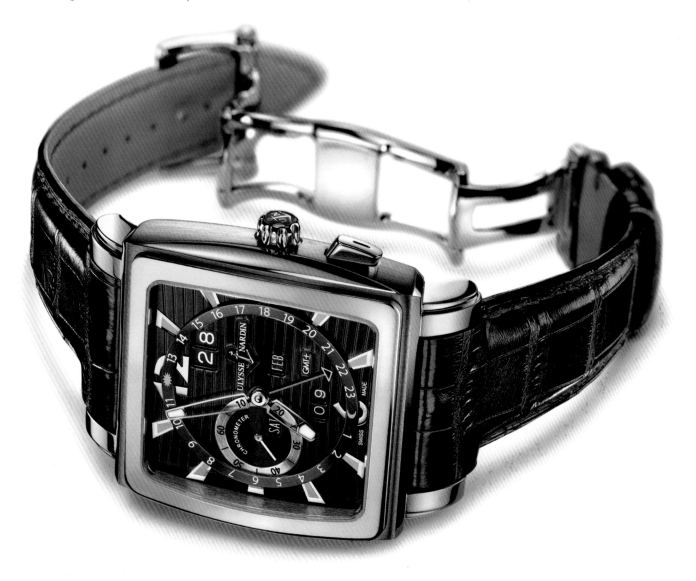

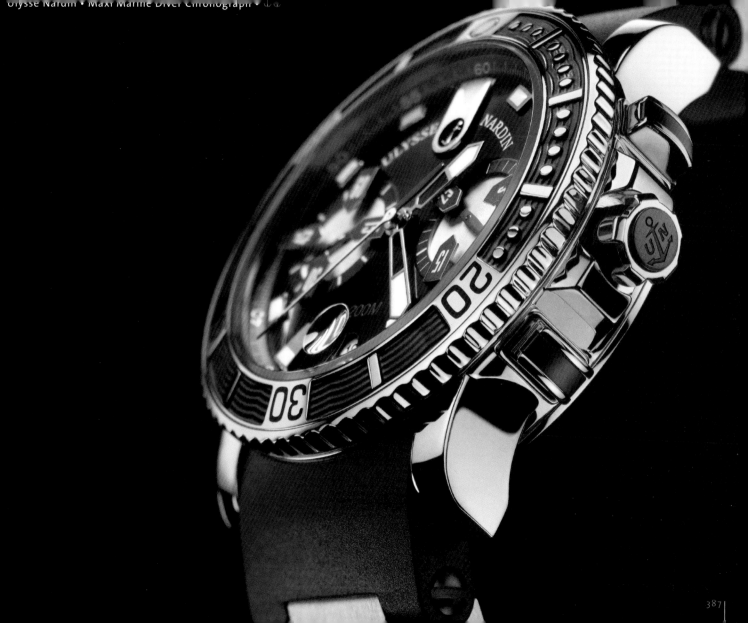

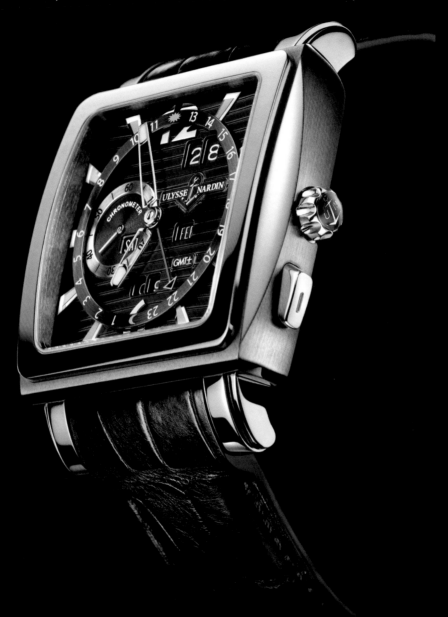

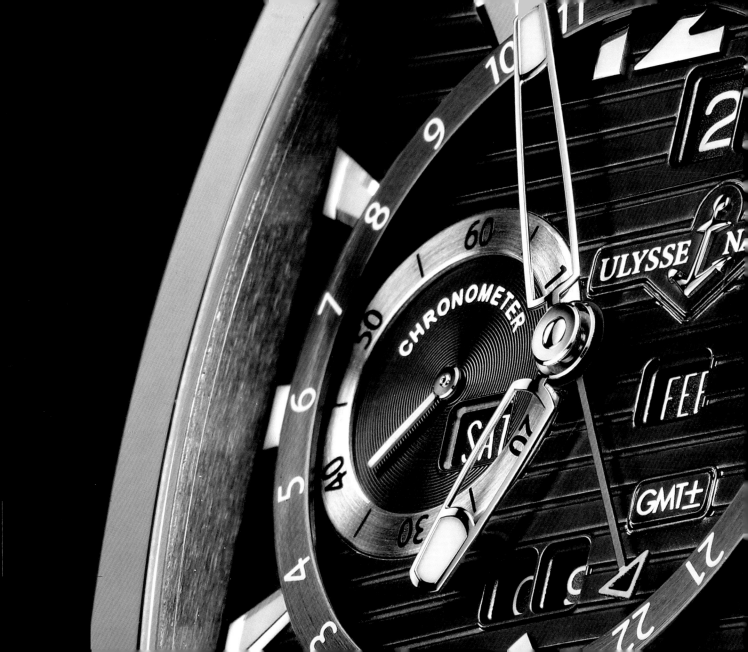

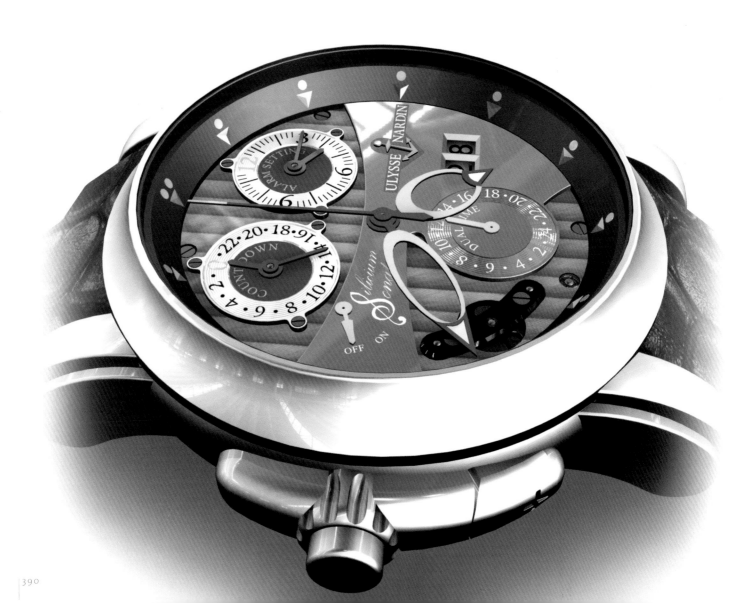

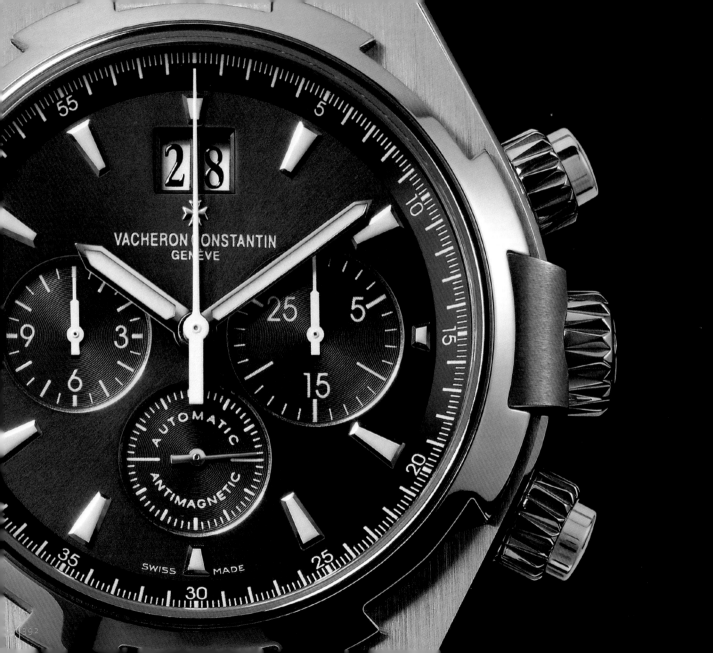

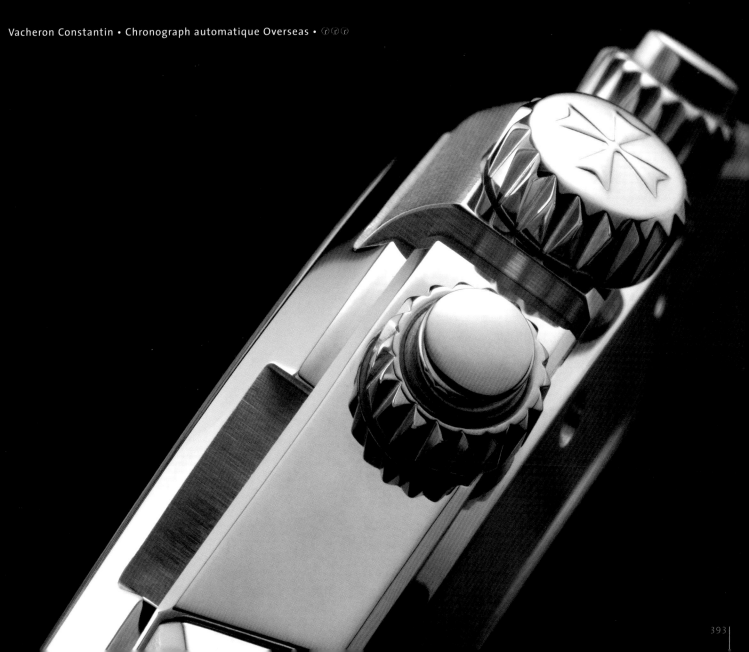

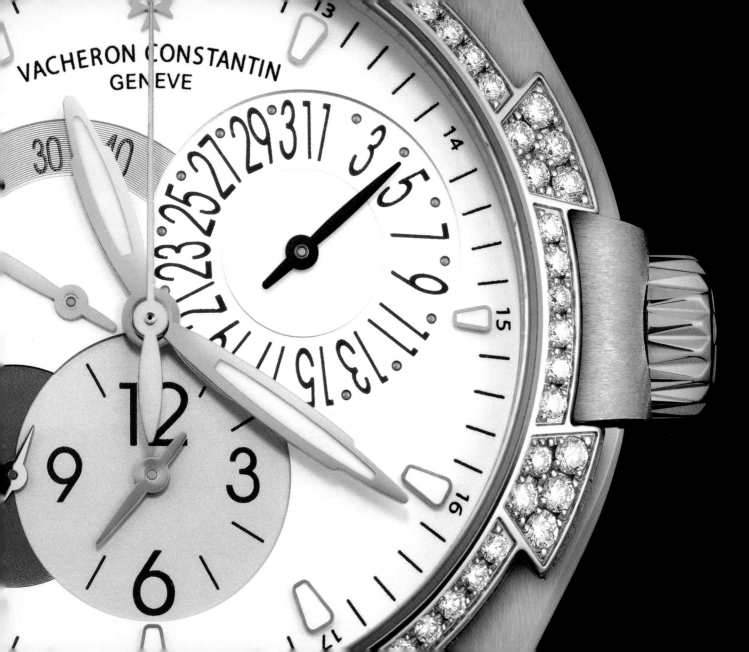

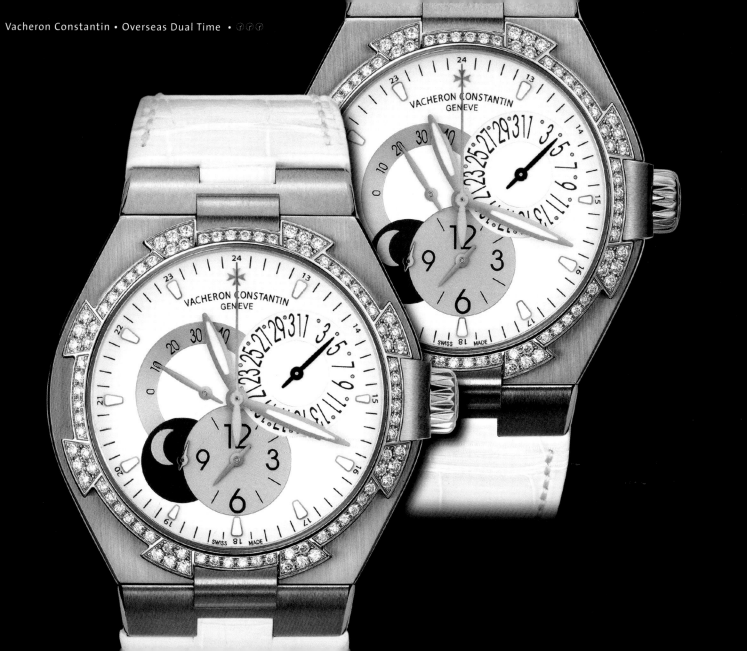

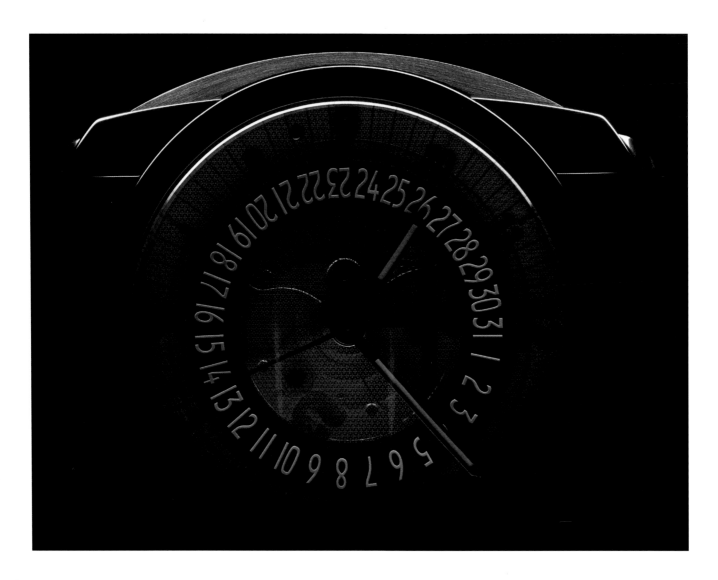

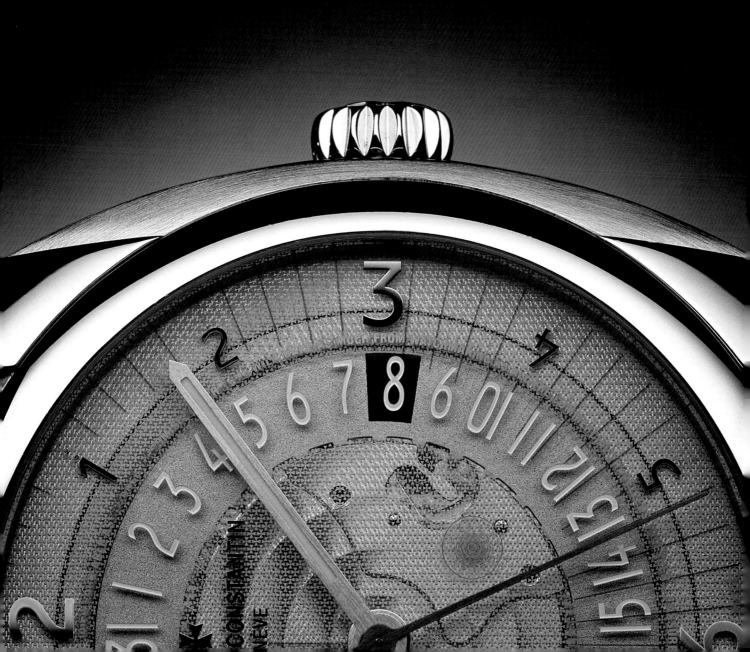

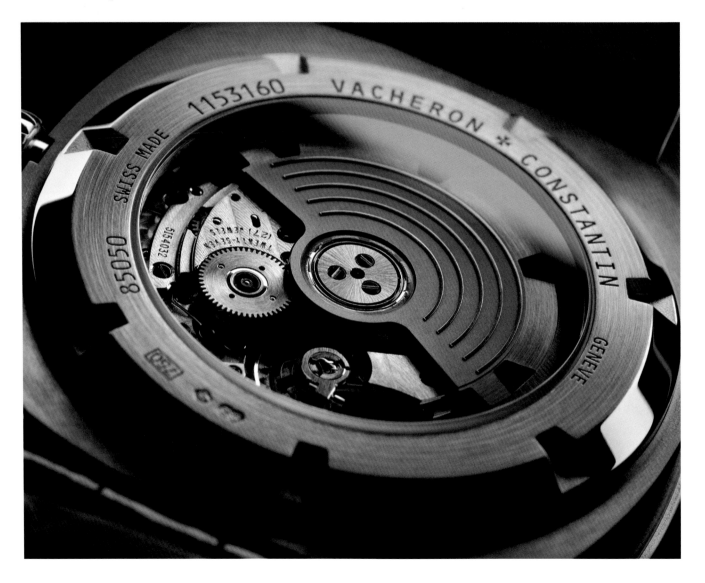

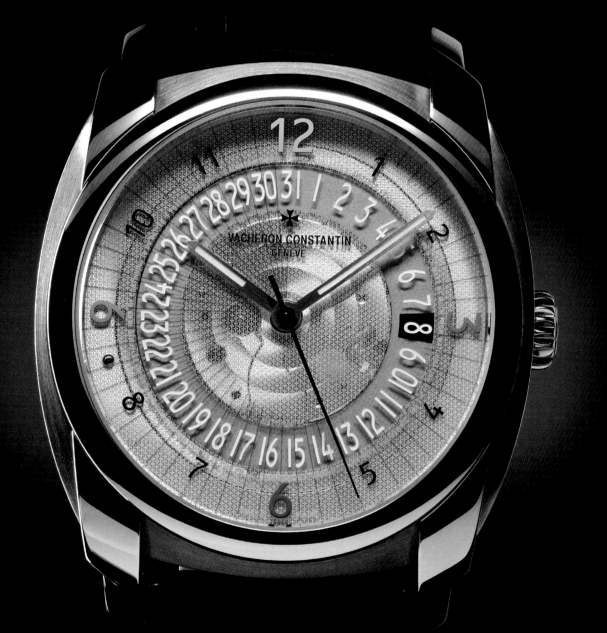

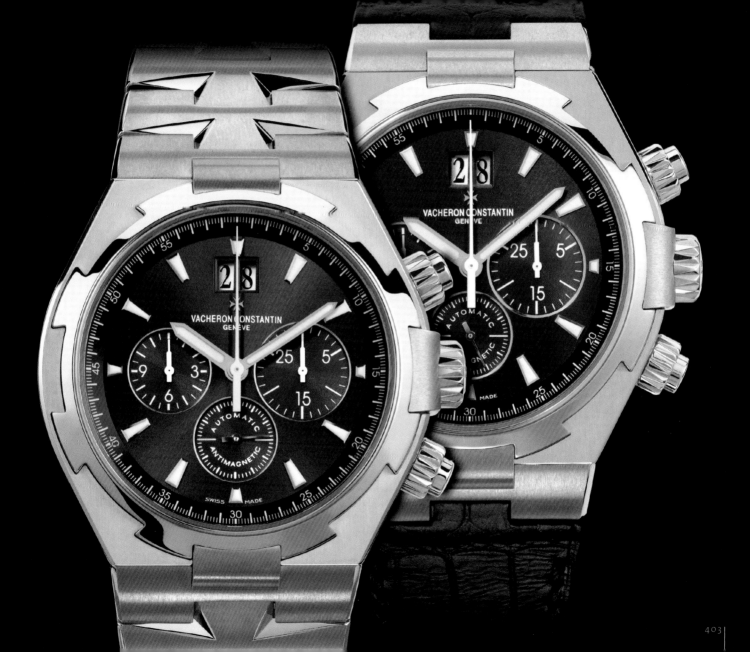

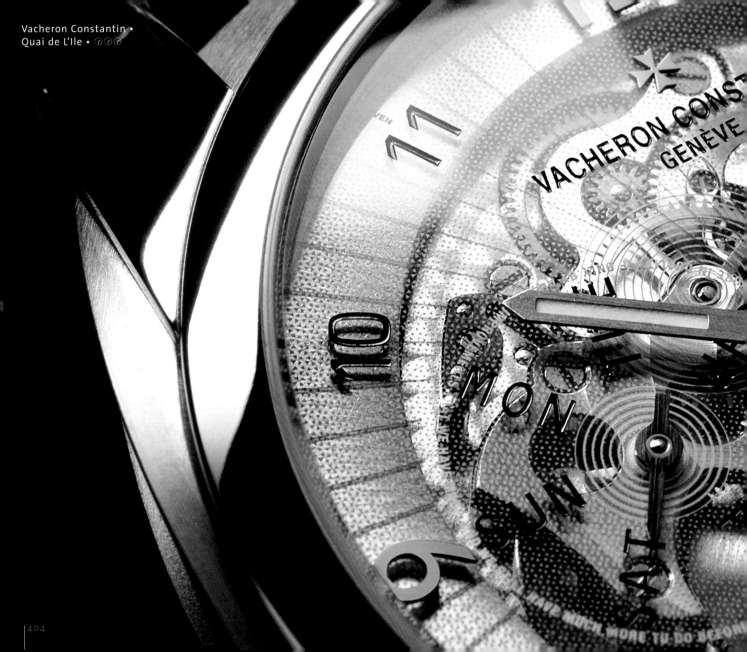

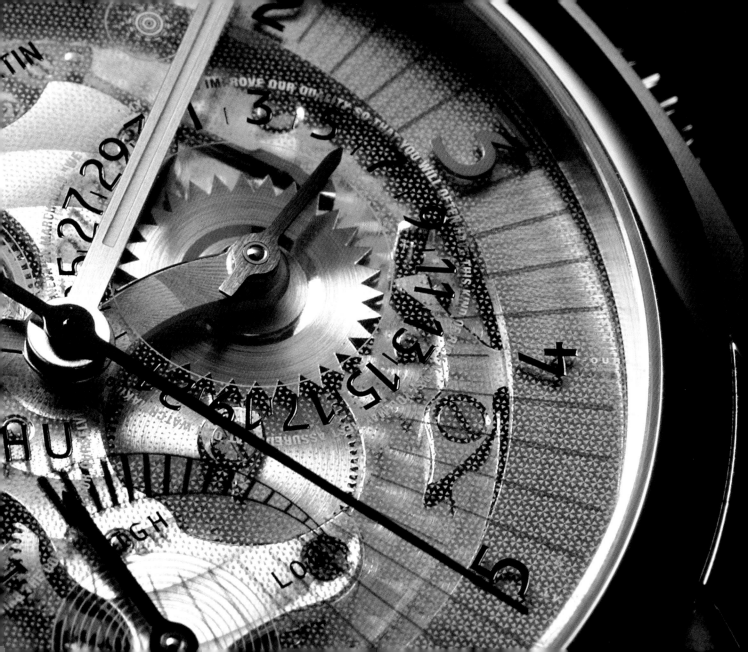

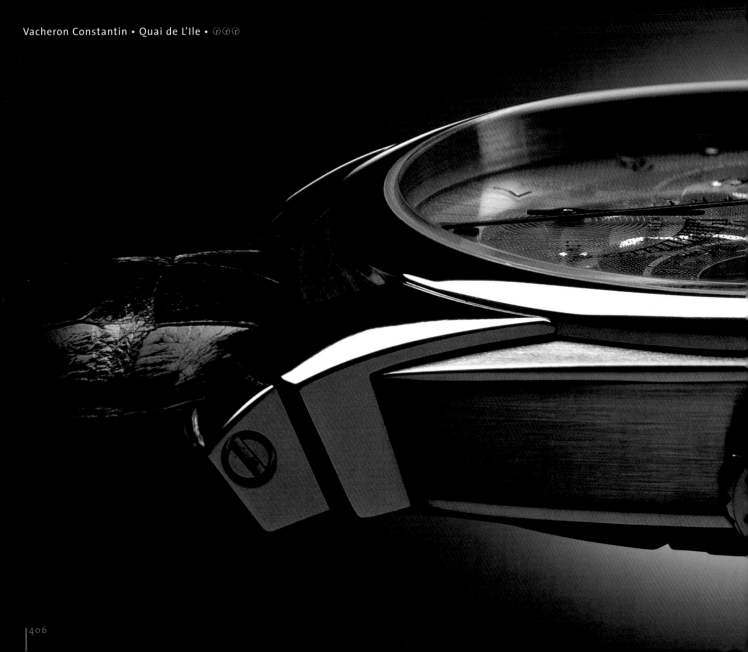

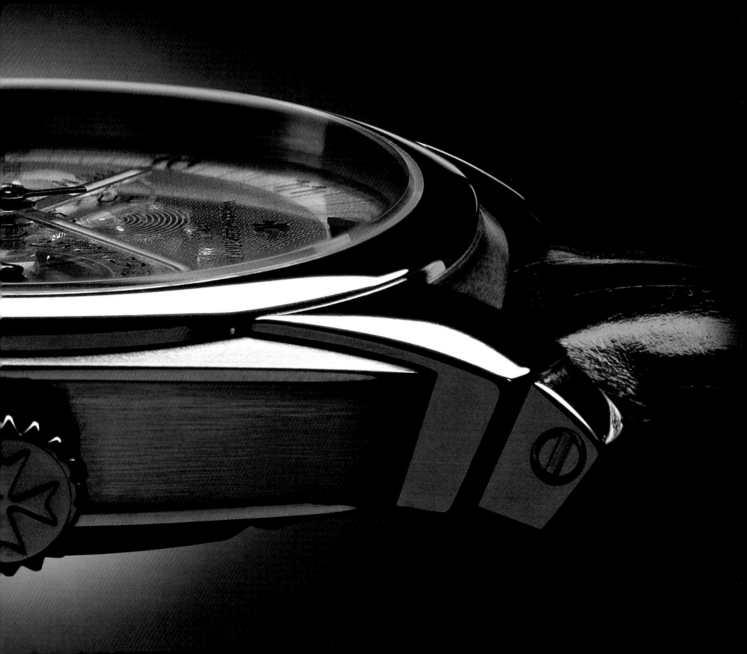

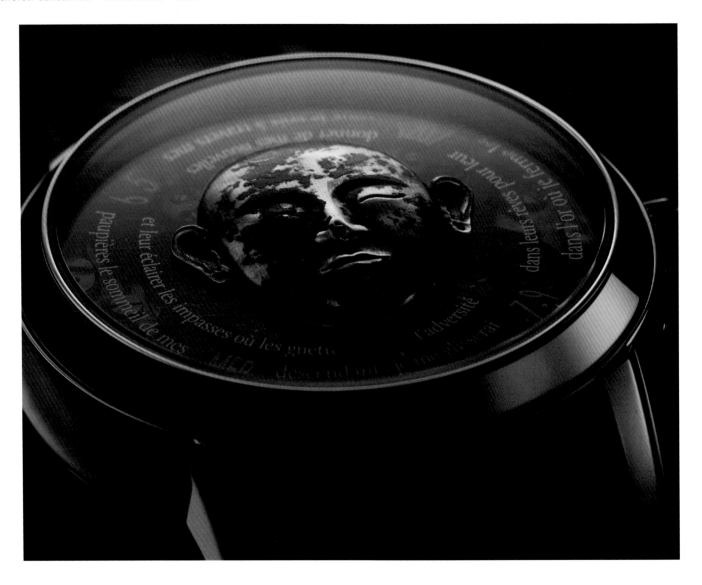

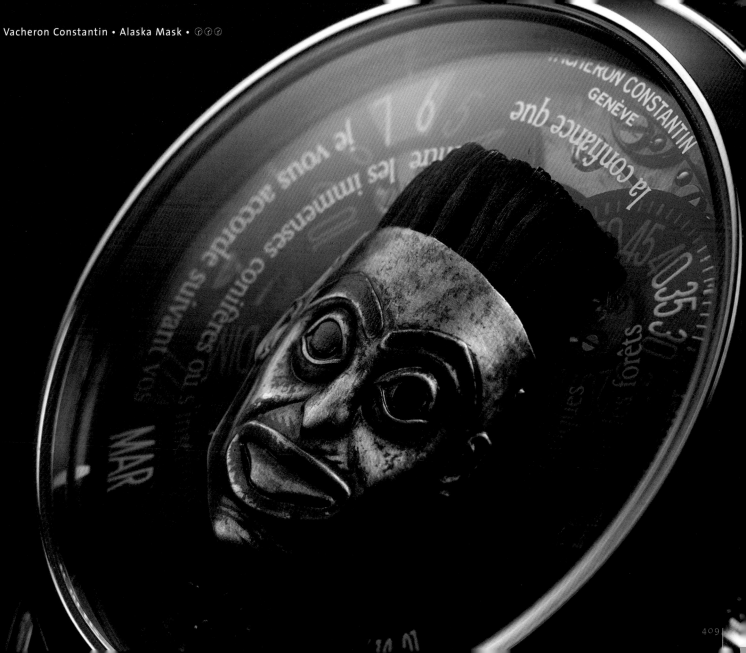

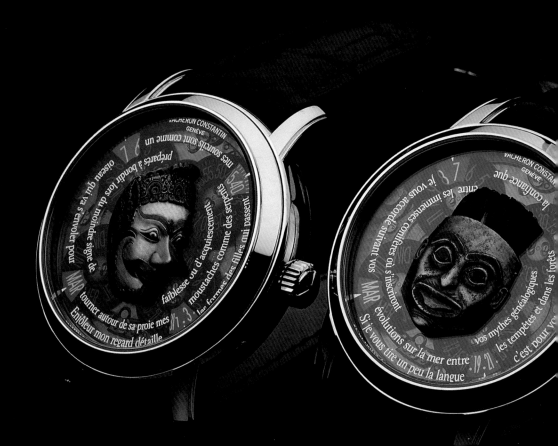

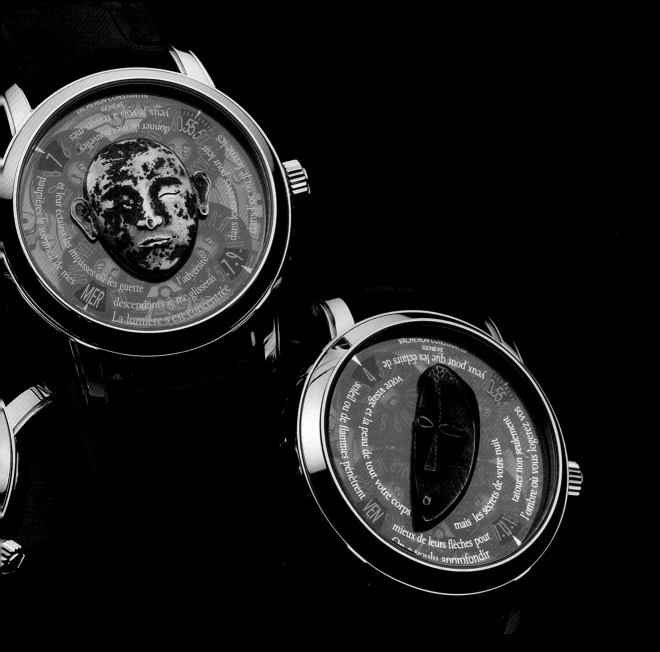

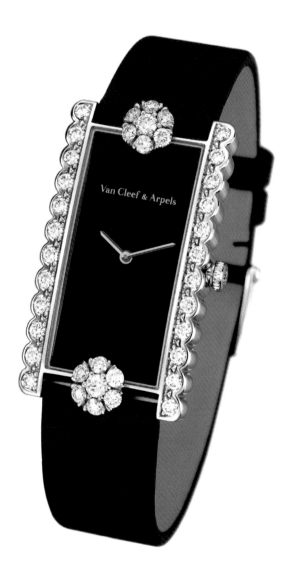

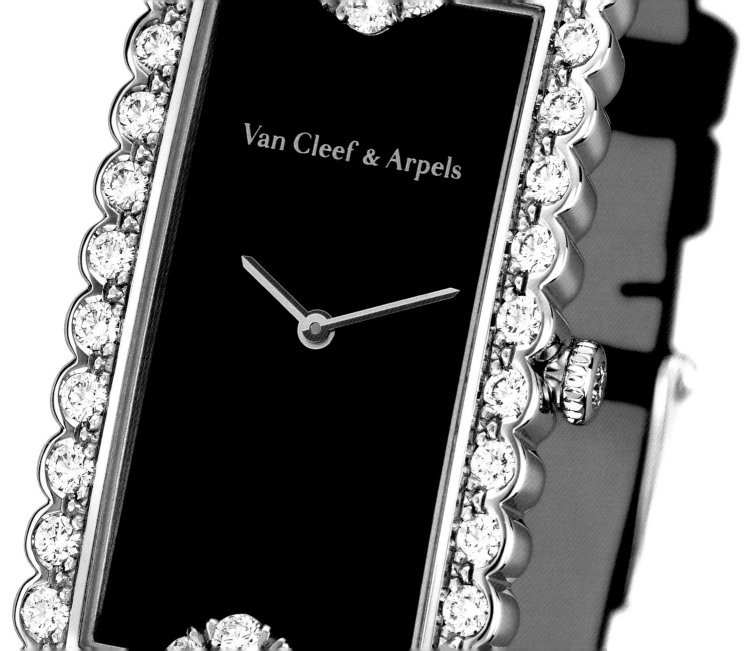

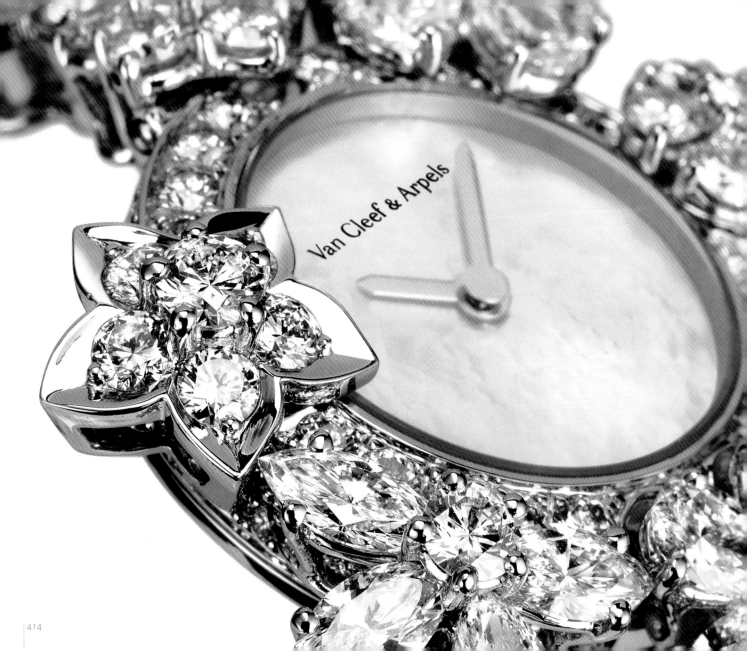

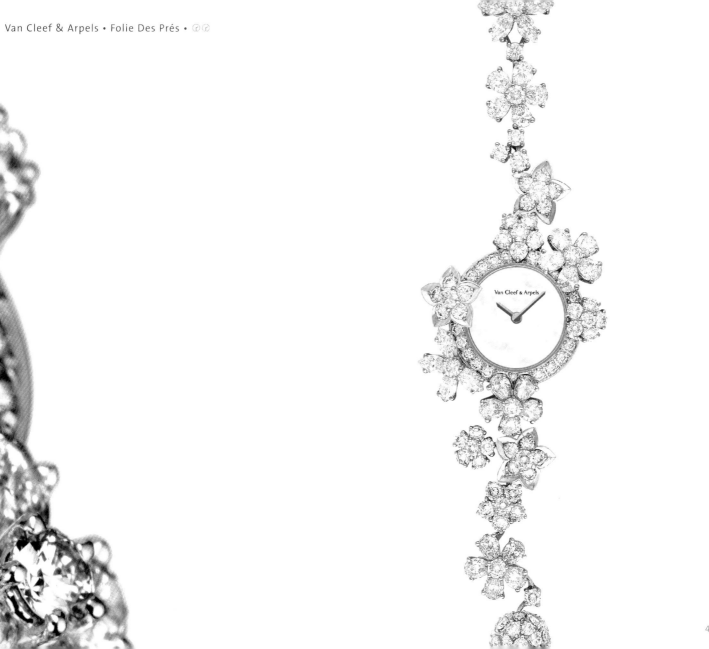

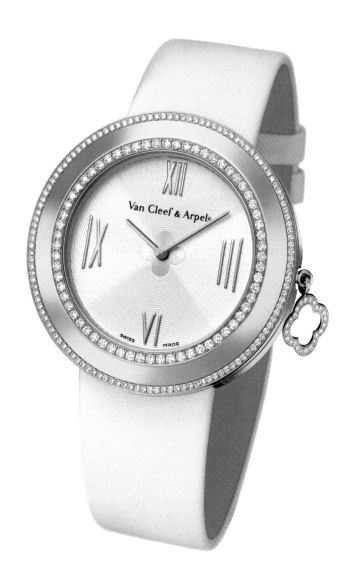

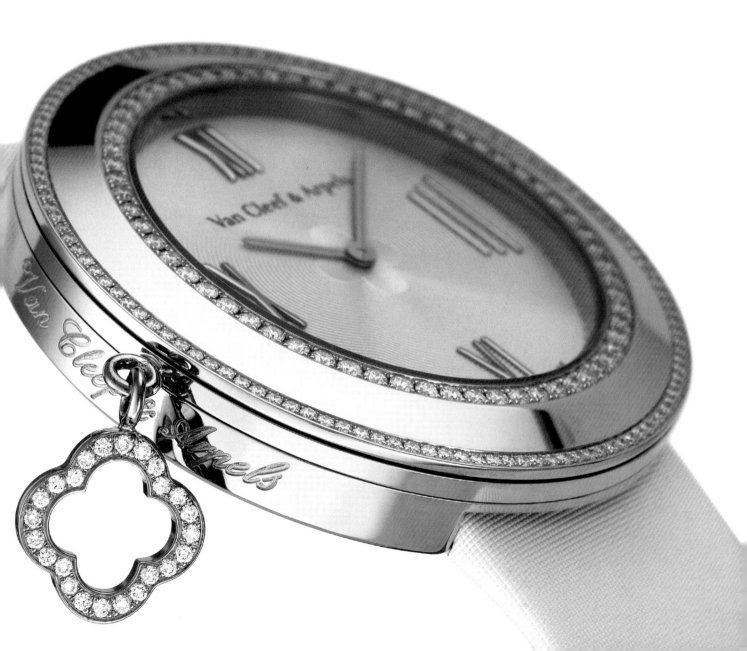

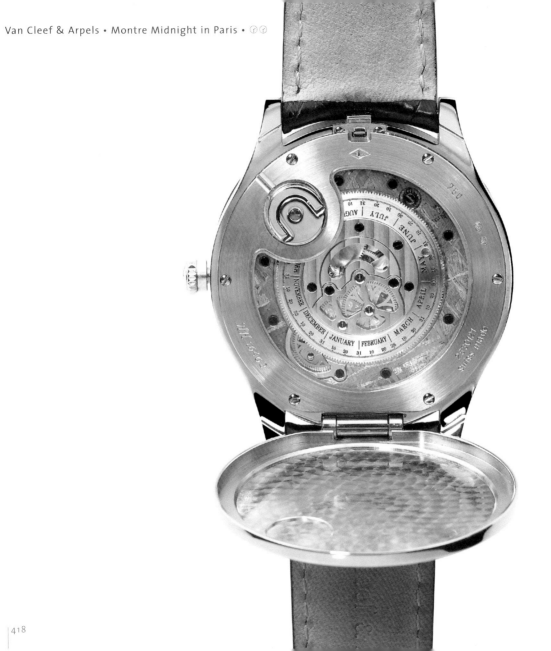

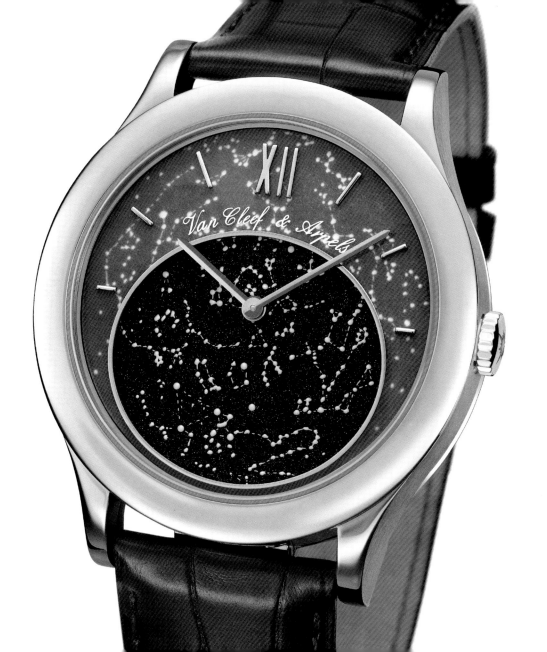

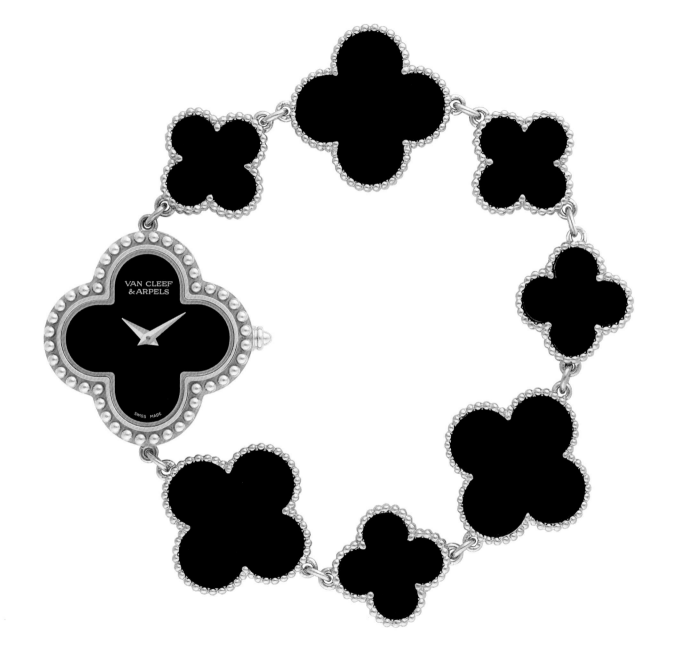

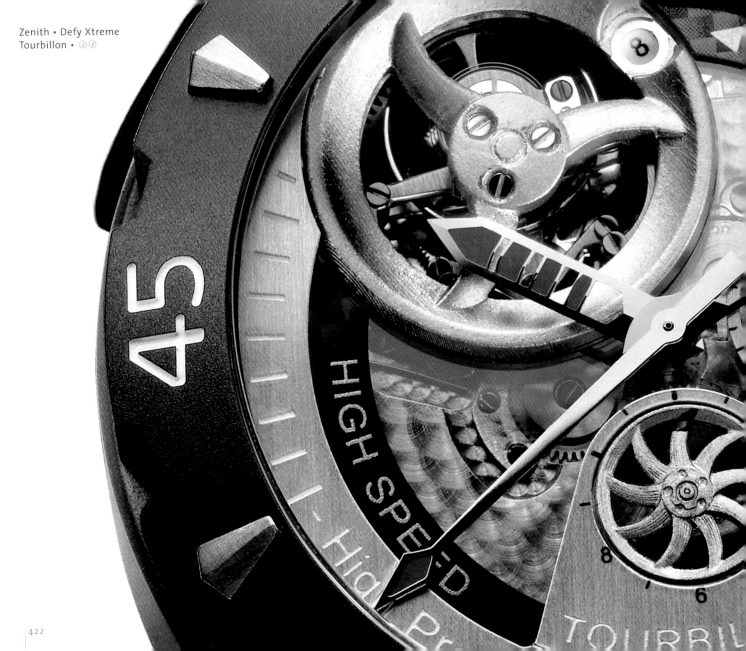

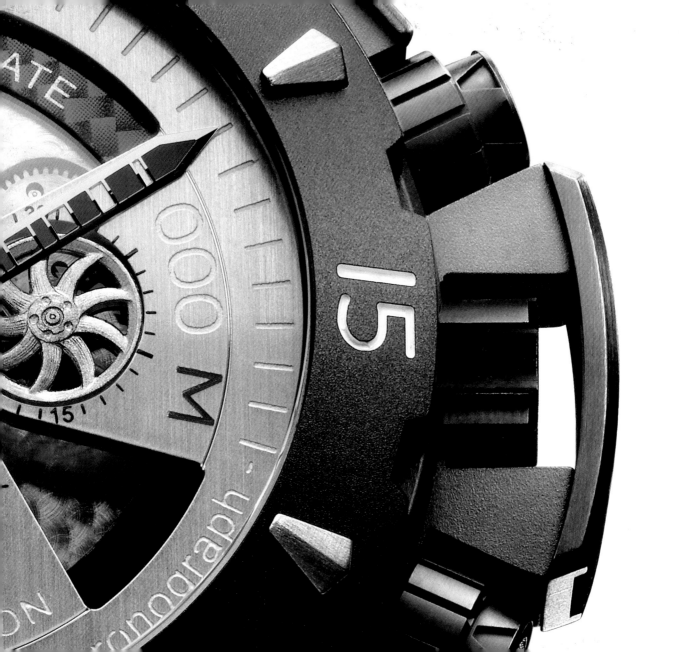

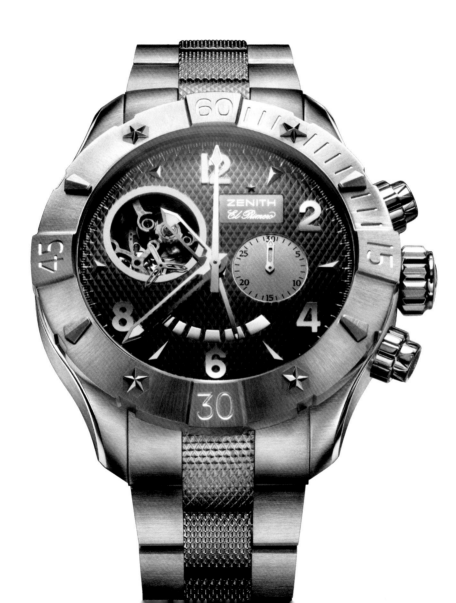

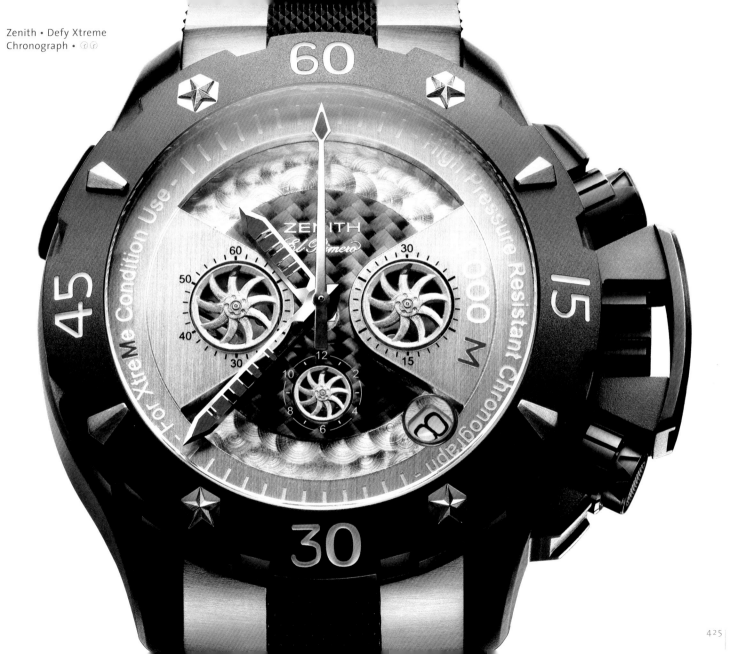

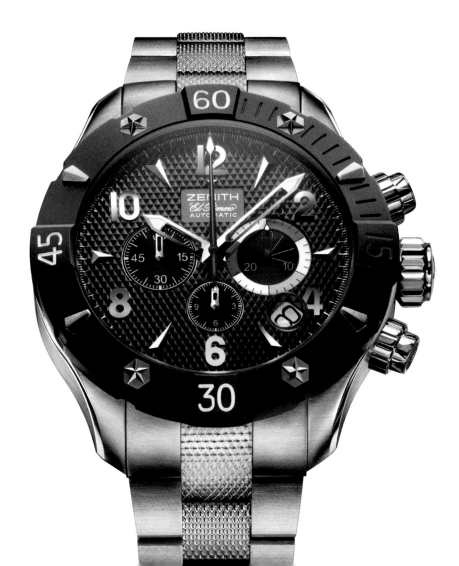

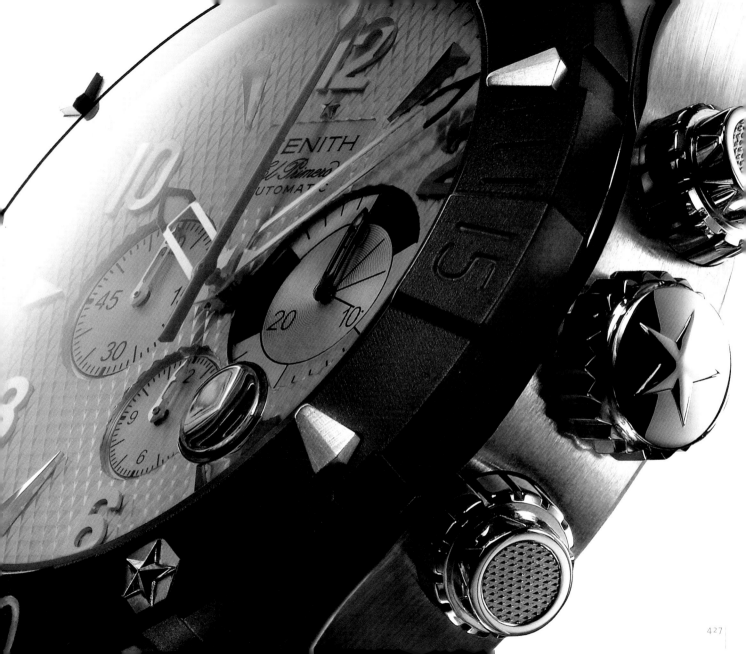

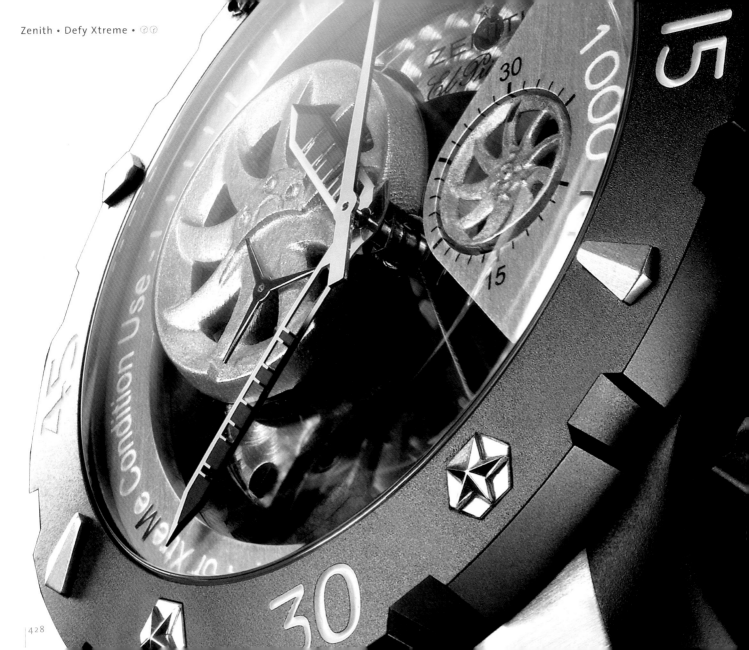

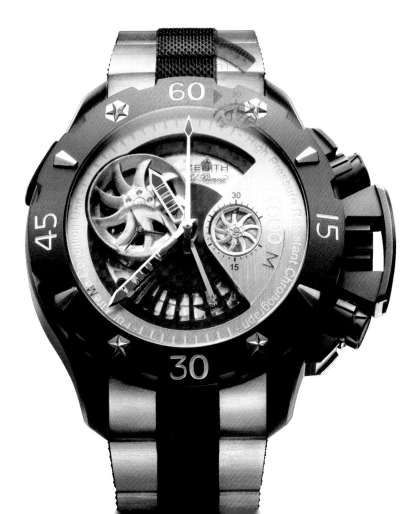

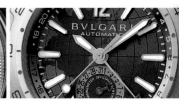

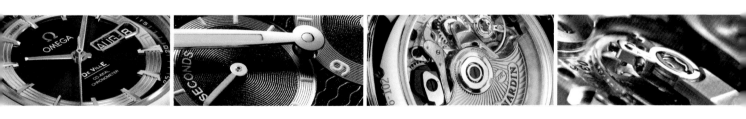

Brands

Alpina	www.alpina-watches.com	
Armand Nicolet	www.armandnicolet.com	
Audemars Piguet	www.audemarspiguet.com	
Baume & Mercier	www.baume-et-mercier.com	
Bell & Ross	www.bellross.com	
Blancpain	www.blancpain.ch	
Breguet	www.breguet.com	
Breitling	www.breitling.com	
Bvlgari	www.bulgari.com	
Cartier	www.cartier.com	
Chopard	www.chopard.com	
Concord	www.concord.ch	
Cuervo y Sobrinos	www.cuervoysobrinos.com	
Ebel	www.ebel.com	
Eberhard & co	www.eberhard-co-watches.ch	
Ferrari	www.panerai.com	
Frédérique Constant	www.frederique-constant.com	
Girard - Perregaux	www.girard-perregaux.ch	
Glashütte Original	www.glashuette.de	
Harry Winston	www.harrywinston.com	
Hermes	www.hermes.com	
Hublot	www.hublot.ch	
Icelink	www.icelink.com	
IWC Schaffhausen	www.iwc.ch	
Jaeger - LeCoultre	www.jaeger-lecoultre.com	
Jean Richard	www.danieljeanrichard.ch	
A.Lange & Söhne	www.alange-soehne.com	
Longines	www.longines.com	
Maurice Lacroix	www.mauricelacroix.com	
Meistersinger	www.meistersinger.de	
Montblanc	www.montblanc.ch	
Nomos	www.glashuette.com	
Omega	www.omega.ch	
Oris	www.oris-watch.com	
Panerai	www.panerai.com†	
Parmigiani	www.parmigiani.com	
Patek Philippe	www.patek.com	
Piaget	www.piaget.com	
Porsche Design	www.porsche-design.com	
Raymond Weill	www.raymond-weil.ch	
Roger Dubuis	www.rogerdubuis.com	
Rolex	www.rolex.com	
RSW	www.ramawatch.com	
TAG Heuer	www.tagheuer.com	
Ulysse Nardin	www.ulysse-nardin.com	
Vacheron Constantin	www.vacheron-constantin.com	
Van Cleef & Arpels	www.vca-horlogerie.com	
Zenith	www.zenith-watches.com	

Photography

p 75 - 77 Franck Dieleman © Cartier 2008
p 79 - 89 Panseri © Cartier 2008

The "Mini Watch Bible vol1" is made in cooperation with the International design and
style magazine WATCH (*www.watch-magazine.nl*) from Yellow House Publishers BV in the Netherlands